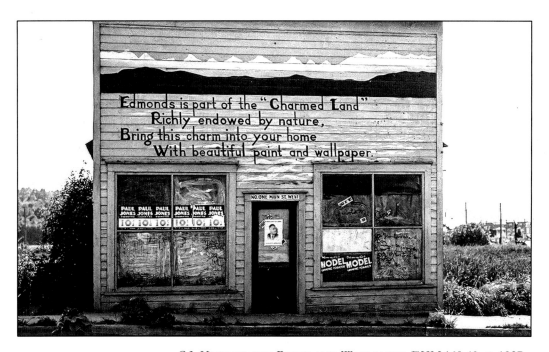

C.J. Hildebrand Paint and Wallpaper, EHM 160.40, c. 1927

EDMONDS THEN AND NOW

EDMONDS THEN AND NOW

1876 to 2023

Arnold M. Lund

Copyright © 2023 by Arnold M. Lund
Printed in the United States of America

All rights reserved. No part of this book may be reproduced or used in any manner without the copyright owner's written permission except for the use of quotations in a book review. For more information, contact amlundjr@gmail.com.

Vintage images are used with permission from the Edmonds-South Snohomish County Historical Society and the Edmonds Historical Museum. Most of the contemporary images are owned by the author, and any others are used with the owner's permission and are attributed appropriately.

First edition October 2023

ISBN 978-1-7368742-8-8 (paperback)
ISBN 978-1-7368742-7-1 (hardback)

Published by:

Edmonds-South Snohomish County Historical Society
118 5th Ave N
Edmonds, WA 98020

Örn Press
437 5th Ave S, #3B
Edmonds, WA 98020

This book is dedicated to two seminal Edmonds historians. One is Ray V. Cloud, whose application of his journalistic eye to the records of the *Edmonds Tribune-Review* to create *Edmonds: The Gem of Puget Sound* is the starting point for most of us exploring Edmonds' history. Without his work, this book would just be a collection of photographs without the stories that light them up.

The other is Betty Lou Gaeng (nee Deebach), who passed away on April 17 this year. Betty Lou moved with her family to Edmonds in 1937 and entered the 5th grade of the Edmonds Grade School when Frances Anderson was the principal. She had long been writing about Snohomish County history in places such as *My Edmonds News*. Her "Looking Back" articles brought delight and inspiration to many as they were shared around kitchen tables. Her interests crossed writing, history, and genealogy. As shared in the recent *My Edmonds News* article about her passing, part of the gold in her writing was, "I start with my own memories, then I go to all the different research places I can until I can't find anymore." Many of us miss Betty Lou, but she will continue to be with us in the memories of those she touched and in the work of those who follow her.

"Not to the Queen City
Not to the City of Destiny
Not to the City of Smokestacks
But to Edmonds, the Gem of Puget Sound!"

- An anonymous toast cited in Ray V. Cloud's
Edmonds: The Gem of Puget Sound

FIRST PUBLISHED IN THE
EDMONDS TRIBUNE REVIEW, C. 1970

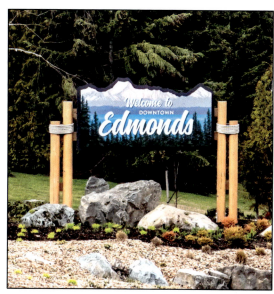

C. 2023

FOREWARD

This year, 2023, is the 50th Anniversary of the Edmonds-South Snohomish County Historical Society. As part of the celebrations around the Anniversary, Maggie Kase (the Executive Director for the Society) has been interviewing people who have helped make the Society and the Edmonds Historical Museum possible. The interviews included Bill Lambert (former-President of the Society), Darlene Newquist (who served on the Society Board and as President of the Guild), and Teresa Wippel (Publisher of <u>My Edmonds News</u> and other neighborhood news sources, and former Board member). The following are selections from the transcripts of some of those interviews.[1]

How did you get involved with the Society?

Bill: "My wife made me do it. She was a longtime volunteer in the gift shop for about fifteen years. She got me involved in the market and told me I had to behave myself and to do good. So I tried to do that."

Darlene: "Mary Van Meter was a member of everything at the museum. One of our strongest members. And she took me by the arm one day when I came and asked an innocent question about the museum and said, 'Come with me and we'll talk!' And the next thing I knew I was President of the Guild, on the Board, you know, doing this and that, working Summer Market, Summer Market Committee, right in the midst of all the fun."

Teresa: "It's actually a funny story. When I was first invited to be on the Board of the Historical Society at the time, the gentleman who invited me said they were trying to make the Board younger! And I was laughing, because at the time I was in my mid-fifties, and I thought, 'Oh, well that tells me something!' [laughs] And it actually was really quite delightful because I have always loved history and once I started getting involved with the Board I found so much more about Edmonds that I hadn't realized in terms of its roots and how much history there really was. It was a very valuable opportunity for me."

What is your favorite memory of your time with the Society?

Bill: "My favorite times are interactions with the people of Edmonds and

[1] With minor editing and the approval of the participants.

surrounding communities. My very favorite was the building of the plaza, and seeing the school bell lifted between the telephone wires and everything and put in place. Thanks to the hard work by a lot of people like Jerry Freeland, Ann Wood (especially for selling bricks), and Dean Averill for being the project manager. And also thanks to Rick Steves and the other funders."

Darlene: "Just the fun with the other members of the museum, and when we worked on the white elephant table. Just talking to people about the museum, and saying along the lines of 'Thank you for supporting the museum. All of this money goes to the museum. We're just volunteers and YOU are supporting the museum. Thank you!' The Museum Summer Market booth was set up in the morning, stocked, refreshed during the day with new merchandise and packed up again at the end of the Market by core members of the Board and Museum. People got informed that way that it was our Museum who produced this Market, vetted the vendors, and brought it all to our city (thanks in large part to Jerry Freeland and Ann Wood.). And we had pricing parties to get the merch ready to sell…It was our fundraiser…I don't know if they still have a booth like that now at the Summer Market. It was a lot of work but also fun…"

Teresa: "Oh, there have been a few. I would say, probably for me, actually the fundraising galas where we had an opportunity to bring in some really wonderful speakers. Rick Steves was one, and Nancy Leson, who was a former food writer for the Seattle Times (who lives in Edmonds), came and spoke about the history of food and kind of connected that to our community. That was fascinating. But what those galas did was really bring people together in one spot to be able to support the organization and have a lot of fun while doing it. Being part of that and the organization of those events was really a fun opportunity for me."

What does the Society mean to you?

Bill: "I have lived a long time, but I've only been a resident of Edmonds for fifteen, sixteen years. So when we moved here from Cincinnati, Ohio, it gave us a place to contribute to the community, and to get to know people in the community…I think it's the relationships that are most meaningful."

Darlene: "I think every city should have something like it. Unless they're brand new, dropped in on a new housing tract of five thousand people, and they are not even a group yet. I think every area should have something that's not government, but that's just people that are interested in being in a good place to live and maybe helping with the work to keep it terrific. And it keeps up with the history of that area."

Teresa: "As a journalist, one thing that I think about when I consider history is something that the late Phil Graham, former publisher of the *Washington Post,* said back in the early fifties actually, or the late forties, which is, 'Journalism is a first draft of history.' As a journalist, I feel like that's something that I do every day when I am documenting what is happening in our community. I realize that that's kind of the start of what may be, in twenty-five, or fifty, or a hundred years, a documentation of what's going on. It really provides a roadmap, not only for our past and where we've been, but where we need to

go in the future. I didn't mention it earlier, but another important event for me being involved with the Society was when we worked with the indigenous people to do the carving outside the museum, and really started to work to recognize the role that indigenous people play in our community, because that's not something that was necessarily reflected early on. We focused a lot on the founder of Edmonds, George Brackett. But truthfully, there were many people here before him. We sometimes forget the role that they played in establishing our communities. Having the Society become involved in that effort was really an important milestone for me personally, and I think for us."

What does it mean for Edmonds more generally?

Bill: "For some, it means remembering the community as it was. For others, it's finding a way to help the community grow and become meaningful. But I think the most important thing I would cite is Edmonds is in the act of becoming. What that will be, there are lots of opinions upon that. But retaining our values, retaining our community for those of us who came later, to build on the legacy that others have helped to put in place. When you really study history, how does a little fishing village become this?"

Darlene: "I think it's a good touchstone for people that come in that are new. To learn about Edmonds…Like I think when you move to a new area, you should go to city council meetings for a little bit, just to get an idea of who knows what they're doing, who doesn't, and what the city's goals are. Same thing for the museum. What are the goals? Do you support those goals? And how can you help with those goals? Or how can you get your opinion across that maybe we should consider not doing x, y, z, or trying it on this very small step and see how that goes. You know that kind of thing. Just working with people to get things done. I always felt that it was a good way to make folk feel welcome to Edmonds. Maybe they just moved here. Maybe it was their first time to the Market. But we were glad they were at the Market and supporting the Museum."

Teresa: "I think one of the things that is a struggle for many volunteer organizations everywhere is recruiting board members, and members generally, and especially younger people. The one thing that I think is often true is that many people don't start thinking about their history until they get older, because all of a sudden, they realize that time is going very fast. They look back at their lives and they think, 'Oh, my gosh! You know, it's important for me to know about my family history, or my community's history. Because I'm not going to be around forever.' When you're in your twenties or your thirties, you're very busy with your life, and I think you don't necessarily always prioritize that kind of work. But whatever we can do, both as a committee and as a Society, to get younger members involved and more diverse members of our community involved, I think will only enhance and enrich our organization, and make it stronger."

c. 2023

LAND ACKNOWLEDGMENT

"The Edmonds Museum and South Snohomish County Historical Society acknowledges that we are on the traditional homelands of the Coast Salish tribes. The Coast Salish represent a large collection of many tribes with distinct cultures and languages who have served as stewards of the land and sea for more than 14,000 years. We pay our respects to the Coast Salish people past and present."

– Land Acknowledgment of the Edmonds-South Snohomish County Historical Society

Nestled along the shores of Puget Sound, the Edmonds area was once a thriving hub of activity for the Coast Salish tribes. For thousands of years, the region's natural resources were integral to their way of life, sustaining them through the seasons. The marshlands provided a bounty of cattails, bark, and other resources, while the Sound offered an abundance of fish and shellfish. The trails from Edmonds to Lake Ballinger were dotted with berry bushes, roots, and the bounty emerging from the rich soil. Although there is no evidence of a permanent village in Edmonds, the marsh was an important gathering place for the tribes. They would come to harvest resources, hold marriage and other ceremonies, and socialize. The marsh spanned nearly forty acres at its peak, but it now covers just around twenty-three acres due to development over the years.

To honor the history of the land and the Coast Salish tribes, the Edmonds-South Snohomish County Historical Society worked with Ty Juvinel, a Tulalip Coast Salish artist. He created the "Marsh Life" mural as a tribute to their way of life. The mural depicts a fisherman and animals in a stylized Coast Salish design. It was carved from two planks of cedar harvested in the Puget Sound region. Using positive and negative shapes, Juvinel incorporates centuries-old motifs and symbols into the carving using the traditional Salish carving style of crescents, trigons, and ovals.

The skylight shelter of the mural also features a Coast Salish frog, known as WAQ' WAQ', which is highly regarded in native communities, particularly in Coast Salish culture. The frog is considered a powerful spiritual figure, capable of moving between the physical and spiritual worlds, and is revered for its ability to live on both land and water and for its ability to hibernate through the winter. Frogs are also considered indicator species. Their presence or absence in an ecosystem can signal its health.

The mural is framed by two salmon guardians, representing the significance of fish in the lives of the Coast Salish tribes. The tribes have long worked in harmony with nature, and as Juvinel notes, "It's a relationship we need to get back to." Through this artistic tribute, the "Marsh Life" mural provides a window into the rich history and traditions of the Coast Salish tribes. It reminds us of the importance of preserving and honoring the natural resources that sustain us. The Edmonds-South Snohomish County Historical Society deeply appreciates Ty Juvinel's sculpture and is grateful to the Edmonds Arts Festival Foundation, the Hubbard Family Foundation, the City of Edmonds, and private donors who made it possible.[2]

[2] historicedmonds.org/honoring-coastal-salish-people

OTHER ACKNOWLEDGMENTS

I need to begin by thanking my wonderful wife, who has been so patient with me babbling about things I have discovered about Edmonds' history and who, yet again, provided me with the key first round of fresh edits and content critique. That input made the book ready for even more eyes to look at it. I also want to thank Maggie Kase for supporting, advocating, and partnering in this journey. She provided invaluable editing advice, especially based on the lessons she learned from previous projects working with indigenous tribes. Her efforts to obtain a grant for the book will help get it into the hands of more people and should increase the benefits the Society and Museum will reap from its publication. Katie Kelly deserves a shout-out for hosting me as I researched the vintage photos in the Museum collection, responding to the seemingly endless requests I made for copies of the photos, and sharing her information and insights in response to my naïve questions about Edmonds history throughout the process.

It is true that a book like this takes a village to write, especially a book about a village. As a result, many others need to be thanked, far more than I can include here. A good example is that one of the *Then* photos was taken from the top of a fire tower that is no longer there, and I realized I needed to get on top of City Hall to duplicate it. Vivian Olson, serving on the Edmonds City Council and President Pro Tem, was kind enough to connect me with Todd Tatum, Director of Community Services. Todd, in turn, linked me to Larry LaFave, who managed to get me on the roof to take some amazing pictures and who kept me from falling off. I then realized that another photo from the fire tower couldn't be duplicated from that position. Jesse Bermensolo was generous enough to reach out to me, offering his drone skills to help out, and we captured the second photo, plus several other ones I couldn't get in any other way. In response to the postings, Mardee Austin reached out and brought my attention to the oldest house in Edmonds, the Bassett House. She provided a wonderful description of Anna Bassett and a picture of Anna that I could use in the book.

Other reviewers whose advice and input have been particularly valuable and helped get the book over the line include John Fahey, Dean Averill, Charles LeWarne, and Jim Landers. Teresa Wippel, the publisher of *My Edmonds News*, was a wonderful source for past articles in the *News* on historical topics and pointers to local experts. Michelle Bear, from the Edmonds Bookshop, provided insights into how best to format the book to maximize the number of people who might enjoy it. Finally, Barb Fahey has been incredibly supportive and helpful in finding contacts with unique expertise for the book and has also provided insightful comments that improved its content. I have also been motivated by the other members of the Board for the

Edmonds-South Snohomish County Historical Society, who have been cheering me on through the journey.

I also want to thank the Hubbard Family Foundation, Bank of America, N.A., Trustee for their generous funding of this project in support of the mission of the Edmonds-South Snohomish County Historical Society and the celebration of its 50th anniversary.

Finally, as usual, I cannot miss the chance to thank my two local coffee shops for their endless supplies of my favorite lattes and cranberry biscotti. Of course, their teams' support was even more important than the caffeine and the calories as they asked about how the book was progressing and the photography. Walnut Street Coffee opened in 2006, and Café Louvre began pulling shots in 2013, and both represent Edmonds *Now* for me.

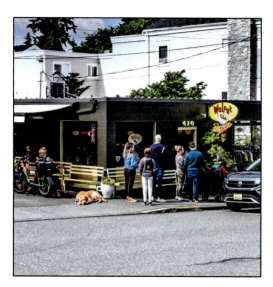 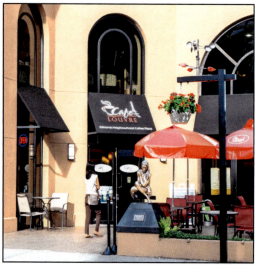

CONTENTS

Foreward	ix
Land Acknowledgment	xiii
Other Acknowledgments	xv
Introduction	**1**
The Setting	1
About the Museum and Society	7
The Photos	8
Photo Spots	12
Overview	13
West on Main Street	**15**
Carnegie Library Building	15
Looking Down on Main Street	19
Murals on West Main	21
5TH and Main Looking West	22
Engel and Fourtner Buildings	25
Schneider Building	34
Edmonds Bakery	37
Princess Theater	40
Beeson Building	44
The Big Snow of 1916	48
Schumacher Building	51
State Bank of Edmonds	56
Roscoe Brothers Grocery	58
Edmonds Café	62
Royal Hotel	64
Hyner Grocery and House	66
Edmonds Hotel	68
Crescent Laundry	72
Shore Area	**73**
Edmonds Ferry Dock	75
Edmonds Train Station	78
Railroad Station Master's House	81
The Mills	85
Looking Towards Brackett's Landing	90

North Edmonds	**92**
Caspers Street	92
Casper's Corner	94
Gerdon House	96
Mowat House	98
Brackett House	100
Brackett's Feed Store	104
Bishop Hotel	106
Sorensen's Blacksmith Shop	108
Edmonds High School	110
High School Field	114
Phillips Motor Court	116
Northside Churches	120
Other Northside Houses	126
East on Main Street	**130**
IOOF Hall	132
Edmonds Independent Telephone Company	137
Murals East of 5th and Main	141
Bassett House	142
The Southeast Bowl	**144**
Edmonds Grade School	146
Southside Churches	150
Engel House	157
Edmonds Opera House and Athletic Hall	160
Yost Auto Company	163
A.M. Yost House	172
Southside Murals	176
Other Southside Houses	177
Looking Up 5th Avenue to Main Street	178
5th Avenue and Main Intersection	**180**
Life Around the Circle *Now*	185
Conclusion	187
Appendix: Pandemic in Edmonds 2019 to 2022	**189**
Appendix: Edmonds *Now* Scrapbook	**191**
Appendix: Historicae Personae Dramatis	**201**
Appendix: Resources	**203**
Author	**205**

EDMONDS THEN AND NOW

INTRODUCTION

THE SETTING

Nestled in the sun-dappled southwest corner of Snohomish County in Washington state lies the charming and vibrant town of Edmonds, which grew out of the traditional and current homelands of the Coast Salish tribes. When George Brackett arrived by canoe and first set foot on these shores in 1870, he found rolling hills, pristine waterways, and dense forests of towering red cedar. As he saw it, the land was ready for what he could make of it as a professional logger, but this was also the perfect spot for a town. He vowed to return.

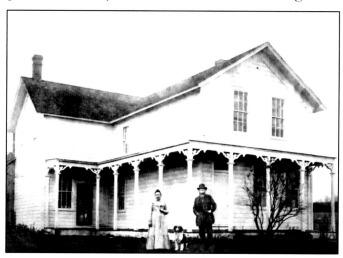

ETTA AND GEORGE BRACKETT, EHM 181.2, C. 1905

And so he did, and in 1876 he acquired a hundred and forty-seven acres of prime land and embarked on a mission to turn his dreams into reality. He began by logging the towering red cedar trees and draining the marshlands, making way for other settlers, each with their dreams and ambitions. Captain William H. Hamlin arrived in 1881, purchasing a large piece of land along the waterfront and building one of the finest homes in Edmonds at 3rd Avenue and Dayton. Charles B. Breed established a sawmill on his homestead. Brackett's friend John C. Lund (not a relation of mine) bought roughly one hundred and fifty acres of timberland several miles north of Brackett's settlement in what is now called Lund's Gulch up in Meadowdale.[3]

With the arrival of each new settler, the town began to take shape and grow. By 1884 the settlement had been platted, it had gained its first post office (George Brackett was the first postmaster, and George Hyner became the second), and you could say it had been blessed with its name. Edmonds was incorporated as a town in

[3] He eventually sold off all but seven or eight of the acres to timber companies.

August of 1890, and the Great Northern track-laying engine rounded Point Edwards heading for town on June 17, 1891.[4] By 1899 a franchise was granted to the Sunset Telegraph and Telephone Company, bringing high technology to the area; poles were planted, and wires were strung. The pace of change was increasing.

There are different stories about how Edmonds got its name. According to Joan Swift in *Brackett's Landing: A History of Early Edmonds*, the area on current maps to the south of the ferry dock called Point Edwards was originally called Point Edmund.[5] Some argue that the town was named after that Edmund, and the "u" was changed to "o" as a misspelling (perhaps as a result of a clerk in Washington, D.C. misreading a cursive entry in a form). Others argue that George Brackett was known to have admired George Franklin Edmunds, a U.S. Senator from Vermont, and that was the intended name that was misspelled at some point. With the city taking the name Edmonds, the Postmaster recommended that the Point Edmund name be changed to Point Edwards.

In her history of Edmonds, Swift shares several stories about this period. One is about a young girl from Michigan stepping off the tugboat from Seattle to Edmonds in October 1890. Maude DePue expressed what many felt in those early days. "We got to Edmonds around twelve midnight. Somewhere Dad got a lantern which lighted us up Main Street over logs and around black stumps to that shanty which Mother later fixed up with roses, flowers, and climbing vines until it was real pretty. But that first morning it was raining and all those black stumps!...I was so homesick I cried and cried and it was some time before I got over it." But it was just another fifteen years until civic boosters could argue:

> "The population at present numbers over 1000. [Edmonds] has ten miles of graded streets, an abundant supply of the purest kind of fresh water, and a fine sewerage system...a serviceable and well patronized telephone system is established and negotiations are in progress and well underway for the establishment of an electric lighting plan, many business houses and residences are already wired." – *Edmonds Review*, September 15, 1905

The early settlers came because of the timber accessible from the shore. Logging, sawmills, and shingle mills were the big industries in town. The hills were covered with old-growth forests, and the trees were huge. Some trees were saplings when William Shakespeare was writing, Magellan circled the globe, and Galileo proved the earth rotated around the sun. The cedar was plentiful, and cedar is a strong wood that doesn't warp, shrink, or swell even in severe weather. The city served the workers and their families, and the infrastructure that grew around these mills to move their products. Grocers, pharmacists, lawyers, restaurants, and others sprang up as needed. Anyone who has played SimCity or other games that let you influence businesses, roads, and other infrastructure to grow cities, would have a sense of the process. Over the next few decades, as the area was largely logged off, farms appeared. As early as 1908, *The Coast* said, "At [Edmonds] large fields of strawberries are grown and have

[4] This factoid comes from myedmondsnews.com/2021/06/looking-back-taming-a-town-while-still-having-a-good-time-in-edmonds/, although historylink.org/File/8688 describes both the railroad as coming south from Everett as well as taking place in parallel all along the Seattle to Canada route.

[5] The first U.S. military expedition to the Puget Sounds was in 1841, and was commanded by Charles Wilkes. Wilkes named the hill Point Edmund. It was perhaps not an accident given that his son's name was Edmund.

THEN, C. 1900

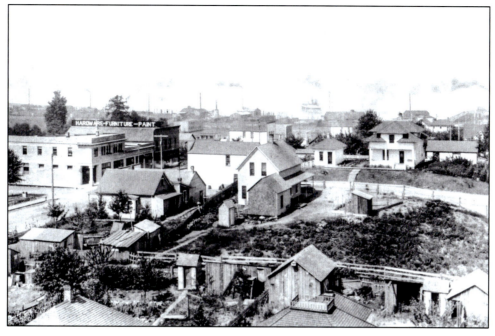

DOWNTOWN LOOKING WEST, EHM 150.190

NOW

FROM THE TOP OF EDMONDS CITY HALL, C. 2023

proven profitable to growers…The strawberry grown on the Sound in [Edmonds] and vicinity will produce 300 to 400 cases per acre." The Edmonds-Richmond Beach-Meadowdale Fruit Growers Association was formed in 1912; remnants of those farms were still around when I grew up in Richmond Beach in the 1950s.

The *Then* photo (EHM 150.190) is looking west towards the mills. Several buildings still there today can be seen (e.g., the State Bank of Edmonds and the Hardware Store). At the time of the photo, the roads are dirt, the mills are smoking, and a ferry is arriving at the dock. There is a roof of a house in both the *Then* and *Now* pictures that is the same as well. The house belonged to Dr. Harry W. Hall.[6] Constructed in 1920, it served as his office for seventeen years.[7] The *Then* photo was likely taken from the top of the relatively new fire tower. To duplicate EHM 150.190, Edmonds was kind enough to let me take a *Now* photo from the top of City Hall.

EHM 150.33 is looking east. Since the fire tower provided the tallest view at the time in this area, this photo probably was taken at the same time as the EHM 150.190 one. After all, if you are going to climb that high on a small ladder to take pictures, you only want to do it once. Looking east in EHM 150.33, you can see the Edmonds Grade School in the distance. The *Now* image was taken by Jesse Bermensolo using a drone to duplicate the tower angle. Between the two photos, you can see how the grade school was replaced by the elementary school (now the Frances Anderson Center). The old Odd Fellows Hall building is still there (although under new ownership). You can also see an amazing home in the left center of both images that provides an anchor to Edmonds' history.

The next wave of change came as the automobile and the roads supporting it spread from Seattle to the Canadian border. It meant people could live in one place and work in another. Edmonds entered the world of suburbia and all that it brought. While the last mill shut down in Edmonds in 1951, the parents of the baby boomers were flooding into the area. Young families were attracted in the 1940s and 50s because housing was about 25% lower cost than in the north end of Seattle. An ad in a 1953 edition of the *Edmonds Tribune-Review* listed a "nice two-bedroom home, full basement, garage, chicken house, large lot, beautifully landscaped, right in the center of the town" for $5,950.[8] By the time my family moved to the area around 1956, homes in a new neighborhood in Richmond Beach were running around $10,000. While still a good deal, inflation in housing prices was similar to markets today. The growth in new residents was the engine that helped drive growth in retail shops and services, including in neighborhoods and communities in and around Edmonds, such as Richmond Beach, Meadowdale, Esperance, Perrinville, Lynnwood, and Alderwood Manor.

Community life in the early days was often sustained by the churches that sprang up from the earliest days, and several are still around. Still, entertainment and the arts are also a spirit that gives vitality and richness to a town; they were present in Edmonds from the beginning. The IOOF Hall and the Opera House supported various kinds of performances and social activities, and the Princess Theater is 100 years

[6] In August 1912, Dr. Hall bought a Flanders car from the Edmonds Hardware Company, which served as the first auto agency in Edmonds. The Edmonds Hardware Company was in the Schumacher building, where Chanterelle is now. Interestingly, today's Ace Hardware partners with the Washington State Licensing Bureau to grant licenses, but, alas, you can no longer buy cars there.

[7] Otto and Hattie Sorenson bought the house from Dr. Hall in 1927. That was the year Otto became a bookkeeper at the State Bank of Edmonds. He had graduated from Edmonds High School in the class of 1918 (the largest graduating class up to that point), and in 1936 he became the Postmaster for Edmonds.

[8] Cloud, *Edmonds: The Gem of Puget Sound*, p. 4.

THEN, C. 1900

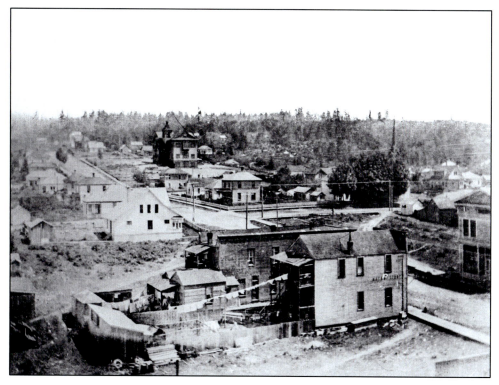

DOWNTOWN LOOKING EAST, EHM 150.33

NOW

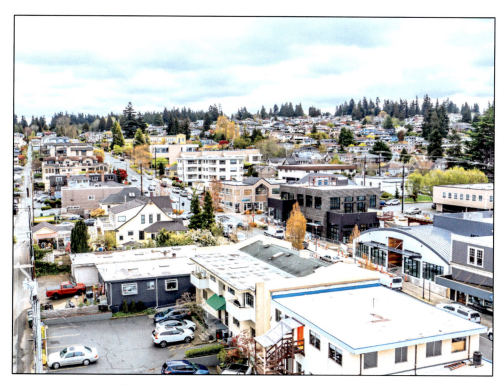

DRONE PHOTO PROVIDED COURTESY OF JESSE BERMENSOLO, C. 2023

old this year. With this new population, the arts became an ever greater part of what it meant to live here and continue to define the Edmonds we live in today. The Edmonds Arts Festival started in 1958, the Driftwood Players were organized that same year, and the Cascade Symphony Orchestra was founded in 1962. The Edmonds Center for the Arts was founded in 2006 and attracts both local and national talent, and invests in growing young talent in the community. The Graphite Arts Center, with its galleries and studios, is the most recent addition to Edmonds and was built on land that had long housed industrial businesses.

DRONE PHOTO LOOKING NORTHWEST PROVIDED COURTESY OF JESSE BERMENSOLO, C. 2023

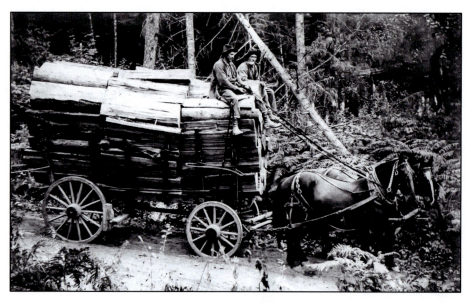

SHINGLE BOLTS ON THE WAY TO EDMONDS MILLS, EHM 144.10. C. 1892

ABOUT
THE MUSEUM AND SOCIETY

"We are dedicated to sharing the history of our community. We achieve this by research, collection, and preservation of historical documents, artifacts, memories, and events, and by utilizing interpretive displays and engaging in public education programming."

- The Edmonds-South Snohomish County Historical Society Mission Statement

The town of Edmonds was born rich in history and cultural heritage, and it was from this foundation that the Edmonds-South Snohomish County Historical Society was formed. Chamber of Commerce President Al Kincaid led the drive to create the Society, and Doug Egan was its first president. Formally established on February 22, 1973, the Society was the result of the tireless efforts of local residents, determined to preserve and share the history of their communities with future generations. In its early days, the focus was on collecting historical artifacts, photographs, and tangible items used by the early settlers, and working to protect and preserve important buildings in the area.

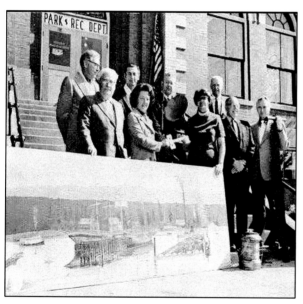

CITY OF EDMONDS HANDING OVER KEYS TO THE MUSEUM, PHOTO COURTESY OF THE EDMONDS HISTORICAL MUSEUM, C. 1973

With the help of Edmonds Mayor Harve Harrison, the Society was granted permission to use the old Carnegie Library building to serve as a museum. On August 3, 1973, the Edmonds Historical Museum was opened with a grand celebration. In those early days, virtually the entire collection of the Museum was on display. Over the years, the Society has expanded its efforts, including establishing a museum and archives, creating educational programs for local schools, collaborating with other historical organizations, and preserving over 26,000 items related to Edmonds and South Snohomish County's heritage.

Today, the Edmonds-South Snohomish County Historical Society remains a vital and active organization dedicated to sharing and preserving the region's fascinating history and ensuring that future generations may continue to learn, grow, and be inspired by the stories that have shaped this unique place. An early vintage mural on a

building near the ferry dock rightly declared, "Edmonds is part of the charmed land, richly endowed by nature," and while in the spirit of early Edmonds it was advertising its wallpapering services, it was also correct in its observation.

PHOTO PROVIDED COURTESY OF LARRY VOGEL AND *MY EDMONDS NEWS*, C. 2023

In addition to operating the Museum, the Society has sponsored traveling exhibits and has installed historical plaques throughout the Edmonds downtown area. It has published and reprinted important books such as Ray Cloud's definitive history of the city *Edmonds: The Gem of Puget Sound*. It collaborates with other historical organizations throughout the county and is even the sponsor of an annual Edmonds Scarecrow Festival.

On February 24, 2023, the Museum celebrated the 50th anniversary of the founding of the Historical Society. At the celebration, a photo was taken of three of the twenty Presidents of the Board for the Society. Left to right in the picture are Jerry Freeland, Bill Lambert, and the current President, Barb Fahey. Maggie Kase, the Society's new Executive Director, and Katie Kelly, the Museum Director, spoke as *Then* images of the Society, the Museum, and the many volunteers that have made this effort possible were shown. The first Board of Directors consisted of Doug Egan, LeRoy Middleton, Jim Warren, Margaret Douglas, Norma Whaley, Loren Bartlett, Harold Seaborg, Bernard J. Sigler, and William Goulder. The current Board can be found at historicedmonds.org/museum-board.

THE PHOTOS

This book celebrates the 50th anniversary of the Edmonds-South Snohomish County Historical Society and the creation of the Edmonds Historical Museum. The focus of this addition to the collection of books about Edmonds' history is on curating vintage photographs and using the latest techniques to bring back some of their original sparkle and, in many cases, to pair them with modern versions taken from as close as possible to where the original images were shot. Other vintage photographs will be used to supplement the stories of the buildings still here, often after a hundred years, and locations that have evolved continuously since Edmonds was founded. The original vintage photographs taken by local professionals (such as W.M. Horton) and local amateurs were generally provided courtesy of the Edmonds Historical Museum. The Museum retrieval code for the photograph is provided for each one and is shown as EHM plus the catalog number. Some of the originals, of course, have suffered damage

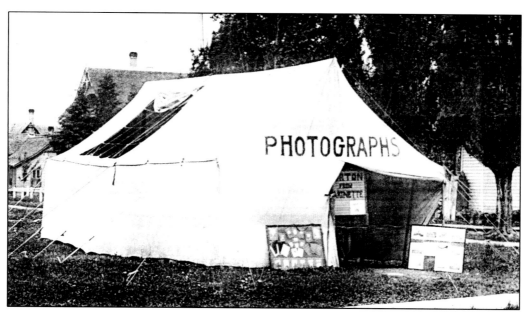

W.M. Horton Photo Tent, EHM 160.235, c. 1926

or had annotations on them that might be distracting. As a result, techniques such as slight cropping, adjusting angles, and restoration by massaging contrast and details, removing spots, and so on were used where it was appropriate to enable readers to appreciate the content of the images. Where possible, text added after the original photograph was taken was also removed. It should be noted that what is not on a photograph cannot yet be brought back, so there are limits to sharpening out-of-focus photos or parts of photos that are "blown out" with too much light. The goal in working with them for this book was to make the most interesting parts stand out.

Before **After**

 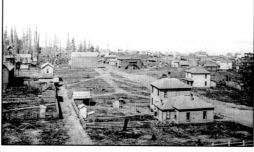

While the goal of the versions photographed today was to take them from as close as possible to the original positions of the photographers' cameras, lenses were different, of course, and in some cases, things like buildings, trees, and other obstructions required compromises. The modern shots were not "posed," however, since the intent was to capture the texture of Edmonds as it exists as a vibrant community today. Parked cars, people walking by, cloudy weather, and so on are part of the delight of living here and give a sense of this moment in what will be history for the future. The *Now* photos were mostly taken over 2022 and 2023.

Resources with background material used to compose the text in the book are included in an Appendix and footnotes. It is worth noting that given the *Now* part of

the vision for this book, artificial intelligence-based photo processing, search, and even writing tools were used. Given trends, there will be even more opportunities to update this content again for the semi-quincentennial of the United States in 2026 (our 250th national birthday and the 150th anniversary of George Brackett's homestead and logging operation in 1876).

"Signs of the changing times appeared in the granting of a franchise in 1899 to the Sunset Telegraph and Telephone Company to erect poles and string wires in Edmonds streets, and the passage of an ordinance in 1900 regulating bicycle traffic. Residents, too, were becoming conscious of sanitation, with talks of sewers and the regulation of outhouses too close to streets or neighbors. On July 2, 1901, a Mr. Cook complained to the council about a horse buried in the street near his home at Seventh and Bell, and the marshal was instructed to exhume the carcass and give it proper burial outside the town limits." – Cloud, *Edmonds: The Gem of Puget Sound*, p. 20

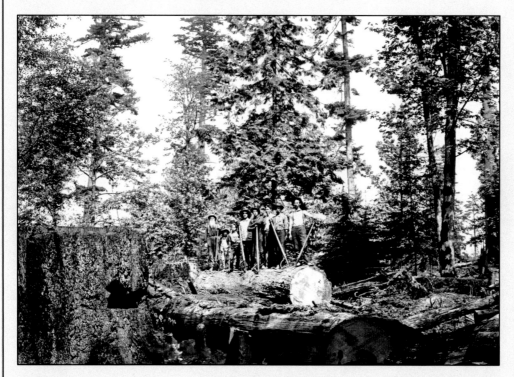

FORESTRY NEAR EDMONDS, EHM 144.16, C. 1900

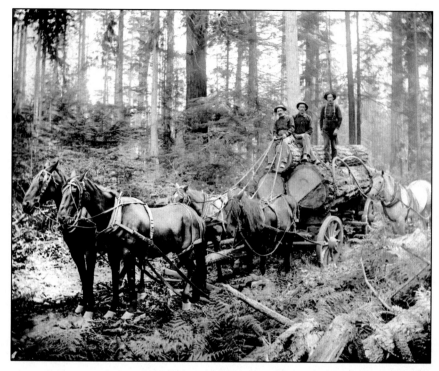

Logging the Edmonds Forest, EHM 144.1, c. 1899

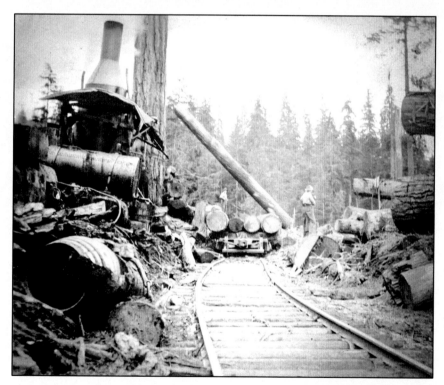

Railroad Logging near Edmonds, EHM 144.19, c. 1900

PHOTO SPOTS

The map and key may help you orient yourself to where you are going and where some of the photo spots are around the Edmonds "Bowl." It shows the individual buildings featured in the photographs and viewpoints that provide overviews similar to those included here. Audio tours of some buildings are available at historicedmonds.org/historic-edmonds-audio-tours/ (and can be accessed using the QR code on the next page). There are links to maps of historic architecture and art around Edmonds in the Resources section in the Appendix at the end of this book. A growing set of oral and multimedia histories of Edmonds that you can view in the comfort of wherever you happen to be can be found on the historicedmonds.org website and the Museum's YouTube channel.[9]

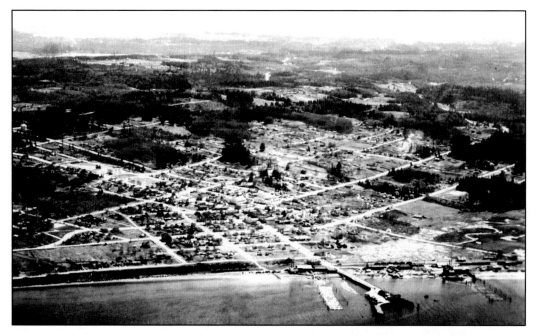

EARLIEST AERIAL PHOTO OF EDMONDS, EHM 152.9, C. 1936

[9] www.youtube.com/@edmondshistoricalmuseum2817

OVERVIEW

 This book contains Edmonds' history, but the goal was not to write an Edmonds history. As mentioned in the Resources section of the Appendix, you will find some of the many excellent books intended to be histories through different lenses, and selections from some of those books are used here and there throughout this book. My goal, however, is to give you a feel for what it was like to walk the streets of Edmonds over the last hundred years and a sense of the trends in how your experiences might have changed at different points in time. Therefore, the text accompanying the photographs is more about giving context to the photographs

rather than using the photographs to supplement a historical text. The photos should be the heroes of the story.

The photographs are organized so the book can be used as a guide when touring Edmonds. It begins at the Edmonds Museum and looks towards where the early shingle mills were located, provides a view from the old Grade School as an overview of the City, and then moves from the Museum to the intersection of 5th and Main looking west. The tour will then head along Main Street towards the ferry dock. It will move over to Caspers Street from the dock and shore area with views of the old shoreline. Turning onto Caspers, images of houses and buildings will be scattered around the north side of the downtown area between Caspers and Main. The journey then moves up the east end of Main Street to revisit the Grade School and then covers buildings on the south side of downtown Edmonds. The trip finishes back at the center of the Edmonds downtown area at *the Circle* and fountain at the intersection of 5th Avenue and Main Street, near the Museum. There are also lists of a selection of the growing set of murals in town that can be found during a walk, and additional houses included in the historic registers and tours of Edmonds but that otherwise are not covered with photographs in this book.

You have some choices for how to read this photographic tour. You can read through it cover to cover, and it is a pretty quick read. But you can also tap into individual sections. Each section can stand alone, although as you read through the book people and places will begin to connect into richer stories. In addition, there will be photographs and text inserts scattered throughout the book that provide a little more context, trivia, and entertainment both about the past and Edmonds today. Think of them as (hopefully) pleasant surprises. They will be set apart in boxes with a light gray background. There is also an Appendix to help you keep track of key people you will encounter through the book, and there are Appendices with additional photos that give more of a feel for Edmonds today.

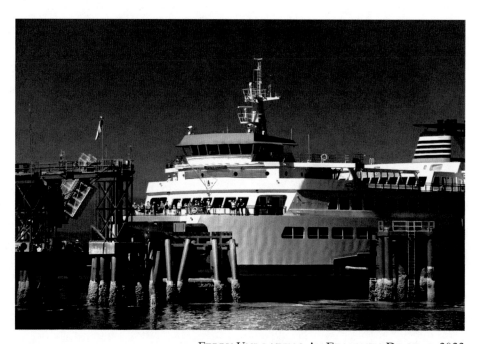

Ferry Unloading At Edmonds Dock, c. 2022

WEST ON MAIN STREET

CARNEGIE LIBRARY BUILDING

The tour begins in the heart of this bustling city of Edmonds, where a magnificent building steeped in history is nestled amidst the quaint streets lined with Victorian homes and shops. The former Edmonds Carnegie Library building has served the community for over a century and is a testament to the city's rich cultural and social heritage.

The story of the Library building began in 1901 when Francis A. Stejer was appointed as the first librarian for Edmonds. Before then, the Book and Thimble Club operated perhaps the first public library in the town hall, leveraging a rotation of books provided every three months by the Washington State Traveling Library committee. In 1907, the Edmonds Library Association, which was dedicated to maintaining an independent collection of books, leveraged two rooms over the newly completed State Bank of Edmonds building for the books. But it wasn't until 1909 that the Library became a full-fledged institution of the city government, with the appointment of the Rev. John W. H. Lockwood as the librarian. Rev. Lockwood was given a budget of $5 per month for purchases.

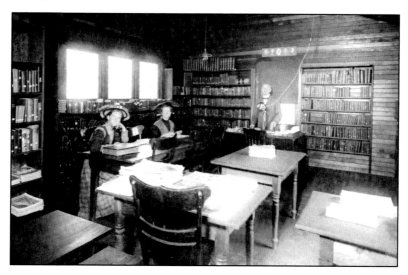

TEMPORARY LIBRARY, REVEREND LOCKWOOD IN THE BACK
(POSSIBLY), EHM 230.42, C. 1909

There was excitement about the possibility of a building to house the library, and the Women's Library Club, along with the efforts of Rev. Lockwood, worked tirelessly to secure a $5,000 grant from the Carnegie Foundation in 1910 to construct a new library building. The architect and contractor H.B. Ward of Seattle was tasked with constructing the building, and the Edmonds Carnegie Library opened its doors on February 17, 1911, to the community's delight. The upper floor of the building housed the library, while the lower floor was home to the city offices, council chambers, and even a jail (which can still be seen within the Historical Museum).

The new Library's inauguration was marked by the kind of drama that has sometimes characterized Edmonds politics even today.

> "On Wednesday evening, February 1, the [city] council met in its new quarters under the library for the first time. Mayor Cook, a socialist, began a lengthy tirade belittling Andrew Carnegie, whose money had helped finance the building. Councilman Beeson[10], a republican, becoming increasingly impatient, made a motion to adjourn, and when it was ignored by the mayor, put the motion himself and it was carried. Mayor Cook then halted, glanced around the table, rapped for order and proceeded with the business of the evening." - Cloud, *Edmonds: The Gem of Puget Sound*, p. 43

As the city grew, the need for a larger facility became evident, and in 1962, the City Hall and Library were moved to the new Civic Center complex. However, the Edmonds Carnegie Library building remained in use, serving as the Edmonds Parks and Recreation Center for another decade. They used it for offices and activities such as pottery and porcelain classes.

As it happens, Doug Egan, a relatively new resident of Edmonds, ran across Ray Cloud's book *Edmonds: The Gem of Puget Sound* (a recap of newspaper stories in the *Edmonds Herald-Review* up until 1953) and he asked Ray whether there was a historical society in Edmonds. There wasn't, and so Egan started to help make it happen. Finally, when Doug Egan became the first president of the Edmonds-South Snohomish County Historical Society, he approached the City Council in 1972, and the Council agreed to hand over the building to the newly formed Society to establish the Edmonds Historical Museum. The arrangement was that the Society "will renovate and maintain the interior of the building for museum purposes if the city will maintain the exterior and the grounds." Today the museum not only serves as a place where visitors can experience history and think about its implications for today, but it is also a place where research on the history of Edmonds and the County takes place. At the Museum's 50th anniversary, it is also undergoing a major interior renovation to create more immersive exhibits that can take advantage of new technologies and perspectives as they emerge in the future.

The Edmonds Carnegie Library was placed on the National Register of Historic Places on April 24, 1973. Of the original roughly 1,700 Carnegie public libraries built, only about 800 remain operational. The Edmonds Carnegie Library continues to be a proud symbol of the city's history. Its grand staircase and elegant façade invite visitors to step inside and be transported back in time to a place where a commitment to knowledge and culture began to grow and shape who we are today.

[10] This is the Beeson who owned what is known as the Beeson Building (EHM 150.106).

THEN, C. 1911

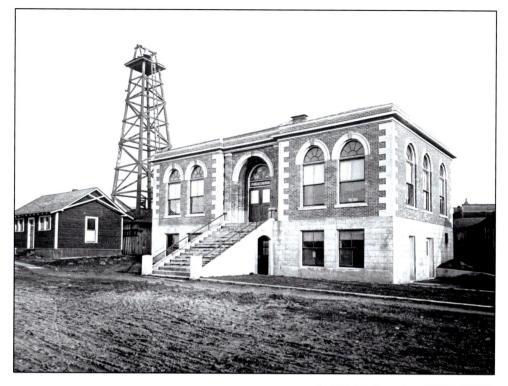

CARNEGIE LIBRARY, EHM 230.30

NOW

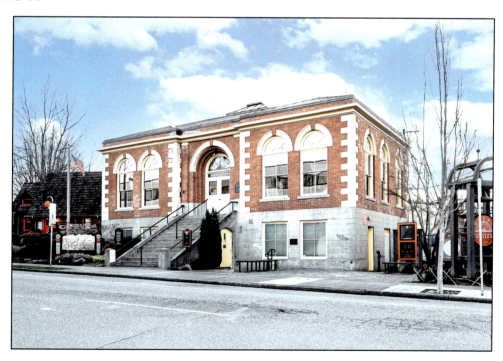

EDMONDS HISTORICAL MUSEUM, 118 5TH AVENUE N

As a side note, the bell that stands outside the Museum was first installed in the old Edmonds Grade School in 1891, and it was then moved to the Hughes Memorial Methodist Church in 1929. In 1969 it returned to the new Edmonds Elementary School building. After the school closed in 1977, it was moved to the Edmonds Historical Museum collection. The bell was refurbished and formally installed outside the old Carnegie Library building in 2015 to celebrate Edmonds' 125th Anniversary. A delegation from Edmonds' sister city of Hekinan, Japan, was also present for the events happening in the downtown area. A time capsule was installed under the bell that will be opened in 2040 as part of the 150th anniversary of the city's founding.

Finally, more information about the Edmonds-South Snohomish County Historical Society and its history can be found on the website at historicedmonds.org, along with information about the Edmonds Historical Museum.

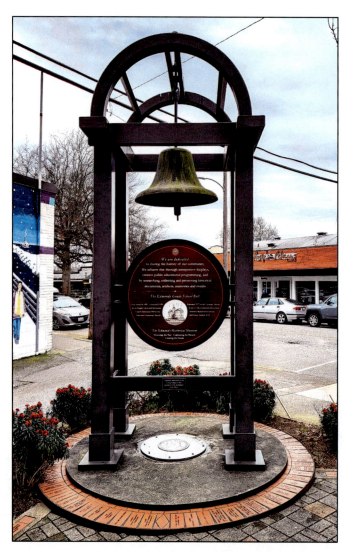

ORIGINAL EDMONDS GRADE SCHOOL BELL, C. 2023

LOOKING DOWN ON MAIN STREET

The old Edmonds Grade School location at 700 Main Street provides an excellent overview of downtown Edmonds. The *Then* picture on the next page (EHM 150.16) was taken around 1895 and looked down what was then named George Street towards the shore. The look when the forests were still around contrasts with the photo looking west that you saw earlier (EHM 150.190) that was probably taken from the fire tower just a few years later.

The Edmonds Elementary School that replaced the Grade School closed in 1972, and the building was expanded into the Frances E. Anderson Center. One of the additions to the property is a descendant of that original Carnegie Library, the Edmonds branch of the Sno-Isle library system (serving the Island and Snohomish counties). The *Now* photo was shot from the deck on the top floor of the current library as I worked around the shrubs trying to get the right angle.

A lot has changed, of course, but the yellow building in the lower right of the *Now* image is the same as the one in the original shot (EHM 150.16) taken more than 125 years ago. That building is known as the Charles Larsen House and was built around 1890. It is an example of the American Foursquare architectural style. In the *Then* shot, you can also see the steeple of the old Edmonds Congregational Church on the far left. The Congregational Church was the first church organized in Edmonds and dates back to 1888. The Bishop Hotel can be seen in the distance and was built around 1894. Brackett's Feed Store (one of the first places classes were held for the settlers' children) can also be seen.

EHM 150.6, C. 1908

To get a sense of how rapidly Edmonds was changing, a follow-up picture (EHM 150.6) was taken just thirteen years later and shows all the buildings that had sprung up. There probably was an advantage for a town like Edmonds to be a mill town in its early days since there was no shortage of construction materials. By 1908, the company that had purchased much of the town and built and named the Bishop Hotel was gone, and Brackett had foreclosed on them. The Bishop Hotel became the Olympic Hotel.

In this photographic tour of Edmonds, while we are starting with the overview, more pictures of the Grade School, buildings along Main Street east of the center of downtown, and changes around the southeast downtown area will be shown later in this volume. I should note a convention I will use in this book. As mentioned, the street shown in the *Then* photograph was known as George Street at the time. George

THEN, C. 1895

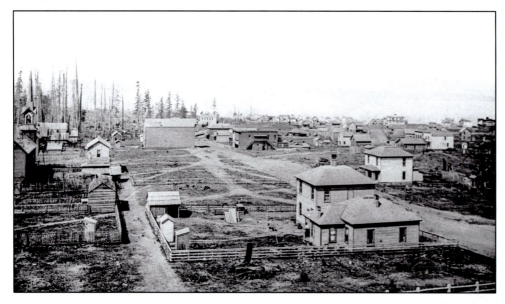

EHM 150.16

NOW

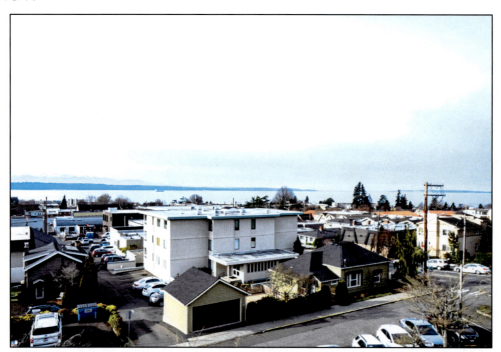

650 Main Street, c. 2022

Street was, not too surprisingly, named after George Brackett. Around 1911 it became known as Main Street, and I will tend to refer to it as Main Street to make it easier to connect with today's maps. Also, in an interview, Betty Lou Gaeng[11], a well-known Edmonds historian, shared that at some point in the 1950s, numbered "streets" became "avenues" with south and north descriptors attached to describe their relationship to Main Street. I will use the current designations.

MURALS ON WEST MAIN

People often use two characteristics to describe Edmonds today: the town's flowers, gardens, and physical beauty, and the art found everywhere. One form that public art takes is the many murals provided by Mural Project Edmonds, a committee of Art Walk Edmonds.

As you explore Main, heading toward the ferry dock, keep an eye out for the variety of murals created that honor the past but that will also be part of Edmonds' history in the future. On the south side of Main, in the alley next to the Beeson Building, is "Before Edmonds" by Andy Eccleshall in collaboration with Ty Juvinel (who created the carving and glass sculpture in front of the Museum). This mural covers both sides of the alley and reminds us of when the indigenous tribes occupied this area before the settlers arrived.

On 4th Avenue on the south side is "Flying Heron" by Susan Coccia. Across on the north side of 4th and Main is "Edmonds to Starboard" by Joel Patience, "Aosagi" by Shogo Ota with Urban Artworks, "Changing Times" by Andy Eccleshall, and "Returning Home" by AJ Power. Looking to the north side of the alley between the 3rd and 4th Avenues is "Floatlines" by Pete Goldlust and Melanie Germond. Finally, as you head down to the shore and the former mill area, in the alley between 3rd and 2nd Avenues on the south side is "Edmonds Mills 1893" by Andy Eccleshall. This mural does a wonderful job of capturing the era of the mills.

"Before Edmonds" on the Beeson Building, c. 2023

c. 2022

[11] Sadly, Betty Lou Gaeng passed away on April 17, 2023 as this book was being written.

5ᵀᴴ AND MAIN LOOKING WEST

One way to start the tour is at the center of Edmonds' downtown area (popularly known today as "the Bowl"). A frequent view of photographers is looking west from this area toward the ferry dock. The town, in essence, grew from the dock and mills up as the land was cleared and more settlers arrived. The intersection of Main Street (which runs east to west and terminates at the ferry dock) and 5th Avenue is the center of downtown Edmonds. Views from that point capture much of the activity of the town. The *Now* picture was taken at sunrise before that activity gets going. Today this intersection is known as "the Circle" and by its fountain. The Edmonds-South Snohomish County Historical Society sponsors the Edmonds Museum Summer Market nearby. The Market and many local festivals are held in and around *the Circle*. The buildings are among the oldest in Edmonds, and many were built by some of the most influential of the early residents.

The *Then* picture (EHM 150.11) dates from 1925. In this view, many of the shops and buildings associated with the early founders of Edmonds can be seen. On the left, you can find the Up to Date Grocery, the Edmonds Dye Works, Chancellor Cigar, Wilson's Café, Edmonds Grocery and Meat, Puget Sound Power and Light, A.B. Bently Reliable Hardware & Furniture, and the Beeson Building. Wiley's Tire Shop, Horton's Studio, the Princess Theatre, Colley's Garage & Service Station, and the Motherhead Building are on the right. Just from the names, you can get a sense of how life was different from today.

Over the years, many photos document the evolution of George (and later Main) Street. EHM 150.34 is from the early 1910s. The street was still dirt and, of course, mud in the winter. The photo shows a drug store (with a very concise sign), the Vienna Bakery, a real estate office, and a bank.

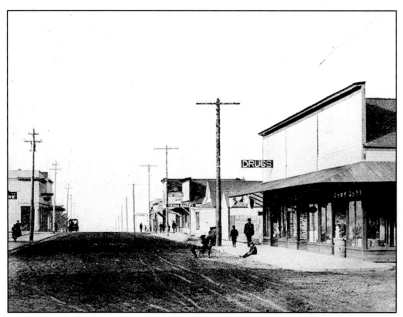

GEORGE STREET, EHM 150.34, C. 1910

THEN, C. 1925

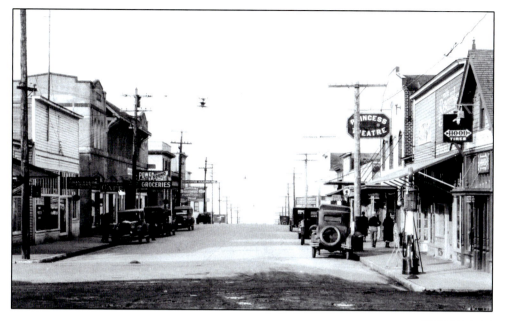

EHM 150.11

NOW

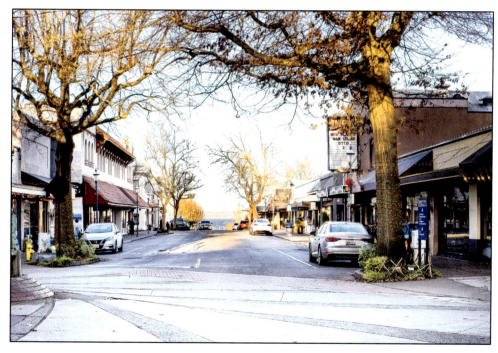

Sunrise, 5th Avenue and Main Street, c. 2022

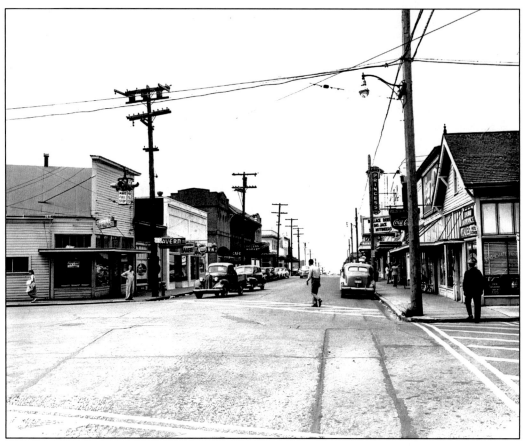

EHM 150.19, c. 1949

Flash forward to 1949 (EHM 150.19), and the image is of a street with a lot of the character that Edmonds tries to preserve today. Note that the marquee in front of the Princess Theater is the one that is perhaps the most iconic at this point.[12] On the left, you can see the Edmonds Cleaners, Up & Up Tavern, the Edmonds Bakery (which is still there), the Edmonds Tavern[13], the Edmonds Grocery & Market, Puget Sound Power & Light, Swanson Pharmacy, and the Hardware and Furniture Building. Hubbard Real Estate & Insurance, Bienz Confectionary (a favorite hangout for Edmonds teenagers), and Berry's Princess Theater are on the right side of the street.

The Edmonds Theater today, which was the Princess Theater then, is celebrating its centennial this year. The history of the Edmonds Bakery goes back to Fred Sticker's Danish American Bakery, which he opened in 1916. The Edmonds Bakery location at 418 Main Street is also celebrating its centennial, looking back to December 1923 when it opened its doors. The northwest and southwest corners of 5th and Main began in the wood-frame building style of the city's early days. Over the years, the buildings have been rebuilt many times depending on what was needed.

[12] The Edmonds Historical Museum is trying to find whoever might have this marquee; so keep your eyes out.
[13] The restaurant that had been in this building most recently is being replaced by MOTO Pizza. As they stripped off the previous restaurant's sign, they revealed the underlying sign "Edmonds Tavern."

ENGEL AND FOURTNER BUILDINGS

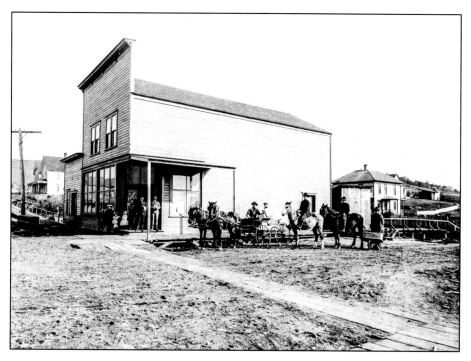

Engel Building, EHM 160.143, c. 1910

The story of the Fourtner Building begins in 1904 when Louis Christian Engel, a German immigrant who arrived in Edmonds in the 1880s, built a two-story structure at the corner of 5th and Main. As with the other early settlers in Edmonds, Engel was a person of many talents and interests. He attempted to get a job as an ox team driver for Brackett but was told they did not need one. Family lore says that Brackett's employees had tarred, feathered, and run the previous cook out of town because they didn't like his food, so Engel got the job as Brackett's mill cook. According to Byron Wilkes in his *My Edmonds News* article on the Engels, "Upon presenting his first meal of meat and potatoes in large pots to the loggers, he reportedly laid a gun on the table too. He told the loggers they could eat the food or not---that was their choice. But if anyone tried to run him out of town, he would shoot them."[14]

Engel opened the first meat market in Edmonds, was a city council member, owned part of a shingle mill, ran a dry goods and grocery store, was a decorated volunteer firefighter, and managed the Edmonds Cooperative Association's grocery/meat departments. He was a City Treasurer, a justice of the peace, and a water rent collector. At one point, Engel owned the entire east side of 5th Avenue from Main Street to Dayton Street (where the old Opera House is located). Part of the adventure of being an early settler in an emerging town was that people often wore many hats. There was a heavy overlap between the community's business, political,

[14] myedmondsnews.com/2023/02/the-l-c-engel-legacy-part-1/

and social lives.

In 1904, when he built the two-story building at the corner of 5th and Main (then George) Street, it faced north. He used the lower floor of his building to operate a successful dry goods store while the upper floor hosted meetings and dances. EHM 160.143 shows how it looked. The home to the right is the Engel residence on 509 Dayton, which is still there. You can also see the IOOF hall in the distance up George Street.

Things were already changing just a couple of years after the 1910 picture. EHM 150.49 shows many of the town's notables outside the Engel Building. In this picture, you can see L.C. Engel's Shoes and Dry Goods, and across the street, Otto's Meat Market, Sherrod Brothers Hardware & Furniture, and the Beeson Building can be seen in the distance. Lined up in front of the Engel Building are Joe Theroux, L.C. Engel, Zetta Fourtner Engel, Eathel Engel Beeson, Alton Arrowood, Wayne Beeson, Ed Martenson, Sam Yost, Ralph Bartlett, Floyd Woodfield, Ernest Fourtner Engel, Frank Milspaugh, George McGowan, and others. Given what looks like a new cement sidewalk, progress was underway.

> "The dances would have been especially significant. Not only were there few women (and therefore few opportunities to mingle with them), many of the women who migrated west were especially lonely and missed the cultural opportunities they were afforded in the east, even when they lived in rural areas."
> – Maggie Kase, Executive Director for the Edmonds-South Snohomish County Historical Society

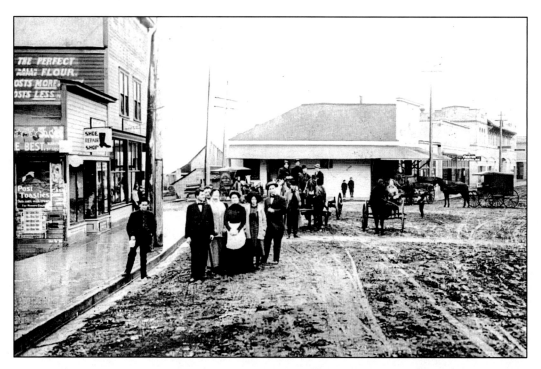

OUTSIDE THE ENGEL BUILDING, EHM 150.49, C. 1912

Jim Everton Wilson

As a side note, the small building next door to Engel's building was the office of James "Jim" Everton Wilson's real estate and insurance business. In WHM 160.2, Wilson is shown in his office. The small building was demolished in the 1930s, and in 1938 a larger two-story brick structure replaced it. Located on 514 Main Street, it became the home for the *Edmonds Tribune-Review* (Ray Cloud was the owner, publisher, and editor until his retirement in 1952). In 1961 the newspaper relocated to a larger building at 130 2nd Avenue S, and the older building became the home for Mode O'Day, a women's dress shop.

Before his real estate venture, Wilson had been in the grocery business. He opened the Crescent Grocery Company store in 1907 and operated it out of the IOOF Odd Fellows Hall, and he later moved it to the Beeson Building. In 1917 he purchased the real estate and insurance agency established in 1901 by the local celebrity and character Col. Samuel Street.[15] Jim had a physical disability, a neurological disorder, but it didn't slow him down. For eighteen years, he served as a police judge and Justice of the Peace. It was said that "no person in the community was better known than James E. Wilson---a man devoted to his family and always ready to render assistance when needed."[16]

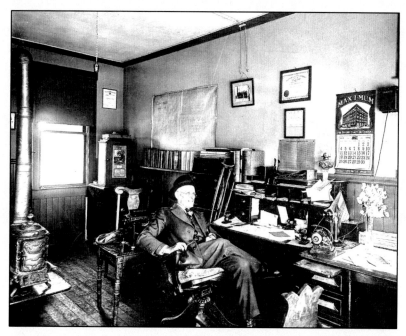

Jim Wilson's Office, EHM 160.2, c. 1922

[15] Street was a Civil War veteran, Edmonds' pioneer, and former mayor. With his distinctive whiskers, Street was well-branded for the time.
[16] myedmondsnews.com/2022/04/looking-back-a-picture-from-the-past-inspires-a-story/

In 1918, as WWI drew to a close, Fred A. Fourtner bought out the dry goods business and the building, and made improvements to accommodate two businesses. Then in 1924, he decided to build a new brick building on the same site and moved the original wooden structure south on 5th Avenue instead of demolishing it. In 1925, the new brick building in the *Then* photo (EHM 150.48) opened for business. The *Then* picture is the Fourtner Building under construction.

Fourtner, like Engel, was involved in numerous other business enterprises and political activities of early 20th-century Edmonds, and he will be profiled under the Edmonds Café part of this book tour. At this point, the focus is on the Fourtner Building and its place in Edmonds history. The Fourtner Building stands tall at the heart of Edmonds and sits at the southeast corner of the intersection of 5th Avenue and Main Street. The building was designed to be a mixed-use commercial building, including residential apartments on the second floor. The building was sold to Dewey and Cecelia Leyda in the mid-1940s and was known for a while as the Leyda Building.

Edmonds launched the "Main Street Project" in the 1980s as a reaction to a decline in the downtown area as malls were luring people away. That project was a source of a revival of the Edmonds downtown. Events around the Edmonds centennial in 1990 spurred further improvements, giving Edmonds the look and feel it has today. The Fourtner Building's weathered brick façade, and the ornamentation on the windows and roof, all fit in with the ambiance Edmonds was looking for as it tried to create an image that reflects the City's heritage. Interestingly, many of the gas-style lights installed as part of the refresh, such as the one outside Starbucks today, look like they were placed in the same footprints as the telephone and power poles in the old photos. Sitting at the tables with a latte and soaking it all up is a delight. The downtown area has undergone a remarkable transformation over the years, from when the Fourtner Building was built in 1925 to the thriving hub of commerce, culture, and community it is part of today.

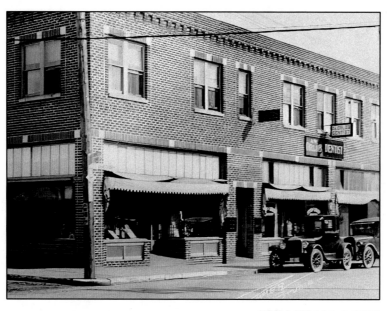

EHM 150.116, c. 1930

THEN, C. 1924

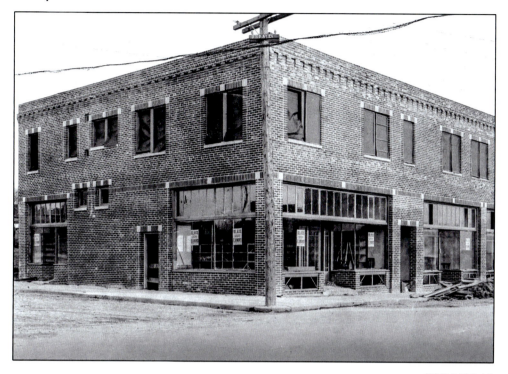

EHM 150.48

NOW

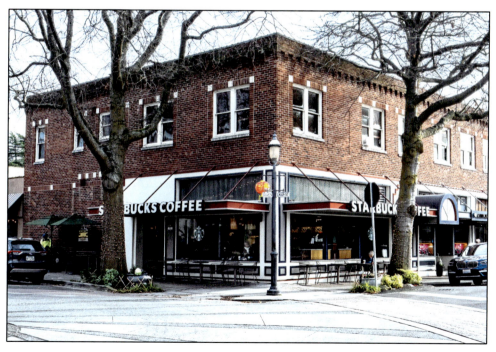

502 Main Street, c. 2022

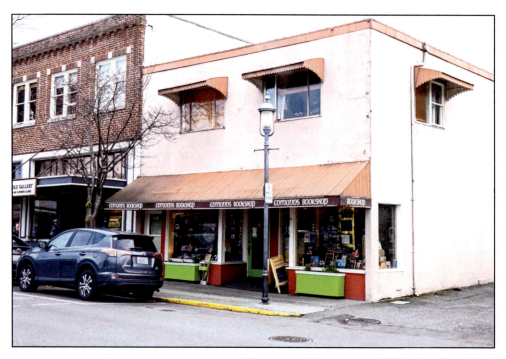

EDMONDS BOOKSHOP, 111 5TH AVE S, C. 2023

The Engel Building (the wooden building that Fourtner moved south on 5th Avenue) is still with us. Over the years, it has housed various businesses, including a law office, a hardware store, a beauty shop, a music store, an optometrist, a radio repair store, a Christian Science Reading Room, and more. At the end of 1973, Kathie and John Chapman had been running a bookstore in the Beeson Building. The address was 408 Main, where the ArtSpot is now located. At that point, the Christian Science Reading room in the former Engel Building decided not to renew its lease, so the Chapmans moved their bookstore into the space. The structure has since undergone some physical transformations, and the bookstore has passed through the stewardship of various owners. Most recently, Michelle Bear, who started working for the previous owners in 2007 and became an assistant manager in 2016, is, as of 2021, the new owner. The building is approaching its 120th anniversary, and the Bookshop is celebrating its more than 50-year history.[17] The bookstore carries a wealth of material about Edmonds and the region, and it sponsors a variety of authors and events (e.g., Nancy Pearl's discussion of books at the Edmonds Center for the Arts). This year it was also recently announced that the Edmonds Bookshop is a finalist for the 2023 Publishers Weekly Bookstore of the Year Award!

L.C. Engel's legacy lives on in Edmonds in another way. In 1927, he built a structure on his extensive property, initially intended as a butcher shop. However, his wife talked him out of it, arguing the work might be too hard as Louis was no longer a young man, and so the first tenant was a bakery. The Sanitary Bakery (one would assume the meaning was more like "Healthy Bakery" at the time) suffered a robbery not long after opening and then permanently closed. A dime store soon followed it, and then a shoe repair shop.

[17] myedmondsnews.com/2023/02/the-l-c-engel-legacy-part-2/

Engel's Pub, 113 5th Ave S, c. 2023

When prohibition ended, Engel and his family pooled their money and opened Engel's Lunch and Tavern, with the first beer license in Edmonds. The license is still in effect today. Louis did know beer and how to brew and enjoy it. According to the family remembrances, his daughter Eathel's vision was that it would be a family place where mothers and children could come for lunch, a soda, and ice cream. Some menu items, like their fish and chips cooked with the special family recipe, developed a loyal following. There was also beer for the men and coffee for the ladies. It was a popular nightspot. Engel was a strong union supporter, so Engel's clientele included many railroad workers, shingle weavers, and men who worked on the tankers and ferries.[18]

After it got going, L.C. stepped out of the business, and Ernest, his son, sold his interest to Eathel, his daughter. Eathel ran it for the next twenty-six years. It grew to be a full-menu restaurant, but by the 1950s, with all the other restaurants opening in Edmonds, it focused on its more limited earlier menu. Ownership changed over the years, and around 1980,

> A variety of people have walked through the Engel's doors over the years. In 1948, Henry Ford II and a group of friends were visiting Puget Sound for salmon fishing, and they stopped at Engels for a few beers before heading into Seattle. After they left, the bartender picked up a crumbled napkin from the bar where they had been sitting. On the napkin were some scribbles and drawings, which appeared to be the design of a new automobile, and included was the hastily scribbled word: "Edsel." – Shared by Pat Ratliff, *Mukilteo Beacon*

[18] www.mukilteobeacon.com/story/2009/06/25/news/think-of-engels-as-a-living-museum/1918.html

the new owner, Michael Dunne, reimagined the restaurant as an Irish Pub. When Dan Schultz later acquired the Pub, he received permission from the family to rename it "Engel's Pub" in honor of the Engel's and Dunne's visions. Engels is approaching its 50th anniversary and continues to be a special gathering place for the community.[19]

As one sits with a latte in front of the Fourtner Building or a beer in front of Engel's and takes in the sights and sounds of the bustling town of Edmonds, it is easy to be transported back in time and imagine what life was like in the early days of the town.

> "With the dawning of the twentieth century renewed activity was apparent in Edmonds. Puncheon and planking had been laid on the most used streets to keep wagons and buggies from becoming mired in the mud, and now attention was turned toward the comfort and convenience of the pedestrian by extending sidewalks into the residential streets. Some were built by home-owners in front of their property, but most sidewalks were built by the town, making the first use of the local improvement district assessment plan. Fred L. Brown did the engineering work, planking was bought from local mills and the work done by contract or day labor. Standard walks were of 2x6s six feet long laid across three 2x6 stringers." - Cloud, *Edmonds: The Gem of Puget Sound*, p. 21

AN EDMONDS YARD, C. 2019

[19] myedmondsnews.com/2023/02/the-l-c-engel-legacy-part-2/

Jim Otto Meat Market and Grocery, Southwest Corner of 5th and Main, EHM 160.12, c. 1902

Otto's Meat Market Interior, EHM 160.24, c. 1902

SCHNEIDER BUILDING

The Schneider Building is located on the northeast corner of 5th Avenue and Main Street, next to the old Carnegie Library building (now the Edmonds Historical Museum). Construction started on the building in January 1926 by Fred Schneider of Seattle, and the EHM 150.104 *Then* photo shows it around completion. A branch of Skaggs United Stores opened in the corner of the building facing the 5th and Main intersection in April of that same year. Skaggs was a predecessor of many retailers we know today, such as Safeway, Albertsons, Payless, and others. The store eventually evolved from the Skaggs-Safeway store into just the Safeway store. Two months later, the post office moved from the Bank Building further down on 4th and Main Street to the north end of the Schneider Building. Over the years, other businesses, including an electric and radio shop and a drug store, also came and went. [20]

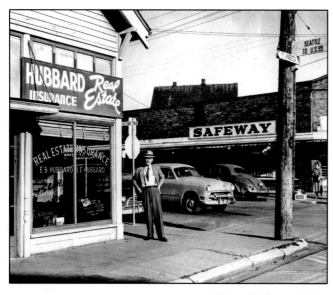

EHM 160.84, C. 1950s

While there was not as much drama around the Schneider Building as some other buildings on Main, it is in the center of the action. On April 29, 1943, a storm came through the area that was so violent that the downpour of rain and hail turned drains into rivers, and the intersection of 5th and Main became a small lake. As a result, the Safeway store was flooded and experienced significant damage.

There have been structural changes to the building over the years, including an additional six hundred square feet of space in 1941 for the Post Office. At some point, the decorative elements on the roof were removed, and windows and doors were modified. But, as you can see in the *Now* picture, the pattern at the top of the walls still exists today in its purple and aqua colors.

In the EHM 160.84 image from the 1950s, Ernest "Ernie" Hubbard (who first came to Edmonds in 1897) stands on the northwest corner of 5th and Main, and the Safeway is in the Schneider Building on the northeast corner. The building where Hubbard is standing is known as the Reece Building. Hubbard was the son-in-law of James E. Wilson. Wilson had first operated the Crescent Grocery store in the new Beeson Building and then turned it over to Hubbard. Wilson subsequently opened his

[20] Most recently, Cline Jewelers (who had been in the Fourtner Building) is in the process of moving into the Schneider Building space that had been occupied by the Sound Styles and Garden Gear stores. In the process they apparently discovered old invoices from the Safeway store that had fallen into cracks in the walls.

THEN, C. 1926

EHM 150.104

NOW

104 5TH AVENUE N, C. 2022

first insurance agency. For a while, Wilson even served as the City Attorney. On his death, the insurance agency passed to Ernie Hubbard, who operated it (along with his son Lawrence) into the 1950s. The Hubbard Family Foundation is still active in funding activities in Edmonds, making this community an even richer place to live.[21] Its mission is to enhance the quality of life for the people of Edmonds and South Snohomish County.

LARRY AND ERNIE HUBBARD, WITH DAVE AND BILL CROW
IN CROW HARDWARE AND MARINE, EHM 160.64, C. 1956

Hubbard liked to tell stories of what Edmonds was like in the early days as a shingle mill town. He remembered Main Street (then George Street) as a dirt road used to skid logs down the hill and through town to the mills on the waterfront. In his telling, "There were 85 teams of horses, and the town's landmark was a big watering trough at the southeast corner of what is now 5th and Main." That watering trough would be where the Engel Building was built.[22]

Today people often observe how many coffee shops there are. In Edmonds, when the vintage pictures were taken, it seems there were several choices for where to buy your groceries. Across the street from Hubbard's Insurance (and across the intersection from Safeway), there was an I.G.A. (Independent Grocers Association) store. It had been the Up to Date Grocery in the 1920s but became part of the I.G.A. in 1933. The I.G.A. had that frontier wood frame look typical of so many early towns.

[21] The Hubbard Family Foundation, in fact, has been kind enough to provide funding to the Edmonds-South Snohomish County Historical Society for this *Edmonds Then and Now* anniversary book project.
[22] myedmondsnews.com/2022/04/looking-back-a-picture-from-the-past-inspires-a-story/

EDMONDS BAKERY

EHM 160.76, the *Then* picture, is a photo of Sticker's Bake Shop and the Edmonds Club. The car is the fun part of the image, but the Bakery is the most important. The Club didn't have the same longevity as the Bakery. The Edmonds Bakery is celebrating its 100th anniversary this year. The Club, however, probably produced the guys in the photograph. Eugene Johnson, Charlie Little, Bud Little, and Orville Milspaugh are sitting in the well-outfitted car. The back of the photograph says, "Possibly Fred Fourtner in black cap on the right."

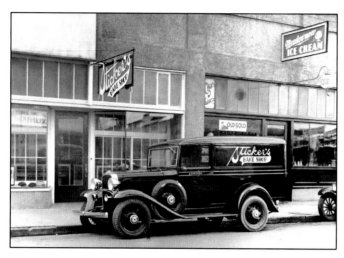

EHM 160.22, C. 1933

The story of the Edmonds Bakery began in 1916 when Fred Sticker opened the Danish American Bakery. Fred Sticker sold the Bakery for the first time to Mr. and Mrs. G.G. Everson and bought the Bakery back a few months later. In December 1921, he sold the Bakery again, this time to Baker & Deitcher, and moved away for a while.

Henry Deitcher operated the Danish American Bakery until August 1923, when it, unfortunately, burned to the ground. Two months later, the remains of the Bakery were sold to F.E. Young. Space became available when The Princess Theater moved across the street, and F.E. Young opened the Edmonds Electric Bakery's door for the first time in December 1923 at the location we know today.

However, tragedy again struck in April 1928 when a fire broke out in the back room of the adjacent Edmonds Club, causing significant damage to the Bakery. Besides the infamous 1909 fire that resulted in the construction of the Beeson Building, this was the second most destructive. The

EHM 160.138, C. 1960

fire was so intense it burned other stores around the Bakery and spread across the street, burning parts of the Princess Theater and other buildings.

The Edmonds Volunteer and Greenwood Fire Departments from Seattle

finally put out the blaze, but the Bakery suffered heavy losses of over $5,000 (about $85,000 in today's dollars). The building's owner, Henry Chandler, announced five days later that he would immediately construct a concrete building in the same space, and the Edmonds Electric Bakery would remain a tenant. The Bakery was back in business six weeks later, but Young sold it not long after.

The Bakery continued to change hands and went through various names. T.R. Ward and R.E. Carr ran it for fourteen years, the longest period until the 1960s. Since 1972 when Joe and Carol Erga took ownership, it has existed under the Edmonds Bakery name. That was also a year when Edmonds was starting a new beautification project, and the Edmonds Bakery and the tavern next door were two of the first to be painted. The Bakery during the 70s and 80s became one of the favorite places for kids and parents to gather, making it an excellent school field trip destination.

Today, the Edmonds Bakery is cared for by Ken Bellingham, and its enduring history is part of its charm. You can still see the original hardwood floors in the back, installed after the 1928 fire, and admire the collection of cookie jars that Ken has amassed over the years. The Bakery's cookie jars are a fascinating sight, with some dating back to the late 1930s or early 1940s.

As you enjoy a freshly baked pastry or a warm cookie as you walk around Edmonds, you cannot help but feel nostalgic for a time when life was a little simpler.[23]

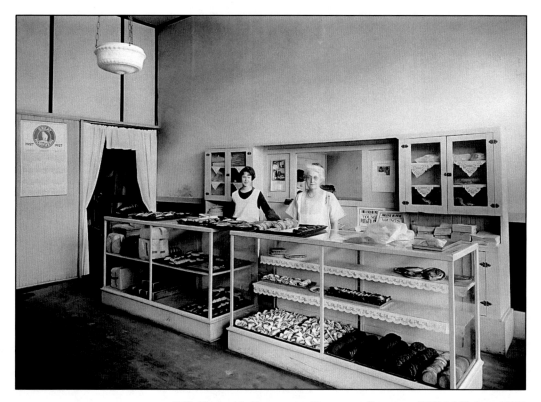

F.E. Young's Edmonds Electric Bakery, EHM 160.5, c. 1927

[23] myedmondsnews.com/2023/01/reflections-on-100-year-history-of-edmonds-bakery/

THEN, C. 1929

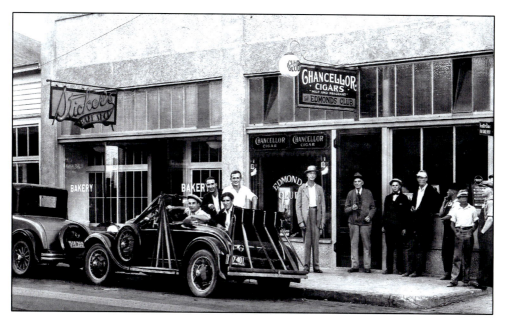

EHM 160.76

NOW

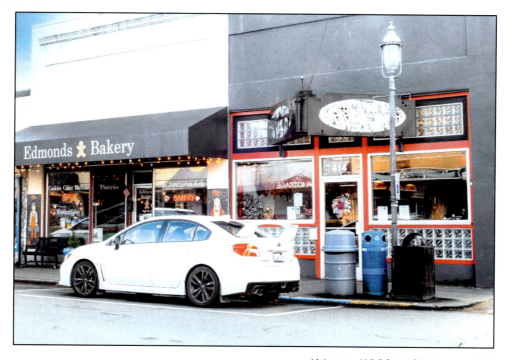

414 AND 418 MAIN STREET, C. 2023

In the *Now* picture, 414 Main now houses MOTO Pizza. In clearing off the most recent sign in preparation for the new MOTO sign, the old Edmonds Tavern sign can be seen on the sign board.

PRINCESS THEATER

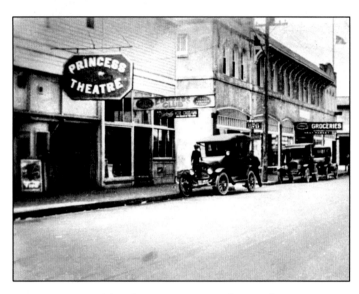

THE PRINCESS ON THE SOUTH SIDE OF MAIN, EHM 160.44, C. 1922

Early in Edmonds' history, silent movies had been shown previously at the Odd Fellows Temple (a.k.a. the IOOF Hall), but the first purpose-built movie theater was Fred Fourtner's Union Theater. The Union opened its doors in 1916 and was located at 418 Main St. in the Lemley Building, which now houses the Edmonds Bakery. Over the next several years, the Theater changed hands and re-branded several times, including as the Acme Theater and the Edmonds Theater. But in 1921, Thomas C. Berry and his wife Helen purchased the Theater and gave it a new name that would endure for years, The Princess Theater (or Theatre, the fashionable spelling of the day).

The Berrys were ambitious, and with the "Roaring Twenties" in full swing, they announced plans to construct a much larger theater across the street from the original location. John McGinnis, a local businessperson and future Edmonds City Council member, was contracted to construct the new Theater. Completed in November 1923, the Princess Theater's operations were moved into the new Art Deco building, now known as The Edmonds Theater.

The grand opening was a spectacular event, attended by local dignitaries and marked by live performances from the Edmonds Band. In its coverage of the festivities, the *Tribune-Review* published a description of the opening of the Theater: "The new screen is one of the best obtainable, the seats are upholstered, the spacious lobby and aisles are carpeted with heavy velvety carpets; beautiful lighting effects are made perfect by a dimmer control; the auditorium has a high ceiling

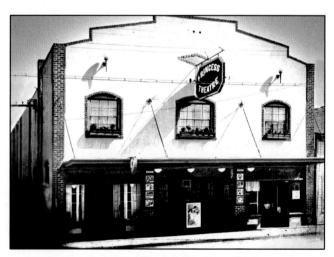

PRINCESS ON NORTH SIDE OF MAIN, EHM 160.20, C. 1927

THEN, C. 1949

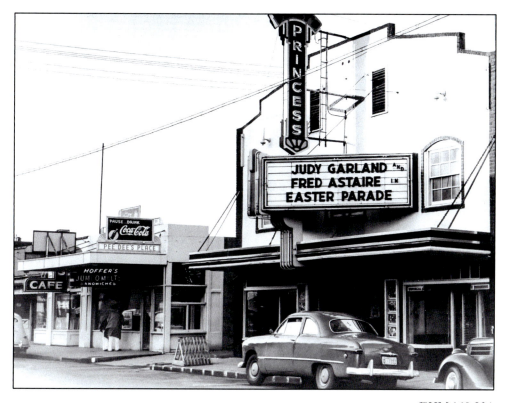

EHM 160.234

NOW

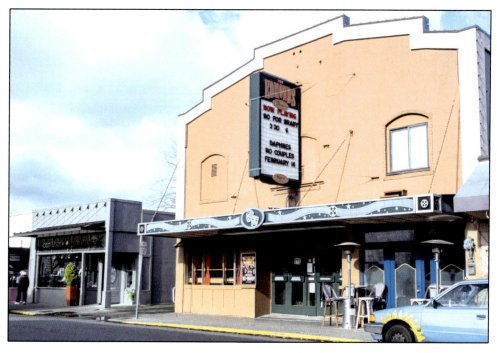

EDMONDS THEATER, 415 MAIN STREET, C. 2023

and is well ventilated and heated; at the rear of the balcony is a nearly furnished restroom for ladies. One side of the balcony is attractively fitted as a lodge with comfortable wicker chairs." In 1929, the theater presented the first talking picture in Edmonds, "Broadway Melody," and it definitely was a community affair.

The Princess Theater quickly became an Edmonds landmark, positioning the community as a center for arts and culture. It weathered the Great Depression and, through its newsreels playing along with the movies, helped keep the citizens of Edmonds informed about events during World War II. The Theater also served as a venue to sell war bonds to help finance the American war effort.

After the Berrys passed away in the early 1940s, the Theater's ownership, focus, and naming again changed several times. In the late 50s and early 60s, my friends and I were seeing movies like "Journey to the Center of the Earth," "The Angry Red Planet," and "The Time Machine" in the Theater. The Theater leaned towards mostly foreign films in the later 60s. From 1979 to 1984, it showed art films primarily and was occasionally used for concerts (e.g., including punk rock bands and others). It eventually began showing second-run movies inexpensively and was also available for special events.

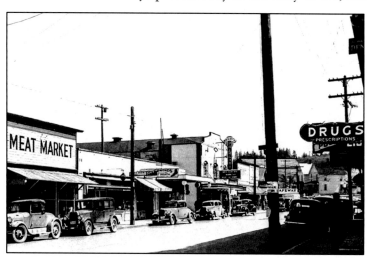

EHM 150.43, C. 1938

Most recently, it has been going through significant upgrades. It has been restored to much of its former glory, and Andy Eccleshall (a local artist) has created a new mural in the lobby. Owned by the Mayo family, Gary Hoskins is now managing the Theater as it celebrates its 100th year. Before the recent pandemic, the big news was that they had purchased a new popcorn machine, and they could leverage popcorn sales to help them get through the tough times. The historic 252-seat movie house is among the state's remaining independent, single-screen movie houses.

By the way, in the photo on the previoud page (EHM 160.234), you can see a sign that says Pee Dees, and there is a note with the photo that it was a favorite hangout for local teens. Interestingly, however, Ray Cloud's *Edmonds: The Gem of Puget Sound* book notes a fire that broke out in 1931 in Horton's photography studio just west of the theater. It then spread to the attic over what is identified as the Bienz Confectionary in that location and across to the corner of 5th and Main, where Hubbard's insurance agency was located. Furthermore, in the 1953 Edmonds High School yearbook (the ECHO), the shop was still advertising as Bienz Confectionary. So the question is, to what did the Pee Dees sign refer? Today, you can even see some old tiles from the floors of the previous shops that occupied the space just outside the front door of Comstock Jewelers.

Finally, in EHM 150.43, you can see the vitality of the downtown area in the

30s. In this part of town, besides the Meat Market and the Princess Theater, there was a watch repair and jewelry store, a barber shop, the Golden Rule Dry Goods and Notions, and Kuzmoff's Edmonds Modern Shoe Hospital. Off in the distance is the Safeway.

"Radio was still in its infancy at the opening of the third decade. Home-made sets were the fad with those who had the knack for tinkering, and many youngsters put together crystal sets with which by manipulating the 'cat's whisker' they could bring in nearby broadcasting stations…Competition was keen between radio fans of that day as to the number and distance of the stations they were able to tune in…In October, 1922, Dan Yost submitted to the *Tribune-Review* a long list of stations he had heard on his home-made radio. The next week Samuel S. Atwood, Esperance Justice of the Peace, came back with a longer list, all picked up the same night---or morning." – Cloud, *Edmonds: The Gem of Puget Sound*, p.94 and 95

Possibly Briggs Barber Shop on Main Street, EHM 160.26, c. 1927

BEESON BUILDING

Many cities in the late 1800s and early 1900s had a major fire that shaped their future destiny as the wooden buildings that were first put up began to be replaced by more fire-resistant structures. On the warm summer day of July 8, 1909, a devastating fire broke out in a building on George Street in the heart of Edmonds. The property was owned by Jennie G. Jones, who was living in Ashland, Oregon, at the time. The wooden structures that dominated the city were no match for the raging inferno, which quickly spread from the warehouse of the Patterson Hardware Company and destroyed several neighboring businesses. The businesses included the B.H. Davis confectionary store, the Brackett & Roscoe grocery store, and even the local post office. Despite the valiant efforts of the local fire department, the damage was extensive, and many of the buildings were left in ruins.

Ray Cloud describes the events in *Edmonds: The Gem of the Puget Sound* (p. 30):

> "At 2:30 o'clock in the morning of July 8, 1909, B.N. Davis, sleeping in a room back of his confectionery store, was awakened by the smell of smoke. As he became wide awake he heard the crackling of flames and hurried out the front onto Main street, to discover the flames were in the back of the store room which had been occupied by the Hicklin Plumbing Company. Davis immediately called in the alarm and Dan Yost who was at the switchboard called J.N. Otto, then both made a run for the fire bell and got out the hose cart. By the time the firemen reached the scene flames had burst out the front of the room and the interior was a seething furnace. In spite of all the firemen and volunteer workers could do, the entire Jones block was a complete loss."

At that time, the fire department only had a hose wagon and cart. According to the *Edmonds Review* article about the fire that week, "Although the fire department was promptly on the ground and did excellent work, it was soon seen that the entire row of new wooden buildings was doomed to quick destruction. It is believed that the fire started in the warehouse of the Patterson Hardware Company, from spontaneous combustion of oils used in the paint department...The *Review* expresses the popular sentiment in giving praise to the local fire department."

EHM 150.50, c. 1909 (July 8th)

THEN, C. 1928

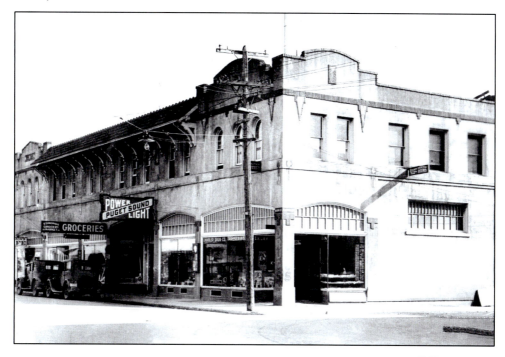

EHM 150.106

NOW

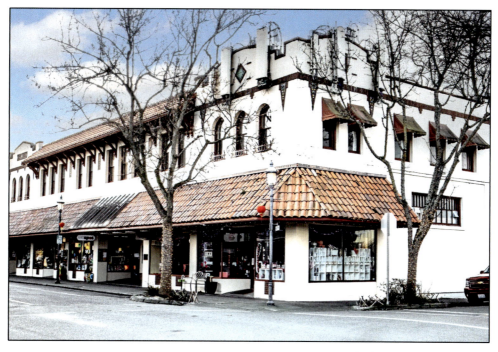

406 Main Street, c. 2023

According to Joan Swift in her *Brackett's Landing* book, given the combination of the volunteer firefighters and an entire town of interested parties, "One local humorist remarked he'd never seen so many good-looking bathrobes in his life!"

The EHM 150.50 photograph of the fire's aftermath shows that a small portion of the post office remained. In the photo, a group of townspeople can be seen gathered around it. Notes on the back of the image also show other buildings relative to the block, such as the Schumacher Grocery Store, A. Warren's home, and Dr. Schmidt's home and office. Florance Roscoe Beeson soon purchased the still-smoldering site. Beeson had recently arrived from Indiana and had come to Edmonds to start a shoe business. Beeson was a man of vision and determination, and he immediately announced plans to build a new, two-story reinforced concrete building on the site.

The Beeson Building was designed in the Spanish-Mission Revival style. It covered the entire block, making it one of the most architecturally distinctive commercial buildings on what is now Main Street. The building was designed by Seattle architect James Stephen and his son, and it was Edmonds' first real office building.

EHM 150.44, C. 1913

The Beeson family lived in apartments on the 2nd floor of the building. Over the years, the Beeson Building has been home to various businesses, including grocery stores, medical offices, and boutiques. It was even the site of demonstrations of the latest technology, such as the Edison Phonograph at the Chandler and Smith drugstore back in the day. Beeson was also a key player in local affairs, serving as mayor from 1918 to 1923 and an active Chamber of Commerce member.

The image EHM 150.44 shows the Beeson Building shortly after it opened with some empty offices, plus signs for Dr. W.C. Palmer Dentist and the Edmonds Drug Company. EHM 150.105 (found after the *Then* and *Now* pictures) is a later photo taken in 1910 as more shops had opened within the building. They included Chandler & Smith Drugs, Edward L. Turner (a lawyer), and the Crescent Grocery. Notes on the back of the photograph identify some of the people in front of the building as Dr. Sherrick, Kenneth Mowat, Bill Otto, and "Shorty" Smith. After Beeson's passing in 1927, his son Hugh R. Beeson took over the building property management and continued his father's legacy of innovation and entrepreneurship. He operated a furniture store in the building and even established a restaurant there.

The *Then* image (EHM 150.106) from 1928 shows the building we know today. In the *Now* picture, you can still see the bones of the original building, but the decorative elements and the trees have softened the look of a building occupied by several popular stores.

Despite (or perhaps because of) the destruction caused by the 1909 fire and the 1928 fire starting in the Edmonds Club next to the Bakery, the city of Edmonds

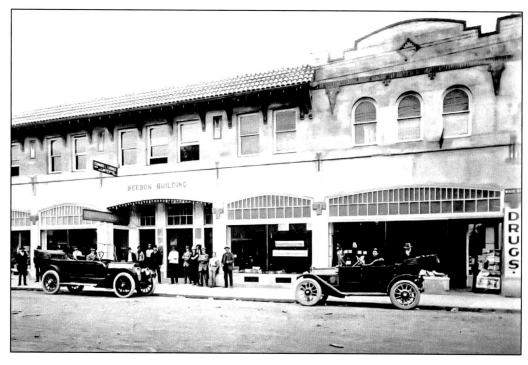

EHM 150.105, C. 1912

has a history of resilience and progress. Throughout the 19th and early 20th centuries across the United States, fire was one of the greatest threats to cities, and the memories of many cities, of course, are defined by their fires. The Chicago, Seattle, and San Francisco fires are all examples that reflect the end of the era of wooden buildings and the new era of building materials and approaches. The change cemented (no pun intended) a sense of community permanence.

The city's firefighting equipment improved vastly in the years between the two fires. In the first decade of the 1900s, the fire department had only a hose wagon and cart, but by the 1920s, they had acquired a 1921 Ford Model T equipped with a chemical extinguishing unit and a 1925 REO Speed Wagon fire engine. In the 1930s, they purchased a new 1938 Ford fire truck from the Yost Auto Company, equipped with a 300-gallon booster tank and 150 feet of hose. The 1938 Ford served as Edmonds' main fire engine (Engine No. 1) for many years and was a sign of the city's commitment to protecting its residents and businesses from the dangers of fire.[24] The odometer on No. 1 still hadn't reached 1000 by 1960. When the milestone finally approached, Mayor Gordon Maxwell and Fire Chief Jimmy Astell drove it up the Main Street hill to pull it over 1,000 miles and celebrate. Today, the REO Speed Wagon is owned and operated by the South County Fire Authority, and the 1938 Ford Fire Engine is owned and maintained by the City of Edmonds. The Edmonds Historical Museum hopes eventually to create a museum dedicated to the first responders in the area that could potentially house the vehicles in the future.

As a parting note on Beeson in the 1930s, there is a story that Hugh was amusing himself with some of the new electronics he had in the store. Since he had a stock of radios, he hooked up a microphone so he could sit at his desk at the rear of the furniture store and talk to people through the radio at the front of his store. Passersby

[24] myedmondsnews.com/2011/04/this-month-in-edmonds-history-1928-fire-strikes-downtown-buildings/

would be startled to hear themselves addressed directly, yet no one would be in sight. Sometimes motorists would be teased about their ability to park or the age of their automobiles. Even a local newspaper editor was frustrated when his paper was insulted, and he couldn't figure out how to reply.[25]

THE BIG SNOW OF 1916

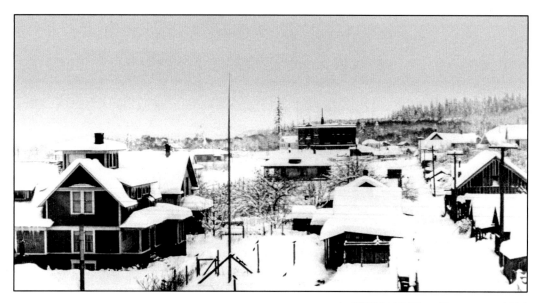

EHM 150.52, c. February 1916

Two of the seminal events in Edmonds were the great fire in 1909 and the later fire in 1928. The third event sitting between the other two is the Big Snow of 1916, especially occurring as it did in the middle of WWI. It struck the entire region, of course, but its impact on small towns like Edmonds was particularly severe. It is considered the worst snow event in the city's history. The snow started falling on New Year's Eve in 1915 and continued for a month. By the end of January, the snow was falling relentlessly. Approximately 21.5 inches fell throughout Puget Sound in the first two days of February. The snow interrupted road and rail travel, mail delivery, fuel and food availability, and school attendance. The February 4th edition of the *Edmonds Tribune-Review* declared that "without doubt the man who last summer said it never snowed on Puget Sound is an unmitigated liar."[26]

This photo (EHM 150.52) looks north down the alley between 5th and 4th. The back of the F.R. Beeson house is on the left, and next door is Charlie Carlson's house. Looking toward the High School, there is a one-story house belonging to the Pattersons, although eventually, it was owned by Frances Anderson, the beloved educator. In the distance is Edmonds High School. It looks like it was taken from an

[25] Cloud, *Edmonds: The Gem of Puget Sound*, p. 100.
[26] Citation courtesy of the *Winters of Yesteryear* exhibit at the Edmonds Historical Museum.

elevated position, possibly through a window on the 2nd floor of the Beeson Building. EHM 150.149 was probably taken from the same vantage point as the photo looking up the alley in EHM 150.52 but towards the Carnegie Library and the Fire Tower. Finally, EHM 150.137 gives a sense of what it was like at street level, looking at the snow piled against the Beeson Building. Other photos of the snow up and down Main give a similar sense of the practical challenges it caused and its impact.

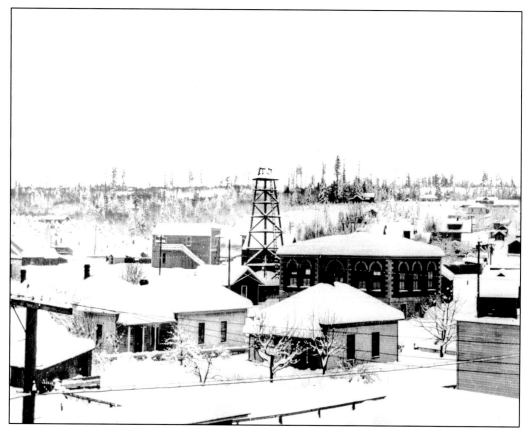

EHM 150.149

The picture of the Beeson house itself in the snow is shown in the *Then* photo EHM 180.51 (on the next page). The image can't be duplicated effectively from the same angle since so many other buildings have grown around it. It currently houses the Edmonds Carriage House (a short-term apartment rental agency) and sits between Rick Steves' Europe and the Crow boutique. The *Now* picture tries to capture a close-up of some interesting architectural details on the current building. The snow is left to your imagination.

BEESON BUILDING, EHM 150.137

THEN, C. 1916

The Front of the Beeson House, EHM 180.51

NOW (FROM THE FRONT)

Edmonds Carriage House, 116 4th Avenue N, c. 2023

SCHUMACHER BUILDING

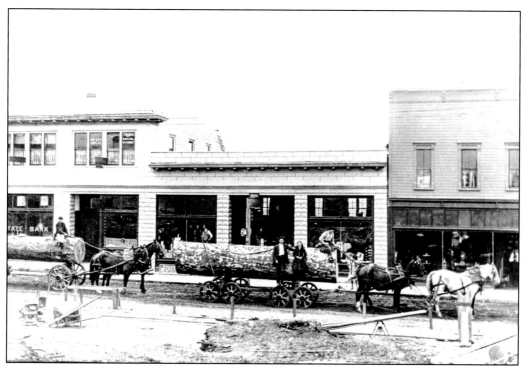

Log Moving Through Town, EHM 144.11, c. 1910

Main Street at 4th Avenue was Edmonds's first permanent business block, and the Schumacher building reminds us of that time. Constructed in 1890 (the year Edmonds was founded) by William H. Schumacher, the Schumacher building was a Western-style "false front" retail building with a well-defined front and a parapet that makes the building look taller. The Schumacher brothers ran a general store that sold groceries and furnishings there for fourteen years. One of the subsequent owners was William Kingdon, who had owned a grocery store closer to the docks. He moved his grocery business to the building and operated it until 1907. As Byron Wilkes notes in his history of the building in *My Edmonds News*, this was the time when his daughter, Esther Knowles (nee Kingdon), could remember, "My father had me working as soon as I could see over the counter." The family lived over the store, and it was one of the earliest buildings to have indoor plumbing.[27]

Eventually, Kingdon moved his grocery store next door to the building that the State Bank of Edmonds had built. Schumacher sold his original building to E.H. Heberlein in 1908 for his hardware store. Heberlein moved his hardware business into the space, and that is the business often seen in early photographs. He ran the hardware business for fifteen years, and redecorated it with a new front and signage. He eventually changed the business's name from Heberlein Hardware to the Edmonds Hardware Company. One of the subsequent owners of Edmonds Hardware, Clyde

[27] myedmondsnews.com/2023/03/Edmonds-history-the-schumacher-building

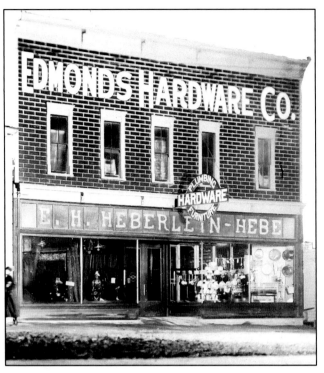

EHM 160.7, C. 1920s

Jackson, moved it up the street to the Fourtner building in 1928. Over the years, the building continued to be the home to various local businesses. A key milestone in the path to *Now* was when Jochen Bettag purchased the building in 1984 and restored it to its original look.

The Schumacher building is one of the oldest commercial buildings in Edmonds and still is a proud emblem of the city's history. It currently serves as the location of the popular Chanterelle restaurant, which has been there for some thirty-seven years now. The sign on the Chanterelle restaurant occupying the space today echoes the design of the earlier Hardware sign. The building front has been a favorite subject for many artists and photographers over the last century. The Schumacher building was added to the Edmonds Register of Historic Places in 2015.

Schumacher himself was a man of many talents and interests, and as with other early pioneers, while he may have started with a general store, he ended up in unexpected places. For example, as mentioned, Schumacher became a director of the newly formed State Bank of Edmonds. On discovering the other founders weren't as committed financially to it as he was, he bought them out. The new bank moved into the building at the corner of 4th and Main in 1907. W.H. Schumacher was the head cashier, and R.W. Schumacher was the assistant cashier. Ole Sorensen, the former blacksmith, became VP of the Bank.

Schumacher was an Edmonds pioneer, an entrepreneurial businessman, a City Treasurer, a founder of Edmonds' first bank, a merchant, and even briefly published the *Edmonds Tribune* newspaper. When the Edmonds Choral Society was formed in 1910, he was named its president.[28] He also served on the new Library Board and even spent a short stint on the city council. In 1913, Schumacher left Edmonds for Sequim, where he remained active until his passing.

The *Then* image (EHM 160.68) is an interesting moment in the early history of Edmonds. It shows a steam donkey engine, with its billowing smoke and metallic gleam, trundling past the Schumacher building and the Heberlein Hardware Store. The lumber wagon in the foreground is loaded with planks, and Sam Yost sits on it. On

[28] Ray Cloud notes in *Edmonds: The Gem of Puget Sound* (p. 36), that while the initial meeting of the Edmonds Choral Society was figuratively and literally harmonious in nature, "two unnamed ladies become involved in personal vituperation in which the chairman was loath to interfere until the lateness of the hour forced an armistice."

THEN, C. 1909

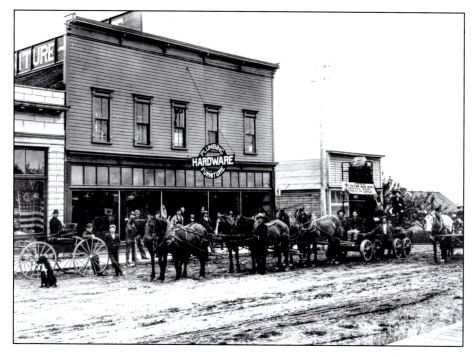

EHM 160.68

NOW

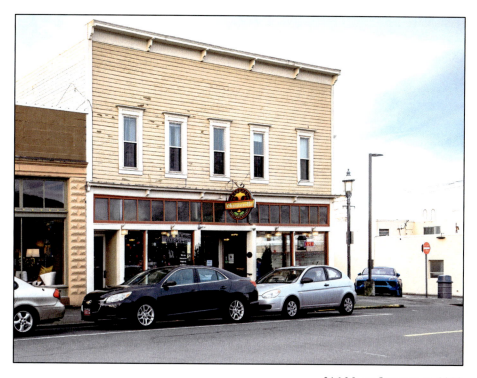

316 Main Street, c. 2023

the donkey are probably A.L. Waddle, Bill Reece, Elmer Reece, and Joe Yost. The bustling scene is set against the backdrop of the State Bank of Edmonds building on the left and the *Tribune-Review* Building on the right. It has been noted that "Downtown Edmonds in the early 1900s was a hodgepodge of pioneer remnants and new technologies. Horses and oxen still trotted through mostly mud streets, joined by the zip and zoom of automobiles and buses."[29] EHM 150.20 shows paving in front of the Hardware store just a few years after the earlier photo. Skidding the logs down the road to get them to the water and the mills no longer made sense either because of how far away logging was taking place or because of the growing maturity of the town at this point.

As mentioned, the *Then* picture (EHM 160.68) shows a small building next to the Hardware building with the *Tribune-Review* name. It turns out that Schumacher bought the *Tribune* from T.A.A. Siegfriedt on October 1, 1908. He combined the paper with the *Edmonds Review* (which was run by Washington State's "Mother of Journalism" and Edmonds resident, Missouri Hanna) to become the *Edmonds Tribune-Review*.

After taking over the paper, he published a letter from Siegfriedt in which the former owner supported the Law and Order League. This group often promoted vigilantism to monitor and compel community behavior. The letter criticized a Citizens' Committee in town, including Zophar Howell III, F.H. Parker, and Mayor James Brady (a very popular Edmonds mayor from 1904 to 1910). Siegfriedt was upset because an effigy of the former editor had been suspended over Main Street during a moonlit night, and the marshal wouldn't take it down. At that point, the landlords of the *Tribune-Review* building ordered Schumacher to vacate the premises. Schumacher's friends came together and, within a week, constructed a building next door to the Schumacher building. Ray Cloud (who bought the *Tribune-Review* in 1921 and ran it for thirty-one years) in *Edmonds: The Gem of Puget Sound*, noted that Schumacher "later commented editorially that the newspaper business, while one of the most fascinating of careers, also proved one beset by the greatest of difficulties." The news operation was eventually leased to the Boomers (George and Alice).

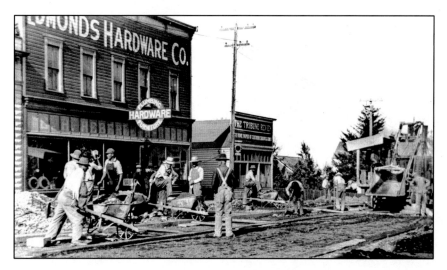

STREET PAVING, EHM 150.20, C. 1917

[29] "Then and Now: 2022 Historic Edmonds Calendar," (2022).

Zophar Howell

In 1903, an "energetic young man" named Zophar Howell III arrived in Edmonds from Philadelphia. He had graduated from the University of Pennsylvania in 1895 and had been working in the wallpaper manufacturing business with this grandfather. On arriving here, he set up a real estate and insurance business. "Mr. [Zophar] Howell was largely instrumental in the organization of the Chamber [of Commerce} and served as its first president. One of the first moves was to purchase about nine acres of waterfront property near the south town limits to be offered as inducement to the establishment of industries. In spite of the efforts of the Chamber and the good intentions of those concerned, most of the industries brought here during those times failed to thrive for long---some because of lack of market or of capital, some because of inexperience or mismanagement of their executives, and some, perhaps, because their promoters were more interested in the sale of stock than in permanent operation. Ill-fated Edmonds waterfront industries included a bolt works, an excelsior factory, a box factory, a smelter, a ramie fiber plant, a 'canite' explosive factory, a sharkskin processing plant, and a pulp mill. But through all this period the shingle mills continued to grow and prosper and new settlers began to build homes in the logged-off areas in and around Edmonds." – Cloud, *Edmonds: The Gem of Puget Sound,* p. 22

THE REMAINS OF YOST'S EDMONDS SPRING WATER COMPANY DAM IN YOST PARK, C. 2023

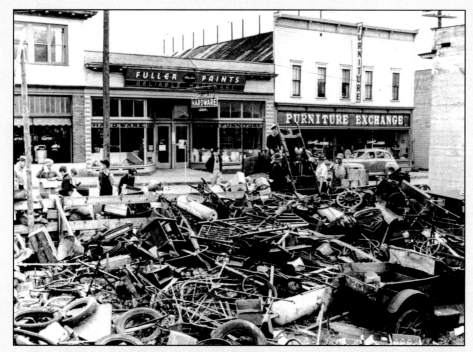

Another interesting image in this general area is EHM 150.29. It was taken during WWII when those on the home front were conducting paper and metal drives to help supply the troops. A vacant lot across from the building became the place where much of the metal was collected. In WWI and WWII, many groups were active within Edmonds, doing what they could to support the troops.

SCRAP METAL TO SUPPORT THE WWII WAR EFFORT, EHM 150.29, C. 1939-1945

STATE BANK OF EDMONDS

The State Bank of Edmonds, shown in the *Then* image (EHM 164.2), was built in 1907. As mentioned earlier, one of W.H. Schumacher's many activities was to create the State Bank of Edmonds. It began with a little drama as he was pulled into an enterprise set up by several other people, only to find that they hadn't put any serious money on the table. He bought them out, and then it was his vision that shaped the bank.

The Bank, as you can imagine, was critical for the early development of Edmonds, especially commercial development. We continue to see what happens when banks fail. The building had a variety of renovations over the years, but the essential structure is the same. The Bank also contracted for a new building between itself and the Schumacher Building. As mentioned, the plan was for William Kingdon's general merchandise store to occupy the new space. The *Now* photograph shows that the Bank building has undergone several facelifts over its life.

THEN, C. 1910

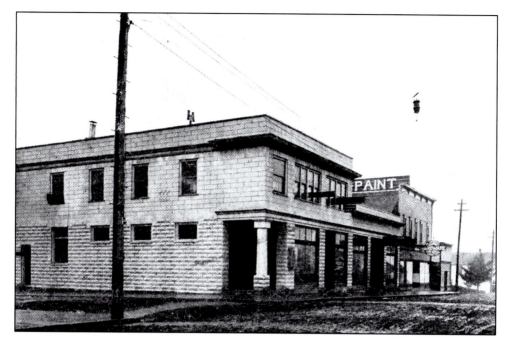

EHM 164.2

NOW

INTERIORS OF EDMONDS, 326 MAIN STREET, C. 2022

ROSCOE BROTHERS GROCERY

Food and other supplies were critical for the rapidly growing population of Edmonds at the beginning of the 1900s. Many Edmonds founders ran grocery stores, dry goods stores, restaurants, and so on at various points. One family that had a big presence in Edmonds was the Roscoe family. EHM 160.27 shows the interior of the Roscoe Brothers Grocery store. It has some of the feel of many little bodegas providing everything we see in urban stores today, or even similar to the "Little Store" in Richmond Beach that provided similar services when I was a kid. In this picture, John C. Lund is sitting in the front, and then from left to right, you see Mrs. John Thornton (Mary), Edwin Roscoe, Mrs. Edwin Roscoe (Clara, nee. Thornton), Reuben Roscoe, and Vern Gist.

In the EHM 160.9 *Then* photo, you can see Ed Roscoe (holding the hat), possibly Clara Thorton Roscoe, and Reuben Roscoe (in front of the door). The State Bank of Edmonds had built the building between the bank and the Schumacher Building, and currently, it houses the HouseWares home furnishings store.

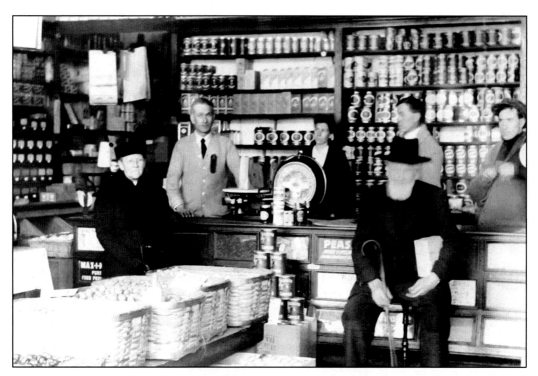

EHM 160.27. C. 1916

THEN, C. 1912

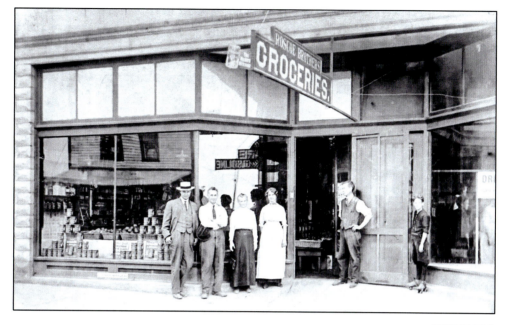

EHM 160.9

NOW

318 Main Street, c. 2023

Frank W. Peabody

Cloud (in *Edmonds: The Gem of Puget Sound*), provides a short biography of Frank W. Peabody. Born in Massachusetts in 1855, Peabody wasted no time seeking adventure and fortune in the West. His endeavors began with running a frontier store in Fort Worth, Texas, followed by a stint prospecting in New Mexico and Arizona, which alas didn't deliver much in the way of a fortune. Peabody eventually acquired ownership of a hotel in Flagstaff, Arizona, but when a fire burned it to the ground, he lost almost everything he had. With a mere $5 in his pocket, Peabody migrated to Seattle and decided to take a chance by gambling at one of the many gambling halls in the wide-open town. He pawned his watch, found a likely place, and played faro. He won $1,400 (equivalent to about $41,000 in today's currency).

With his newfound fortune, Peabody and Joseph Pearsall then set out to prospect in the Cascades. While admiring the scenery through their binoculars from Silver Tip, the highest peak in the Silver Creek area of eastern Snohomish County, they spotted a large vein of ore on the side of a mountain range to the east. Peabody named it the Monte Cristo after discovering what appeared to be a fabulously rich and extensive vein of gold and other valuable minerals. As you can imagine, news of the discovery spread quickly, leading to a surge of prospectors flocking to the area. However, Peabody and his partners had formed a company and filed the best claims. It wasn't long before John D. Rockefeller and other capitalists paid a significant amount of money for those claims, although Peabody retained some of his holdings. By the time the richest veins were exhausted, approximately three million dollars in gold and silver had been extracted from the area.

With the money from the sale of these claims, Peabody joined a Seattle syndicate and bought most of the holdings of George Brackett, Captain Hamlin, and others in the Edmonds area. Peabody then moved to Edmonds as the resident manager of the company and ran a real estate office here through the rest of his life. While the syndicate was not responsible for much development in Edmonds, and indeed blocked many potential improvements, their general promotions did bring many new residents to the area which in turn drove development of streets and other infrastructure.

According to Cloud's description, Peabody was "a slender vegetarian with a long, flowing beard." As you can tell from the photo EHM 160.116, he "bore a striking resemblance to George Bernard Shaw," and "on frequent trips on the steamers to Seattle or Everett he was said occasionally to have reverted to his taste for cards and to have become a worry to the ship captains because of his skill."

Cloud shares a story about Peabody: "Not long after the first World War when a stunt flyer was taking up passengers from the Edmonds beach in a two-seated open-cockpit biplane at $5 for five minutes, Peabody approached the pilot after almost each landing to offer him $3 for a flight. Finally, when there were no more $5 passengers and the tide had not yet covered the sandy beach, Peabody was offered a three-minute ride for $3, he clambered into the seat like a youngster going to the circus and was carried off into the blue with his white beard swept back over either shoulder by the wash of the propeller." – Cloud, *Edmonds: The Gem of Puget Sound*, pg. 24

FRANK W. PEABODY, EHM 160.116, C. 1912

EDMONDS CAFE

The Fourtner Building was described earlier, and it is worth exploring Fred A. Fourtner in more depth. As you've seen, during the early 20th century, Edmonds was home to a vibrant community of entrepreneurs and pioneers, and Fred Fourtner. Fourtner was another example. He was a prominent businessman and a well-respected and beloved mayor who held office during some of the most challenging times in the city's history, presiding through the stock market crash and WWII.

The *Then* photograph (EHM 160.45) of Fourtner in front of the Edmonds Café captures a moment in time, a glimpse of the man and the place that he called home. He stands with a determined look, surrounded by his wife, Elsie, and an employee, Edith Perry. The Edmonds Café was one of many businesses that Fourtner owned and operated throughout his life. In addition to the Café, at this time, the Fourtners also provided for boarders and people needing short-term housing.

Fred Fourtner was a true pioneer, having been one of the first fourteen pupils in the Edmonds school when it opened in 1887. His family moved to Lynden on the Canadian border for a few years, and Fourtner worked in the shingle industry for a while. But Fourtner returned in 1912 to Edmonds and stayed. One of the first things he did was to buy the Bartlett Brothers cigar and confectionary shop at the foot of Main Street. In 1913 he opened it as the Edmonds Café. The photo in front of the Cafe has a note on the back saying the first customer was Reuben Roscoe, a prominent businessman, city councilman, and two-term mayor who served twelve years the second time (a record serving as mayor at that point). In 1913, Fourtner also purchased the Lemley Building and opened the first dedicated motion picture house in Edmonds in 1916. In 1924, Fourtner built the brick building on the southeast corner of 5th and Main that stands today and bears his name, and he moved the old Engel Building up 5th Avenue.

Mayor Fourtner was known for his outspoken nature and his peculiar administrative style. According to former Mayor Gordon Maxwell, he would sometimes doze off during long discussions, ignore issues he didn't want to address, and even had his own form of a "pocket veto" that he exercised by simply "forgetting" to implement certain council actions.[30][31] Despite his quirks, Mayor Fourtner was highly regarded by the community and loved for his straightforward approach and unwavering dedication to the city.

[30] "Fred Fourtner presided as Mayor of Edmonds longer than anyone," *Edmonds: 100 Years for the Gem of Puget Sound*, p. 12.
[31] Satterfield, *Edmonds: The First Century*, p. 54.

THEN, C. 1913

EHM 160.45

NOW

214 Main Street, c. 2022

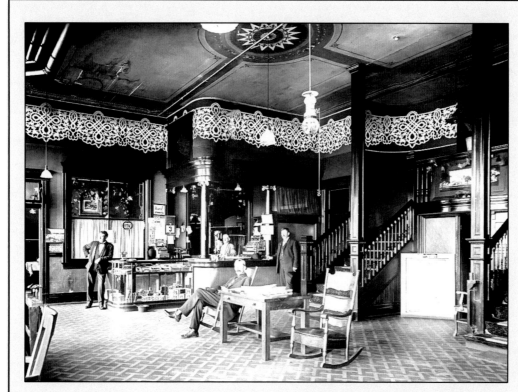

PICTURE OF EDMONDS' OLDEST TAVERN, EHM 160.81, C. 1912

ROYAL HOTEL

The Royal Hotel was a landmark in Edmonds. It was located on Main and 2nd and had been a lodging house for many years. It had once been one of the buildings that Samuel Fourtner owned and later was purchased by O.E. Christensen. In May 1931, it was seriously damaged by fire, and was almost completely destroyed by fire in March 1932. In November of that year, its fate was sealed with yet another fire that ravaged the building. In the spirit of those early years, today, we see another multi-use building in its place.

THEN, C. 1900

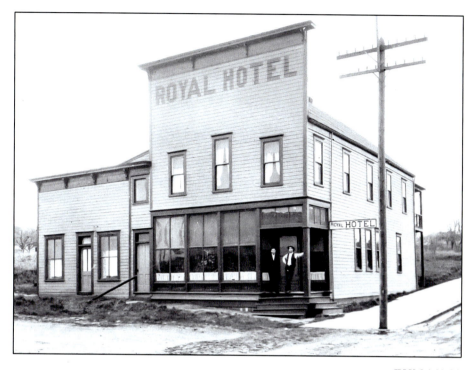

EHM 161.21

NOW

201 Main Street, c. 2023

HYNER GROCERY AND HOUSE

M.E. Hyner, his wife Clara, and their three children (Paul, Ruth, and Robert) arrived in Edmonds on February 21, 1887, on the steamer *Monroe*. The high tide helped the ship dock at the small wharf they found there. Hyner soon bought a store that was near the dock, enlarged it, and according to Cloud, "became Edmonds' first real merchant."[32]

The Hyner grocery store was at Main Street's base and served the needs of travelers arriving by ship and later by train. The house was near the grocery, as you can see in photo EHM 160.41. That lower part of Main was covered with what was called a corduroy road. In this type of road, logs were placed perpendicular to the direction of the road to help manage swampy or muddy areas. The *Now* photo of Rory's is a stand-in to illustrate roughly where the grocery store was located, and the house was probably further east of that location up the hill on Main.

In 1896, Hyner was appointed postmaster, taking over from George Brackett. In those early days, the mail would arrive by a Seattle steamer. If the tide was low, it was hard for the ships to dock at the pier, so Hyner would need to row out to pick up the mail. Hyner put a cupola on his house, and one of the jobs for the kids was to watch for the smoke from the ship funnels as they appeared coming around Point Wells to the south or around Whidbey Island to the northwest.

THEN, C. 1890

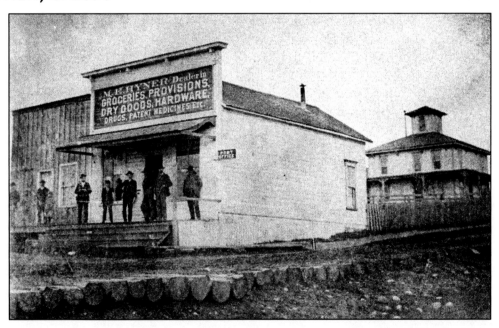

EHM 160.41

[32] Cloud, *Edmonds: The Gem of Puget Sound*, p. 11.

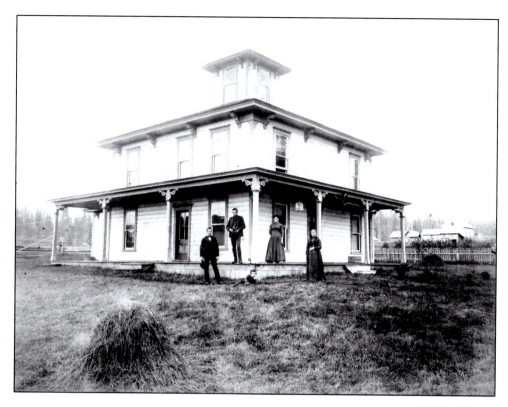

EHM 180.103

NOW

Rory's of Edmonds, 105 Main Street (near the former grocery)

EDMONDS HOTEL

In his *Patch* article, Larry Vogel observed that early in the twentieth century, with the mills operating continuously, many were lured to Edmonds as workers and investors. One category of buildings that grew at the foot of Main Street were those serving meals, lodging, and other services to those working in the area and traveling through. Vogel notes that traveling through Edmonds to and from the Olympic Peninsula could be a two-day affair, so room and board were in demand. With the demand and variable ferry schedules, autos would be lined up for blocks on busy weekends, and travelers would be looking for something to eat and other supplies.[33]

Besides the Royal Hotel, another fixture near the ferry docks serving visitors coming through Edmonds was the Edmonds Hotel, shown in the *Then* image EHM 160.165. It was placed well for visitors arriving by train and needing a place to stay overnight. Like other buildings in Edmonds, there is a story before the story. In the image EHM 160.15, you can see the Eagle Café and Lodging House run by Mrs. Samuel Fourtner (shown in the picture). It sat on the southeast corner of First Avenue (now Sunset) and Main.[34]

EHM 160.15, c. 1905

According to Cloud, in *Edmonds: The Gem of Puget Sound* (p. 64), in December 1928, W.H. Wilson began building a restaurant that opened as the Eagle Café a few months later. A second story was added in November, providing eleven hotel rooms as well. This implies the earlier Eagle Café and Hotel had either been replaced or destroyed (perhaps by fire). By 1941 the Café and Hotel were owned by John E. Yost and were leased by Margaret Caldwell (who had moved here from Anacortes). But a few months later, J.J. O'Conner, who had arrived from Montana, took over the lease.

[33] patch.com/Washington/emonds/the-eagle-café-an-early-twentieth-century-landmark
[34] Interestingly, it does appear that the building next door to the Eagle Café and Hotel (apparently a barbershop) is the same one that became the Edmonds Café and potentially was moved further up Main street to where it is in EHM 160.45.

THEN, C. 1960

EHM 160.165, C. 1960

NOW

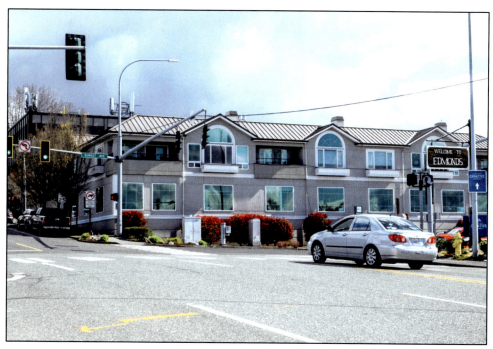

LOOKING EAST ON MAIN STREET

It changed hands again, and Mr. and Mrs. D.A. McFarland bought the hotel building and renamed it the Edmonds Hotel.

During the 1974 realignment of the approach to the Edmonds-Kingston Ferry for Washington State Route 104 and the provision of a holding area, the Edmonds Hotel that had stood there for so long was demolished. The new alignment shifted the highway to the current extension of Edmonds Way and Sunset Avenue. The *Then* image (EHM 160.165) on the preceding page is one of many that shows the Edmonds Hotel over the years, and the *Now* image is one of the not particularly sexy boarding lanes for the ferry that goes through where the Hotel had been located. The Plumbing store in the *Then* image would be to the right of where the *Welcome to Emonds* and the *Creative District* signs are now.

In the *Then* image, you can also see another of the typical businesses in the "industrial" part of Edmonds. It is called West Coast Metals. It was established around 1950 and occupied a building that had been used by Long Motors and Welding Company (which had worked on fishing boats). Its plant created various aluminum products for the building industry (e.g., gutters, downspouts, and fittings). Its punch-presses could generate almost anything people needed to be made out of aluminum. In the beginning, Jerry Martin was president and engineer, and Max Wicen and Dr. W. Nelson were directors. The buildings in the *Now* photo are about where it was located.

In the 1960s, Dr. Nelson's son, Bill Nelson, was running West Coast Metals along with my father. They had also moved to a larger building that had once been the garage built by P.E. Bacon in 1928, about a block further east on Main. In EHM 150.60 (in the section on the Edmonds Ferry Dock), you can see the corner of the garage in the view of the traffic lined up for the ferry. I worked there as a kid in the summer of 1968 and decided a life of working a punch press was not for me. By the mid-1970s, West Coast Metals had been replaced by Mar-Vel Marble (which had been in the building that became the Edmonds Senior Center down on the shore before moving to its new location). More recently, the old building was torn down in 2017 and was replaced by the Graphite Arts Center and the Charcoal restaurant.

GRAPHITE ON SITE OF WEST COAST METALS/MAR-VEL MARBLE,
202 MAIN STREET, C. 2023

Between Sunset and Railroad Avenue, South of Main, c. 2023

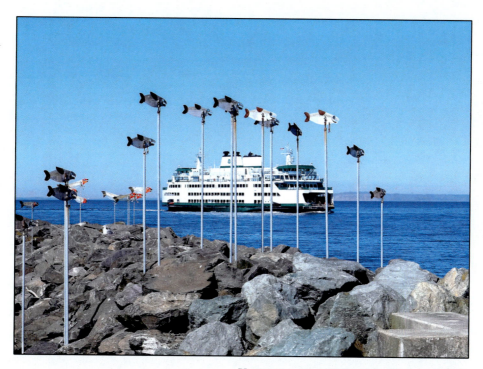

View from the Edmonds Shore, c. 2019

CRESCENT LAUNDRY

In 1930, Mr. and Mrs. John C. King began constructing a new location for the Crescent Laundry at the foot of Main Street, which opened in 1931. They operated Crescent Laundry for 15 years and then, in 1944, sold it to Arthur Clausen and Ross Billings. Clausen and Billings, in turn, sold it to the Metropolitan Laundry Company of Seattle in 1950. Today Demetris Woodstone Taverna is a favorite restaurant on the shore, with only the occasional train pausing conversation.

THEN, C. 1930

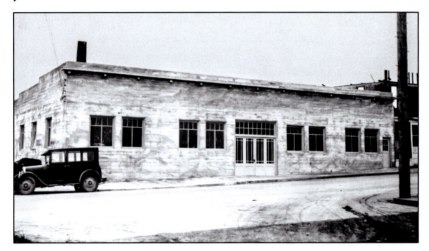

EHM 160.43

NOW

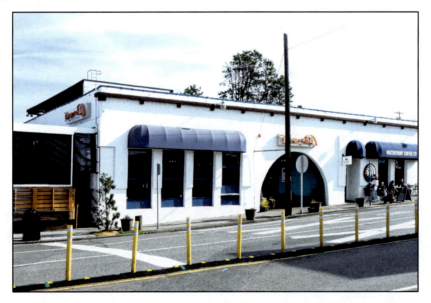

DEMETRIS WOODSTONE TAVERNA, 101 MAIN STREET, C. 2023

SHORE AREA

Like many towns in the Pacific Northwest, Edmonds has a strong link to the water. It is believed that the Coast Salish tribes (e.g., the Suquamish, Snohomish, Snoqualmie, and Duwamish) frequently fished the waters and scoured the beaches for shellfish. White settlers did not come to Edmonds until the 1860s, and George Brackett was one of a stream that was starting to flow faster. He arrived in 1870.

But at this point, it is worth taking a mental journey back to the rugged wilderness of Restigouche, New Brunswick, Canada, in the mid-1800s. The air is fresh, the sky is wide open, and the forests are dense with various towering trees such as cedar, balsam fir, white spruce, birch, aspen, and poplar. Amidst the breathtaking natural beauty of this landscape, George Brackett was born in 1841 into a family of twenty children. Betty Lou Gaeng notes in her *Edmonds Beacon* article on Brackett, "The men of the region were mainly lumberjacks, fishermen and farmers, and the people were tough, frugal, and hard workers. In fact, the area and the people were much like what George Brackett found when he arrived in the Pacific Northwest."[35]

Brackett grew up in the Restigouche River area, where his father farmed and raised livestock, but it was the allure of the forest and the logging industry that drew him in. At 18 years old, he began working as a logger, cutting down trees in the dense forests of Maine and Wisconsin. As he followed his dreams, he saved his money and made his way to the West Coast of the United States. After a brief stay in San Francisco, Brackett booked passage on a sailing ship heading north to the Washington Territory. Once he arrived, he began logging in the virgin forest land of the Puget Sound region and, with his earnings, bought his oxen teams and equipment to further his logging endeavors. He eventually obtained a land patent of 162.35 acres near La Conner in Skagit County, and later exchanged the property for forested land in Seattle.

It was on a day in 1870 that George Brackett set out in his canoe to search for new timber sources near the shoreline of Puget Sound. As the story is told, due to a sudden storm, he sought refuge on the shore just a short distance north of what is now Point Edwards. He secured his canoe in the marshy area and took in the land that would become Edmonds. Even before Brackett arrived, the titles to much of the unceded land around here were held by other settlers, Federal Government land grants following earlier wars, and the lumber giant the Puget Mill Company in Port Gamble.[36]

As he explored, he came across Daniel Hines, a 29-year-old with a small shingle

[35] www.edmondsbeacon.com/story/2019/10/10/news/george-brackett-revealed/22119.html
[36] These titles, of course, were granted relatively recently at this point. The Treaty of Point Elliott was signed in 1855, and it took until 1859 for it to be ratified.

operation. Mr. Hines was living alone in a rustic cabin in the area. However, the dense forest surrounding him caught Brackett's eye. The area was rich in Douglas fir and cedar trees. It turns out he had discovered the 140.75-acre preemption claim of a man named Pleasant H. Ewell, one of the early settlers in Snohomish County. Hines was working on the property.

Brackett didn't settle here immediately, though. From 1872 to 1876, he continued to work his existing rights, including the area that became Fort Lawton (now Discovery Park) and an area called Farmdale, which is now better known as Ballard. As context, remember this was before the Great Fire in Seattle and was still the time of the Yeslers and other founders of Seattle. In 1872 he did meet some of the other people who had arrived in the area. These included Thomas F. Kennedy, a former fisherman, who had settled on his 149.25-acre homestead, which adjoined the old Pleasant Ewell property on the north, and James C. Purcell and his extended Salish family, who were living on a 79-acre homestead south of the area. The Purcell place included the bluff that we know now as Point Edwards.

It wasn't until 1876 that George Brackett finally purchased that 140.75-acre Ewell property from the people who had the title at that point, and it cost him $650. $650 then isn't a lot in today's dollars (about $18,000), but a price of about $5 per acre was what undeveloped land was going for back then. The land he purchased extended north from today's Dayton Street and included about one-half mile of waterfront and the land east up the hill. This downtown area is largely the focus of this photo journey and is the heart of *the Bowl* of Edmonds today. Brackett then built a cabin on a knoll above the beach, close to where Brackett's landing is today. He also began draining the marsh and, with his brother-in-law, began to build the first mill in the area.

EDMONDS MARSH, C. 2022

EDMONDS FERRY DOCK

As mentioned, Brackett arrived by canoe as he had been looking for opportunities up the coast and was pushed ashore by weather and destiny. The water provided many opportunities, but the water and the surrounding hills that define the downtown area of Edmonds isolated the area. Many early settlers arrived by steamboat, and one of the first things Brackett did was build a wharf. Much of the infrastructure development in the early days involved improving the Edmonds docks.

"When the city council granted a lease, on October 17, 1922, to Joyce Brothers of Mukilteo, for a portion of the city wharf as a terminal for a ferry service between Edmonds and Kingston, a new era opened in the history of Edmonds. The ferry, City of Edmonds, built for the route, was launched on April 16, 1923, and a holiday was declared on May 16 to celebrate the opening of the route. Accompanied by the Park Band of Edmonds, local people packed their lunch baskets and boarded the ferry to Kingston where a program and picnic were enjoyed." – Cloud, *Edmonds: The Gem of Puget Sound*, p. 79

It was clear that ferries and rail were critical to unleashing Edmonds' potential. After the Great Northern Railway started to build toward Edmonds, a newly formed land company bought much of Brackett's land holdings. Part of their plan was to construct a new and better wharf. When the company failed due to the depression at the time, and Brackett foreclosed on them, Brackett made it a mission to secure automobile ferry service for Edmonds. Ferry service was secured shortly before his death, and in 1923, the first auto ferry route was established between Edmonds and Kingston; by 1935, Edmonds was a key port for ferry traffic in Puget Sound. The *Edmonds Tribune-Review* called Edmonds the "Hub of the Northwest."[37]

EHM 150.192, C. 1920s

The City of Edmonds made its first run on May 20, three days after it was scheduled to begin service. Alas, it had broken down during its trial run. Other ferry routes came and went over the years, such as between Edmonds and Port Townsend (in 1931) and between Edmonds and Port Ludlow. On June 14, 1935, the Puget Sound Navigation Company launched an Edmonds and Victoria route. It was serviced by a remodeled Olympic automobile ferry. The Olympic glowed with new paint, and had a

[37] Private ferry service was taken over by WA State Ferries in the 1950s.

large observation room, a dining room with new linens, and modern staterooms. While all the other routes are no longer with us out of Edmonds, the Edmonds and Kingston connection has persisted. Eventually, highways and bus routes completed the network of transportation that converged in Edmonds, and Edmonds is still a "Hub of the Northwest."

EHM 150.23, the *Then* photo, shows cars lined up for the holiday. The ferry is the Quillayute, and other buildings in the photo include the Royal Hotel, a Lunch Room, and the Crescent Laundry. The EHM 150.192 image shows the cars lined up north on 3rd Avenue, all waiting to load onto the ferry. Something similar can be seen on holiday weekends today, but now the backup goes up towards the southeast on 104 and Edmonds Way. In the distance, you can see Brackett's Edmonds Feed Store, which housed the first class of students before a more permanent school was built.

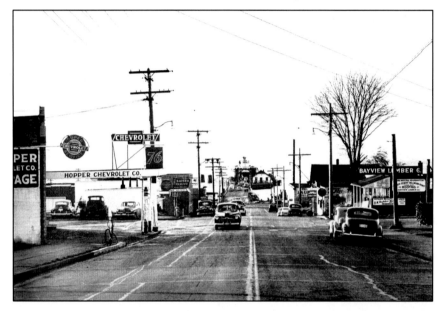

EHM 150.60, c. 1948

The site of Brackett's Landing was purchased in 1963 and named in honor of George Brackett. Brackett had built the settlement's first dock in 1883, just a little north of the current ferry dock, and it served the mosquito fleet boats stopping as they traveled up and down Puget Sound. The jetty was constructed in 1989, and in 1993 upland improvements were completed. In 1970 the City created the adjoining Underwater Park, a twenty-seven-acre marine preserve and sanctuary. The Park was

> "Skeptics questioned whether or not it was motion picture star Lana Turner who had a soda at Quiett's Hi-Liner one day in June while waiting for the Edmonds ferry. In any event, Mr. Quiett preserved one of his menus on which were inscribed the signatures of the gorgeous star and of Eddie Cantor who almost escaped the notice of the fans scrambling for Lana's autograph. The Hollywood group were in the Pacific Northwest visiting Army posts and war industry plants in the interest of the current War Bond Drive." – Cited by Ray Cloud in *Edmonds: The Gem of Puget Sound*, p. 194

THEN, C. JULY 4, 1927

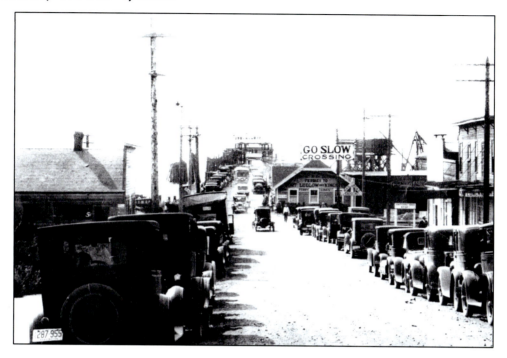

EHM 150.23

NOW

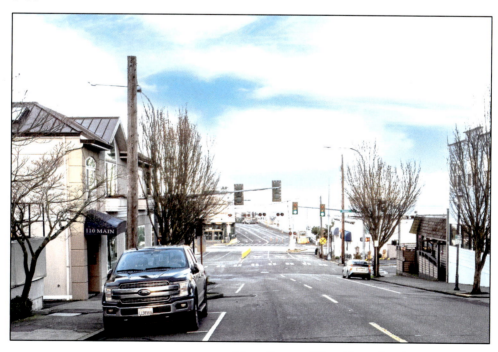

MAIN STREET WEST FROM 2ND AVENUE, C. 2022

one of the first underwater parks on the West Coast. The site includes tide and bottomlands developed with features and trails for scuba divers.

EDMONDS TRAIN STATION

EHM 240.55, C. 1930

James Jerome Hill, also known as "The Empire Builder," founded the Great Northern Railway in 1889 by combining several smaller railways. The railway extended from Duluth and Minneapolis/St. Paul across North Dakota, Montana, and Idaho into Washington. The Great Northern track-laying crew reached Edmonds from the north in 1891 and moved to Seattle over the proposed right-of-way of the Seattle and Montana. In 1893, the Great Northern Pass Route was completed when the last spike was driven at Scenic, WA, and railroad service was extended to Edmonds and on to Seattle. Great Northern later purchased the Seattle and Montana railroad, and the Fairhaven & Southern railroad, which provided tracks to Vancouver, BC.

The Great Northern Railway in 1910 had two tracks through Edmonds, and with eight trains and an increasing number of steamers, demand was growing. Initially, the train station in Edmonds was located on the west side of the tracks, away from downtown, and was considered too small and inaccessible for the growing city. In 1909, the Washington State Railroad Commission ordered Great Northern to improve their depots, including a modernized facility for Edmonds, after a formal investigation of stations across Snohomish County. Great Northern agreed to build the new depot after further consultation with Edmonds city leaders regarding its location and amenities. Brackett was reluctant to let his land be used for a depot, but the Chamber of Commerce eventually won, and the site that is used today was chosen. A new depot was constructed with clapboard sidings and a wooden platform connected to street level by a series of ramps. It was served by eight daily passenger trains by 1910. The new depot also accepted freight services from the Olympic Peninsula by boat from shingle mills there.

THEN, C. 1947

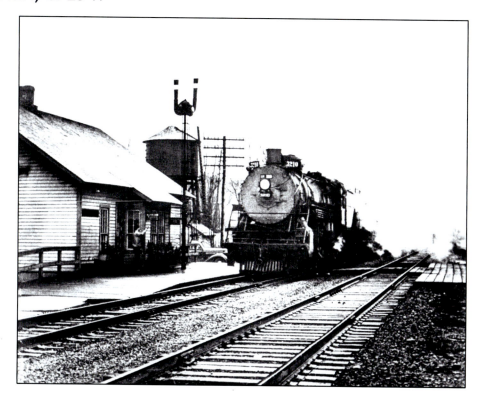

EHM 240.20

NOW

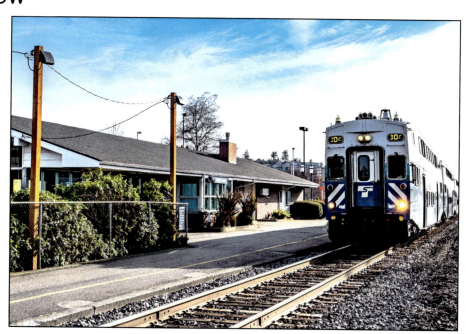

211 Railroad Avenue, c. 2023

Over the years, the Great Northern Railway saw changes in its service, with declining passenger service and increased freight business during the 1920s. In 1956, Great Northern announced plans to build a modern station in Edmonds to serve the suburban areas north of Seattle. The new station included a large parking lot, a blacktop platform, and a streamlined waiting room with contemporary design elements. The former depot was demolished, and the new station was put into service in December 1956, with the first transcontinental Empire Builder train arriving on January 7, 1957.

After the Great Northern turned into the Burlington Northern in 1970, Amtrak took over Burlington Northern's passenger routes the following year. Passenger service from Edmonds station began in July 1972. Sound Transit began operating Sounder trains to Edmonds station in December 2003 and later funded a project to rebuild the station and transit center in 2011. Today, Edmonds is served by six daily Amtrak trains, including the Empire Builder between Chicago and Seattle/Portland, the Eugene-Portland-Seattle-Vancouver Amtrak Cascades, and the Sound Transit commuter service. Freight trains also regularly roll through town. The Edmonds Model Railroad Club (i.e., the Swamp Creek & Western Railroad Association) had occupied a small annex to the station that contained a scale model of a fictitious railroad that represented the railroads running through this area of Washington from 1977 to 2022.[38]

JOHN C. LUND (L) AND SETTLERS HELPING CLEAR LINE FOR THE 2ND GREAT NORTHERN RAILROAD TRACK, EHM 134.57, C. 1900

[38] Burlington Northern has taken the space back as it returns to a double-track line through Edmonds, so the Swamp Creek club has moved to Everett to build its new layout. It will be in the Everett Amtrak Station under its new name, The Everett Railroad Heritage Association.

RAILROAD STATION MASTER'S HOUSE

When you have a Station, you need to have a Station Master to run it. The Station Master's house for Edmonds has moved around perhaps more than any other building in Edmonds. In EHM 240.79, the house is located near the Edmonds Train Station on the Great Northern Tracks. At that point, it had won an award for the "most beautifully landscaped yard on the Great Northern Line." Sam Macchea (presumably the Station Master) and his wife are standing in front of it. The Train Station itself was also covered with flowers around that time. You can see the same water tower for the engines in the background that is visible in the picture with the train coming into the station.

Interestingly, the Edmonds Floretum Garden Club (the oldest garden club in Washington), featured in a recent Edmonds Historical Museum exhibit, celebrated its 100th anniversary in 2022. Looking back at the Station Master's House and the EHM 240.55 image, gardening in Edmonds back in the day appeared even along the industrial waterfront.

Before moving to Edmonds, the Station Master House was near the original Union Oil Docks, further south and closer to Richmond Beach. Pictures from the 1960s show it on Dayton west of 3rd Street S. The City of Edmonds Historic Sites map shows it at its current site on the 1000 block of 2nd Avenue S. Who knows where it will find itself next?

THEN, C. 1920

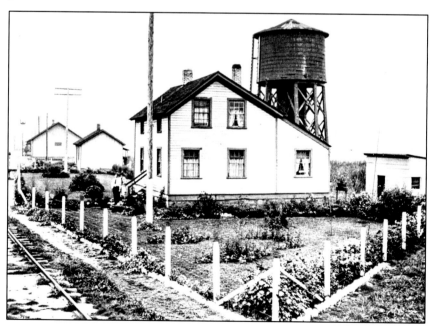

EHM 240.79

NOW

The Station Master's House Lot is Now a Commuter Train Stop, c. 2023

The Station Master's House is Now a Private Residence,
1000 Block of 2nd Avenue S, c. 2023

EDMONDS HISTORICAL MUSEUM EXHIBIT, C. 2023

"Late one afternoon in June 1928, two mayors walked up the railroad track from the Great Northern depot at Edmonds to the ferry dock at the foot of Main street, chatting as they walked. One was Mayor Fred A. Fourtner of Edmonds; the other was the mayor of the largest city in the Western Hemisphere—James J. Walker of New York City. 'Jimmy' Walker had been persuaded by Capt. J. Howard Payne to make his trip to Victoria via Edmonds." – Cloud, *Edmonds: The Gem of Puget Sound*, p. 97

MAJOR FRED FOURTNER AND JIMMY WALKER OF NEW YORK CITY, EHM 232.3, C. 1918

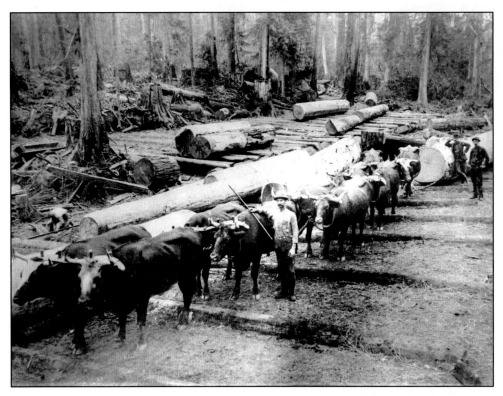
George Brackett and His Oxen Team, EHM 144.12, c. 1890

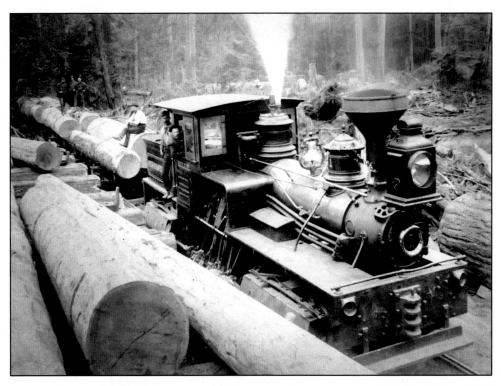
Railroad Logging in Edmonds/Meadowdale, EHM 144.20, c. 1895

THE MILLS

If you close your eyes and imagine Edmonds in the early days, you can almost hear the sound of saws cutting through the towering fir and western red cedar forests that once covered the land. With their saws and axes in hand, early settlers worked tirelessly to harvest the trees and transport them to the mills that dotted the shoreline. Some of the trees were so big that it took several men to fell them, and the stumps left behind were sometimes big enough to be used to build small houses or even serve as dance floors. Of course, it also meant that the dense cedar forests that sustained the indigenous tribes for millennia and that had taken hundreds of years to grow in a short space of time were gone. The land would never be the same.

One of the first logging operations in Snohomish County was located at Brown's Bay near Meadowdale in 1862. At that time, no sawmills were in the area, so the logs were roped together and shipped by water to the Tulalip mill or Henry Yesler's mill in Seattle. It wasn't until 1889, when Washington achieved statehood, that the buzzing of Edmonds' first shingle mill was heard on the waterfront. Built by George Brackett, it could mill twenty-five thousand feet of cedar a day.

EDMONDS WATERFRONT MILLS, EHM 141.39, C. 1910

As timber was logged off the hillsides, additional mills appeared, and soon the shingle mills became the town's backbone. The mills dominated the waterfront with their black smokestacks churning out gray smoke, bundles of shingles, and occasional fires. At the height of the mill activity, there were at least a dozen mills, representing $2.2 million in invested capital (or about $65 million in today's dollars). Many of the Edmonds pioneers owned mills at one time or another, and their employment of local men gave many a start and supported their families. The mills were also an engine that

> "The exciting event of [1902] was the outbreak of smallpox. The council equipped a 'pest house' on the beach and paid the health officer and attendants to care for all who were stricken with the disease." – Ray Cloud, *Edmonds: The Gem of Puget Sound*, p. 22

drove prosperity and growth throughout the Edmonds community. They were a place of constant activity, with logs processed, dried, and shipped out to customers.

You might be wondering who the mill workers were. There was a large Swedish immigrant population that was working in the timber business throughout the Pacific Northwest. There had also been a significant Chinese presence in the industry in the middle of the 1800s, but by the late 1800s, most Chinese had been forced out of the West Coast timber industry by the Knights of Labor (a national labor organization). According to another report, there were about 2,685 Japanese working in lumber camps and sawmills across Washington State in 1907, in about 67 of the 1,263 mills in the State. But after 1907, with anti-immigration movements in the country, this number quickly dropped. It is also true, however, as in many areas, the record keepers hid much of the history of immigrants during this time.

Along with the mills, there were drying sheds and lumber yards, and occasionally other, unrelated businesses appeared along the shore for brief periods. The Washington Excelsior Manufacturing Company, a mink farm, a wrench manufacturing company, boatyards, a builder of barges, and even a firm that sought to make leather from seal and whale skins all came and went. Still, the shingle mills gave the town its character. There were fires, injuries, and layoffs as the economy rose and fell over the years, but the industry remained a constant presence for decades. However, by the 1920s, the shingle mills began to dwindle. By 1923, only five mills were operating.

As local forests were depleted, it became costly to obtain timber from outlying areas, and one by one, the mills shut down until only the Quality Shingle Mill remained. It is shown in the *Then* image EHM 142.21. On June 1, 1951, the boiler fires went out at the Mill for the last time. It had been the Big Swede Mill when father and son C. L. Wiley and D. C. Wiley acquired it in 1893. When sold to a group of Everett shingle weavers in 1915, it became the Quality Shingle Mill, a name it retained for the rest of its existence. In 1913 it shipped 60,000 shingles to Alaska. Today, if you walk along the shoreline, you can still see rotting pilings that are reminders of these mills and the marks the mills left on the character of the shoreline.

When the Quality Shingle Mill shut down, Ray V. Cloud, publisher of the *Edmonds Tribune-Review*, wrote, "The shingle industry was the mainstay of Edmonds through the critical decades when the wage-earner could not travel many miles from his home to find employment; he either found work close at home or moved on to another location." But with the changing times, this "one tall smokestack stood on the waterfront to remind the remaining pioneers of the dozen or more that sent smoke into the sky above the night and scent of fresh-cut cedar and the steady zip-zip of the shingle saws."

As mentioned, EHM 142.21 shows the Quality Shingle Mill after it had shut down, and 140.2 shows the activity of the mills when they were still going strong.

THEN, C. 1953

The Quality Shingle Company, EHM 142.21

NOW

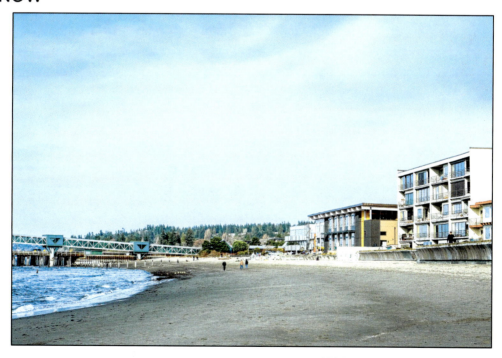

220 Railroad Avenue, c. 2023

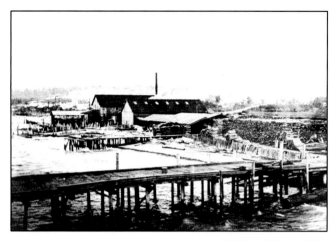

EHM 140.2, C. 1910

The ferry dock is in the distance. The *Now* image shows the landscape of buildings today and the changes made to make the area more enjoyable for those who live here. There is a large condo building in the middle, and next to it, about where the Mill was located, is the new Edmonds Waterfront Center. The Center had been the first non-profit senior center in Snohomish County. In 1972, it was featured at the Second White House Conference as a model for multipurpose senior centers. The concept shaped the formation of thousands of senior centers throughout the country. Edmonds came to own the property and declared it would be a permanent home for a senior center but would also be a community resource. Their vision is to make it "The place community members gather to explore ideas, learn, grow and improve their lives and those of others." It is a fitting tribute to what those earlier mills meant to the emerging town.

A supplemental photo from 1970, EHM 134.3, shows the evolution of the waterfront that replaced the shingle mill. Condos had been built, among other buildings. In the distance, where the mill was (and where the Waterfront Center is now), a dome is in the process of being demolished. The dome had been the Ford Pavilion at the Seattle World's Fair and was moved to Edmonds in 1962. It served as a yacht showroom until the late 60s, as the harbor area accelerated its transformation into the area we know today.

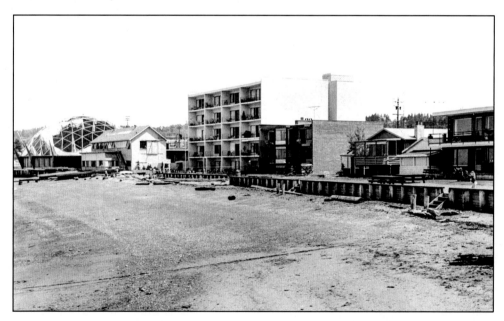

EHM 134.3, C. 1970

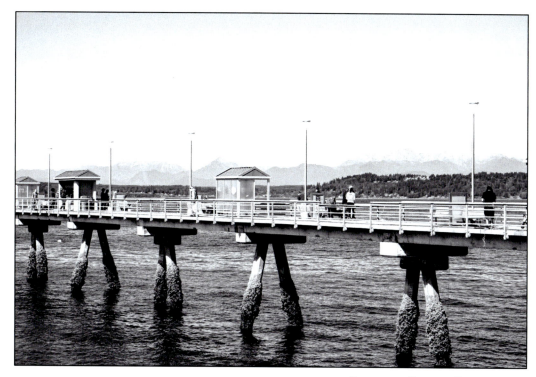

Edmonds Fishing Pier, c. 2022

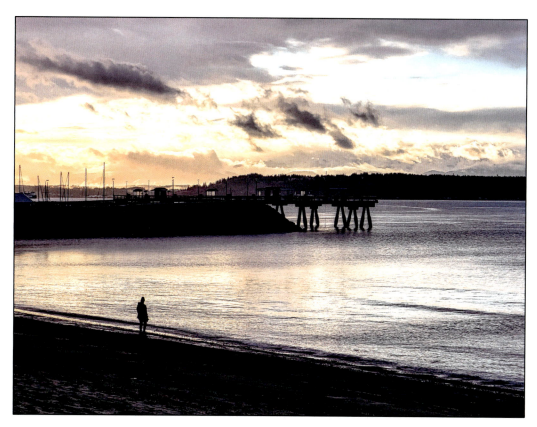

Mill Area Transformed into a Public Space, c. 2022

LOOKING TOWARDS BRACKETT'S LANDING

In the early days of Edmonds, before the ubiquity of the auto and roads to carry them, Edmonds was relatively isolated from Seattle and other major cities both figuratively and literally. Access tended to be by boat, and so a wharf was a priority for Brackett and the early town leaders. The next biggest priority for the entire region, and Edmonds especially, was access to the railroad. From the angle in EHM 130.1, you can see where they came together and were eventually joined by the growing network of roads. Telecommunications and power were even centered in this area.

Today, looking towards Brackett's Landing and the ferry dock, the view resembles the *Then* photo. As with the mill area, however, Edmonds today is turning more of the area into a park where people can enjoy the beautiful view looking out at the Olympics. And it is always possible that seals or orcas might be spotted. In the area to the immediate right of the *Now* picture, Edmonds has even created an Underwater Park (www.edmondsunderwaterpark.com/).

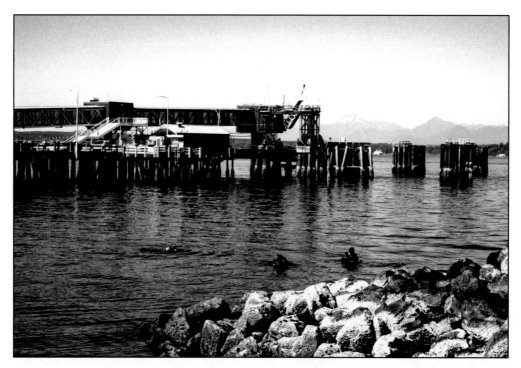

EDMONDS UNDERWATER PARK, C. 2022

THEN, C. 1930

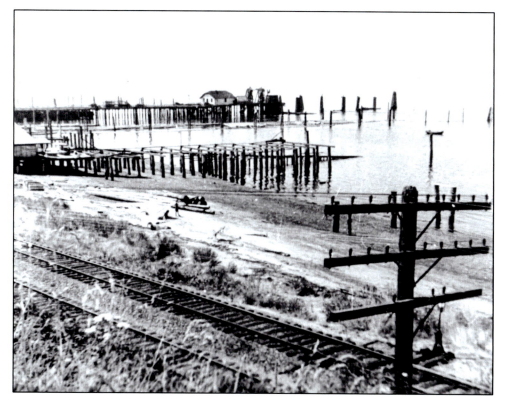

EHM 130.1

NOW

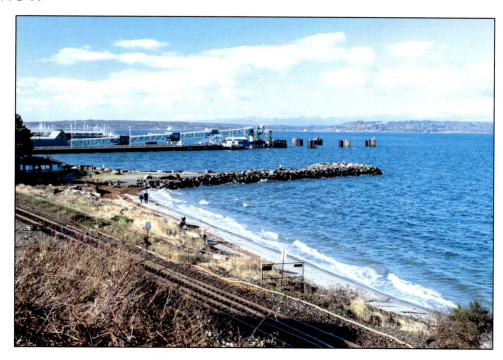

BRACKETT'S LANDING NORTH, 50 RAILROAD AVENUE, C. 2023

NORTH EDMONDS

CASPERS STREET

The *Then* image (EHM 150.138) shows the street identified in the vintage photo as Klossens Took after it was paved. Today it is Caspers Street. I must confess, however, I have not been able to find the backstory of who the Klossens were and what a Took would have meant to the people at the time. The modern name comes from James Caspers and his family, who had a large farm in the area. It is also worth noting that the Edmonds United Methodist Church, the descendant of Hughes Memorial Methodist Church (c. 1924, located on 5th and Dayton), is built on old Caspers farmland. In the *Now* picture, the location of the Methodist Church is up Caspers Street, where detail is lost in the distance.

While the corner is interesting in what has changed and what has stayed the same, you can tell from the early morning walkers that it is also a fascinating viewpoint. It provides an excellent panorama of Puget Sound and the Edmonds shoreline. You'll also find one of the historic plaques scattered around Edmonds, and this one features Missouri Hanna.

Missouri Hanna wasn't a nickname; it was her actual name. She was Mrs. Missouri T. B. Hanna and was born in Texas and grew up in Arkansas. Unfortunately, her husband and a young son died tragically while the family lived in Spokane Falls, Washington Territory. To add to the tragedy, one of her daughters (Mercie) had a bicycle accident and became an invalid. Hanna, who had been running a real estate business after her husband died, decided to bring her two daughters to Edmonds, partly so Mercie could benefit from the sea air. She sold her holdings in Spokane and moved here in 1904. Near where the photos were taken, a street heading out along the

c. 2023

THEN, C. 1917

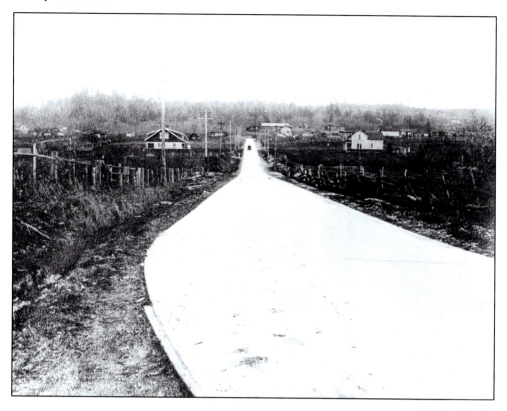

EHM 150.138

NOW

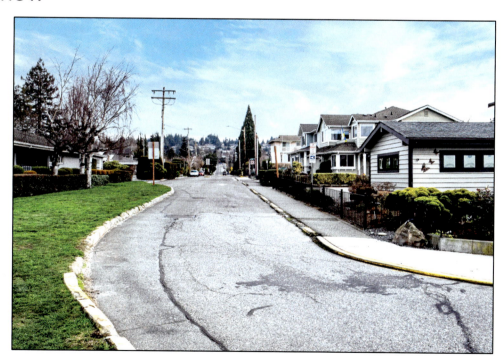

Caspers Street at Sunset Avenue, c. 2022

> In 1910, "Mrs. Anna V. Bassett had the distinction to be the first woman to register in Edmonds after the passage of the woman's suffrage amendment. However, after Registrar [Zophar] Howell had registered three or four women he inquired from the attorney general, to learn that registration of women was not legal until after Governor Hay had proclaimed the law in effect. As this was delayed until after the closing of the registration books, women were denied the vote in the November election, although Mrs. Bassett made an attempt to do so." – Cloud, *Edmonds: The Gem of Puget Sound*, p. 29

bluff called Hanna Park Road honors where she lived.

Hanna left her mark not only here but across the nation. She is known as Washington's "Mother of Journalism." She was the first woman newspaper publisher in Washington when she purchased and ran the *Edmonds Review*. The *Review* was eventually sold to William H. Schumacher, who combined it with the *Edmonds Tribune* to become the *Tribune-Review*. She also published the first suffrage newsletter on the West Coast (i.e., *Votes for Women*) and was instrumental in helping make Washington the first state to recognize women's rights to vote in its constitution.[39]

CASPERS' CORNER

James Caspers' son Anthony owned the Caspers Corner Texaco station on the southeast corner of 3rd Avenue and Caspers Street, opening it in June 1926. Anthony ran Caspers' Corner Texaco for twenty-four years, and he eventually sold it in 1950. The location was at the city limits of Edmonds at the time. Anthony's two sisters, Adrienne and Julia, taught in Edmonds School District #15. While Julia eventually married and retired from teaching, Adrienne continued as a very popular teacher influencing the lives of Edmonds' children for forty-two years.

The gas station shown in EHM 160.221 was probably positioned on the angle of Caspers Street and 3rd Avenue. The building that can be seen behind the gas station is his house at the time, and you can see a little of his Model T towards the rear of the station. Notes on the photo call out the *Everett Herald* newspaper box, the National Mazda Auto Lamps, and Old Gold and Lucky Strike Cigarettes. In the *Now* photo, I have left the tree in the picture. Either the vintage shot intentionally excluded the tree, or the tree has been very happy and has grown quite a lot in the last century.

[39] https://www.history.link.org/file/9029

THEN, C. 1929

EHS 160.221

NOW

Private Residence, Caspers Street and 3rd Avenue N, c. 2023

The S.S. Buckeye was built in Seattle in 1890 and served Edmonds, Richmond Beach, and Seattle. The Buckeye brought the influential Allen M. Yost family from Seattle to Edmonds in 1894.

EHM 2.0

GERDON HOUSE

The Gerdon House (also known as Madrona Manor) was built by Ira Gerdon. While it is hard to imagine from the beautifully restored Dutch Colonial home shown in the *Now* picture, it started as a kit from Montgomery Ward (a competitor of Sears at the time). The house had been manufactured in Chehalis by the Gordon-Van Tine company and arrived in Edmonds by rail. The lumber was pre-cut and numbered, and Gerdon began putting it together in 1922 and completed the house in 1923. This wonderful building was added to the Edmonds Register of Historic Places in 2018.

Behind the house was a holly farm of about 200 trees. Gerdon worked the farm from the 1920s through the 1940s, and shipped his holly worldwide. According to his granddaughter, Joan Gordon, "My grandfather was very energetic and worked the holly farm as a one-man operation."

In 1950, it was the home of Jim and Betty Mueller. Betty was known throughout Edmonds for her volunteer activities, and helped found the Edmonds Police and Fire Foundations. She was also honored by Fire Station #16, which was named in her memory.

The *My Edmonds News* story[40] about the house and the farm shares a memory from Betsy, one of their children, that captures a little of the time from the 50s and 60s. "The holly farm was no longer being worked when we moved in and a cow was pastured in the field with the holly trees. As children we always wanted a horse, so Jim [one of her brothers] and I would ride the cow around instead. She was pretty energetic, and we'd jump Shell Creek together with me on her back! After seeing how much we enjoyed this, my parents broke down and bought a horse."

[40] https://myedmondsnews.com/2016/03/old-edmonds-holly-plantation-gives-way-to-new-homes-enhanced-habitat/

THEN, C. 1922

EHM 180.15

NOW

PRIVATE RESIDENCE, 209 CASPERS STREET, C. 2023

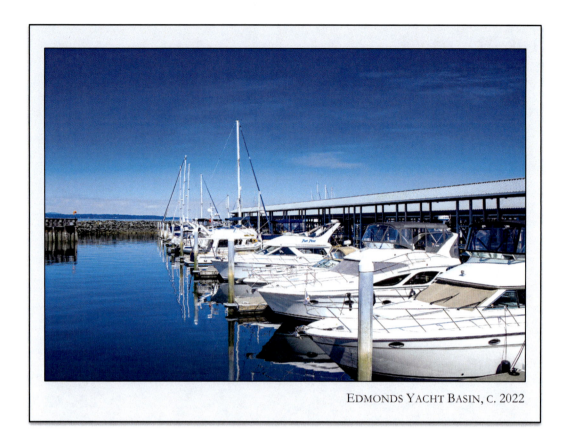

EDMONDS YACHT BASIN, C. 2022

MOWAT HOUSE

Arthur Mowat contracted the house that would bear his name in 1890, and it was completed in 1891. Mowat was a mill owner. The house was built for $500 and is the only house still standing from the original plat laid out by George Brackett in 1884. The house was restored by John Wells in 1975 and is listed on the State Register of Historic Places, and it is sometimes referred to as the Wells House.

Mowat also was elected the first fire chief for the new Volunteer Fire Department in 1904. Alas, Mowat's tenure didn't work out well because on May 4th of that year, there was one motion in the City Council to create a committee to get a nozzle for the fire hose, and another motion creating a committee to ask Chief Mowat to resign. As we say today, apparently, the role was not a good fit.

As a side note, 1912 was not a good year for Mowat either. There was a major fire at this shingle mill in Echo Lake, and in June, his mill here in Edmonds was destroyed by fire. That being said, this was a time when people stepped up despite disaster and pressed on. In 1938 the Mowat Lumber and Shingle Company was still going strong.

THEN, C. EARLY 1900S

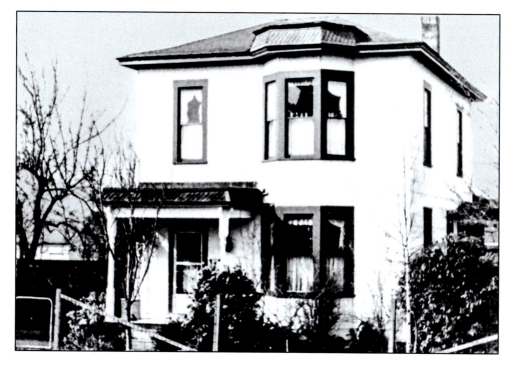

EHM 180.22

NOW

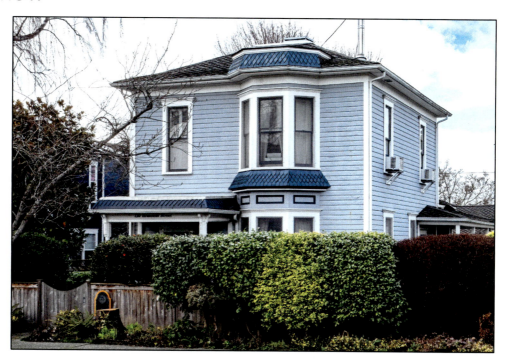

Private Residence, 120 Edmonds Street, c. 2022

BRACKETT HOUSE

"The Fourth of July was the grand reunion day…We had the largest house in the country at that time, and after a dinner in the woods the crowd would usually gather at our place for a dance in the evening. Prayer meetings were held frequently at different homes and these were also made the occasion for general reunions." – Etta Brackett, quoted in the *Edmonds Review*, September 15, 1905

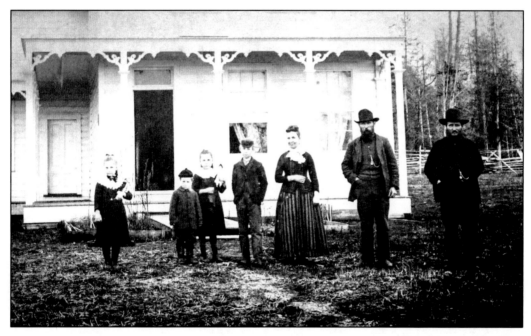

BRACKETT FAMILY PHOTO, EHM 181.1, C. 1890

There isn't a lot of detail about Brackett's house. In the EHM 181.1 image, you can see his family, including (from left to right): Nellie, Ronald, Fannie, George Jr., Etta, and George himself. The last person on the right might be George's brother. I have already provided quite a bit of information about George, but it is also important to learn about his partner in these early years, Etta.

Etta E. Jones was born in March of 1859 in Minnesota, a newly established frontier state. Her father, Edwin E. Jones, was born in New York in 1832, and her mother, Melvina Kennedy, was born in Clayton County, Iowa, in January of 1842. Melvina was the daughter of Ambrose Kennedy and Mary McDowell.

In 1860, Edwin and Melvina moved to Altoona, Nebraska Territory, where Edwin worked as a miner. Etta was one year old at the time. In 1862, Edwin enlisted in the Union and served in the Sixth Minnesota Volunteer Infantry Regiment. In 1864, the regiment was ordered south to join the war against the Confederacy, and they were

THEN, C. 1905

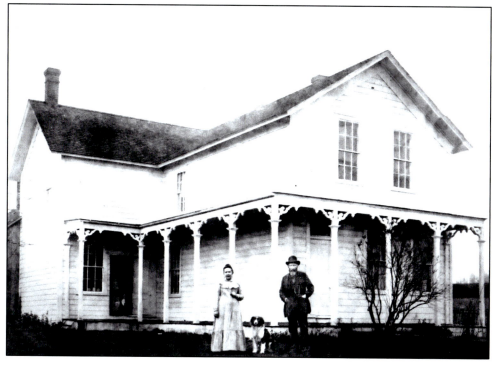

Etta and George Brackett (and Dog), EHM 181.2

NOW

The Breakwater, 300 2nd Avenue N and Edmonds Street, c. 2023

EHM 201.1, C. 1889 EHM 201.7, C. EARLY 1900S

encamped in malaria-infested swamps. Disease took its toll on the regiment, and they lost more soldiers to disease than to battle. Edwin, discharged on Oct. 6, 1864, due to a disability from disease, died in March of 1865, leaving behind his pregnant widow and their 6-year-old daughter. A son, Edwin A. Jones, was born after his father's death.

Melvina applied for and began receiving a widow's pension based on her deceased husband's wartime service. She and her children lived with Etta's maternal grandparents on their farm in Traverse des Sioux, MN. In 1870, when Etta was 11, Melvina married William McKenderie Wixon, another Civil War veteran, and the family lived on a farm in Meeker County, MN. They later moved to St. Paul, MN., where two of Etta's half-sisters were born.

In 1875, when Etta was 16, the family moved west to settle in Kitsap County, Washington Territory. Two years later, still a teenager at 18, Etta married George Brackett in Seattle. George was twice her age, and whatever the backstory, that had to be a challenge. The following year, they moved to a new home on their land in the Ten-Mile Beach Settlement (now Edmonds) with their baby son, George Jr. You can imagine the stresses for this young woman who had been through so much, but she stepped up to her role as one of the founders of Edmonds.

Etta stood by her husband during the development of Edmonds, and she became a leader in introducing culture and helping to shape the logging town as other families arrived. However, the couple divorced in 1905, and Etta married Mr. Carpenter, a vice president of the Edmonds Mill Company and an Edmonds neighbor. The Carpenters lived on Front Street before eventually moving to San Diego, California, where Etta died in 1934 at 75.

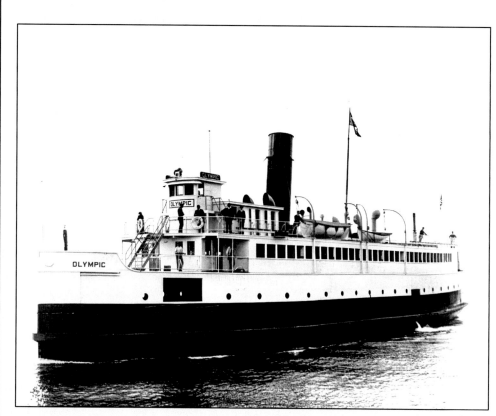

S.S. Olympic, Edmonds To/From Victoria, EHM 3.6, c. 1935

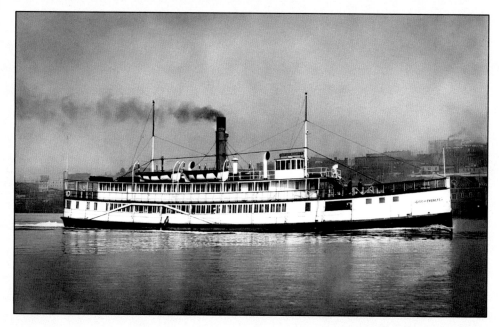

City of Everett, EHM 3.4, c. 1900

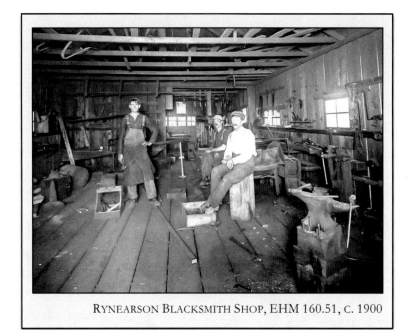
Rynearson Blacksmith Shop, EHM 160.51, c. 1900

BRACKETT'S FEED STORE

"Our first school was held in Mr. Brackett's feed barn, with meager equipment. The seats and desks were double, two pupils in each seat; consequently, we did not always study. We had some fun, too. Miss Houghton taught one term after Miss Morris married. Later we were housed in a small school building, located on a knoll between Third and Fourth Avenues. Note our school grounds---natural tall trees, shrubbery, ferns and beautiful wild flowers---grew back of the schoolhouse. These, we children gathered after school hours for our parents and teacher. Wild berries also grew abundantly over the old stumps and fallen logs. We had no such modern equipment as our children now enjoy." – Mrs. Flora Deiner Koelsche[41]

Brackett's Feed Store appears in the background of many photos of this area of Edmonds, but there aren't many closeup photos from when it was active. The Feed Store was built around 1900. In 1932, W.H. Joslin sold it to Norman Beans & Albert E. Smith. It was eventually sold to Earl L. Smith of Walla Walla, who ran it until he died in 1946. The *Then* image (EHM 160.32), from 1960, wasn't taken long before it was demolished in 1964. The building was getting a little worse for wear at that point.

Besides being an essential service for a community that depended on horses, oxen, and raised cattle, Brackett also made it available to the Edmonds School District #15. As described in Flora's recollections, the first six students in Edmonds met there until a dedicated structure could be built.

[41] Cited by Ray Cloud in *Edmonds: The Gem of Puget Sound*, (p. 10) from a paper read at the Old Settlers' picnic at Hall's Lake, August 5, 1938.

THEN, C. 1960

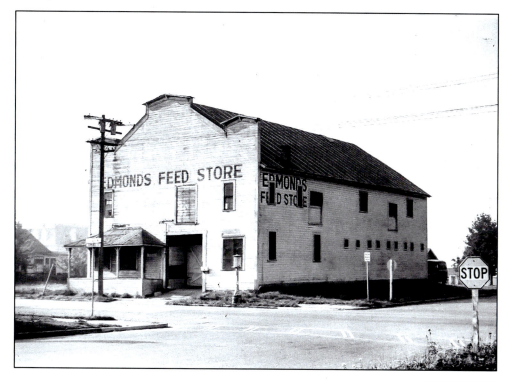

EHM 160.32

NOW

EDMONDS TOWNHOMES AND CONDOMINIUMS, 233 3RD AVENUE N, C. 2023

BISHOP HOTEL

The *Then* image (EHM 150.15) is of Walter Rynearson and Frank Hough leveling Bell Street outside the Hotel Bishop on 2nd Avenue. The Hotel was long a destination for Edmonds visitors.

As the Great Northern Railway moved into town, the Minneapolis Realty and Investment Company bought 455 acres from George Brackett. To get a sense of the scale of the purchase, the $36,000 they spent bought them the entire town of Edmonds plus adjacent land. The company re-platted the town. They built a new wharf and a small office building (that later became a post office), and in 1890 they constructed the Bishop Hotel in anticipation of the growth in the area with the railroad coming through. The Bishop Hotel was named after James H. Bishop, the Minneapolis Realty and Investment Company president. When Allen M. Yost arrived as a young carpenter, the Hotel was still under construction, and he got his first job working on it.

The Hotel was Edmonds' first three-story building (excluding the cupola on the Hyner home). Unfortunately for the Investment Company, there was a depression, and of course, business downturns are still happening. Brackett, ever the savvy businessperson, foreclosed on them and repossessed what he had sold. Mr. and Mrs. W.S. Stevens acquired the hotel from Brackett and completed the work on it. When it opened on April 16, 1894, the Stevenses changed its name to the Stevens Hotel. There was a grand opening gala to celebrate, and it was *the* event to attend.

EDMONDS HISTORICAL MUSEUM EXHIBIT, C. 2023

By 1908 it was known as the Olympic View Hotel and was owned by Mrs. Annabelle Turner.[42] She had bathrooms and other improvements installed and turned it into one of the best hotels in Puget Sound. Fine banquets and Sunday dinners distinguished it. While it changed hands several times, trains would stop in Edmonds for many years so that people could dine at the hotel. It was also a place where some of the shingle mill workers boarded.

After WWII, the Hotel was remodeled into ten apartments and operated as the Olympic Apartments. In 1975, it was finally demolished, and the Harbormaster Condominiums building in the *Now* photo took its place.

[42] At this point, you should be recognizing the many Edmonds properties and businesses at the beginning of the 20th century that were owned and being run by women. This is in addition to all the activities many women were driving that were critical in turning a pioneer town into a modern city.

THEN, C. 1902

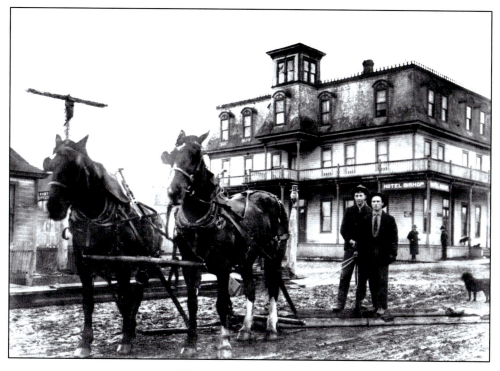

Grading in Front of the Bishop Hotel, EHM 150.15

NOW

Harbormaster Condominiums, 200 2nd Avenue N, c. 2022

SORENSEN'S BLACKSMITH SHOP

Today we need auto repair shops to keep the cars running that our modern world depends upon, and occasionally computer experts to help with the tech in the cars as well. Then, the auto was the horse; you needed blacksmiths to keep them "running" well. One of the earliest in Edmonds was Ole C. Sorensen. He arrived from North Dakota with his young bride, Anna, in 1889. He initially found work as a smith in a logging camp, but by 1892 he had opened his own blacksmith shop on the northeast corner of 3rd and Edmonds. He was in business for fifteen years until he got into the shingle mill business and opened his mill near Echo Lake. He was elected to the City Council in 1902 and became vice president of the State Bank of Edmonds (our first bank). Sorensen is another example of that entrepreneurial spirit of the day that lets many people start in one place and end up in another.

In the *Then* photo EHM 160.25, Sorensen's sons may be sitting in the wagons. An earlier picture of the Sorensens in front of their home is shown in EHM 180.28. It includes in the buggy: Ralph and Otto (children of O.C.) and Mildred and Edna (cousins of Ralph and Otto). Standing behind the fence are (left to right) Ed Sorensen's wife (O.C.'s brother's wife), Ed Erickson, O.C. Sorensen, and Anna Sorensen (Mrs. O.C.).

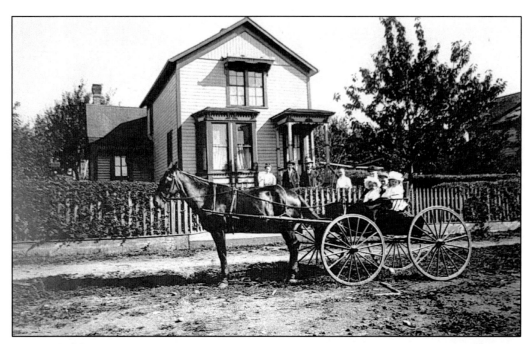

Sorensen Family and Residence, EHM 180.28, c. 1900

THEN, C. 1906

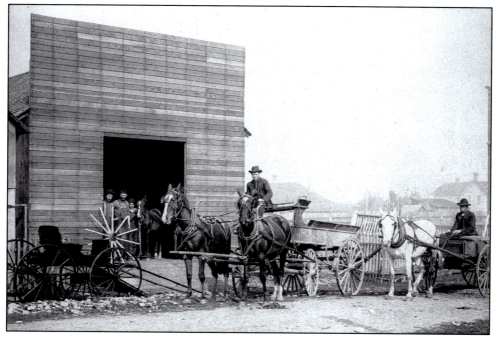

Sorensen's Blacksmith Shop, EHM 160.25

NOW

3rd Avenue N and Edmonds Street, c. 2022

EDMONDS HIGH SCHOOL

Groundbreaking for the Edmonds High School happened on October 14, 1909. Prof. W.H. Dorgan, who served as the Principal, and other teachers followed a plow along with a double team of horses to break the ground. Edmonds High School played its first football game even before the cornerstone was set. Unfortunately, they lost to Ballard 33 to 5, but the excitement of the events probably distracted them. Local celebrities Col. S.F. Street, Prof. Dorgan, Rev. John W.H. Lockwood (the first librarian for Edmonds and responsible for the Carnegie Library being built), and Etta Brackett all spoke.

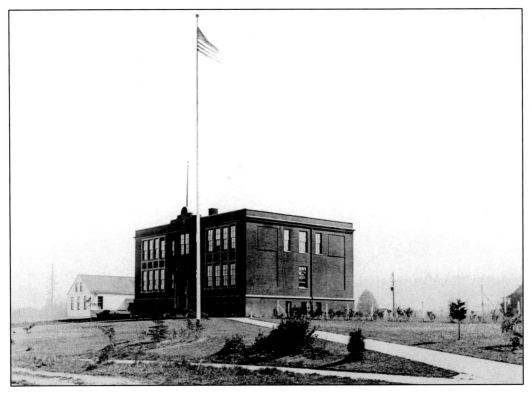

EHM 102.19, C. 1912

Until 1933, when the District organized its bus fleet, Yost Auto Company supplied transportation to get students from outlying areas to the school. The next big milestone was October 23, 1937, when their new athletic field was dedicated. It had been one of the WPA projects that had transformed the nation at the time and just this year was refreshed as the new Edmonds Civic Field.

With the post-WWII baby boom explosion, by 1955, the High School could not handle the increasing enrollment even with the additions that had happened. A new, lovely art deco building was built and opened on November 11, 1957, but in fact, the workmen were still putting finishing touches on the building even as people were moving in. There was some controversy around the new building as a few parents felt that the new open corridor design in the building would cause their kids to catch colds.

THEN, C. 1957

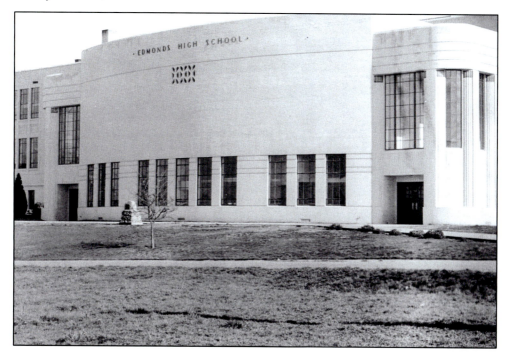

EHM 102.18

NOW

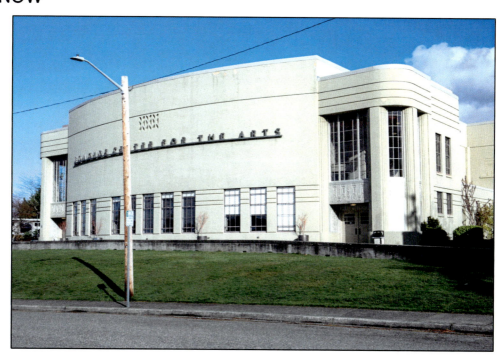

EDMONDS CENTER FOR THE ARTS, 410 5TH AVENUE N, C. 2023

Interestingly, the cornice over the front door of the old building was reused in the design of the new building, and a marker was placed in front of the new school to show where the flagpole in front of the old school had been (i.e., that small pyramid of rocks in the *Then* photo). It may have been an attempt to give the community a sense of continuity from a school that meant so much to so many. We still see the commitment parents and kids have when changes threaten beloved schools.

Still, it was almost impossible to keep up with the demand. From 1957 to 1969, District enrollment increased by 1500 to 2000 students yearly. They had to open a new high school every three years, and a new junior high every two years. Some of this growth was tied to Boeing. Many people living in Edmonds were working at the Mukilteo Boeing plant. But when Boeing lost the SST (supersonic transport) contract, it not only devastated Seattle, but the impact was also felt here. People moved away as fast as they had moved into the area. Edmonds Elementary was closed in 1972 as a result. Two school funding levies failed in the spring of 1976, and almost a quarter of the teaching staff was laid off.

CORNICE FROM THE OLD HIGH SCHOOL, C. 2023

In 1983 the School Board decided to close Edmonds High School, although because of the outcry of parents and students, the process took until 1990 when it was merged with Woodway High School. The cornice from the original building that had been reused in the new High School when it was first built now stands at the entrance to Salish Crossing.[43]

In 2001, the site of the Edmonds High School was purchased by the Edmonds Public Facilities District to develop a regional arts center. The 1939 auditorium was preserved, as was the exterior look of the building. The Edmonds Center for the Arts opened in 2006 in the building. You can still find graffiti in the stage's wings from the generations of students that performed there.

[43] Salish Crossing is located at 190 Sunset Avenue, and among other delights, includes the Cascadia Art Museum.

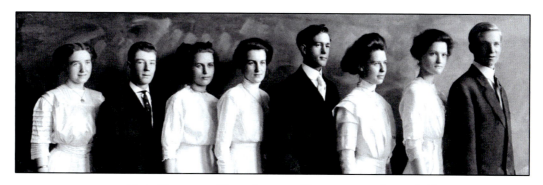

First Edmonds High School Graduating Class, EHM 102.27, c. 1911
Left to Right: Myrtie Rynearson, Elias Cook, Anna McKillican,
Ethel McKillican, Earl Sweet, **Frances Anderson**, Anna Holmes, Oscar Johson

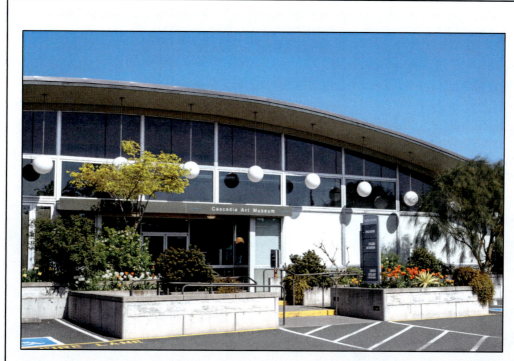

Salish Crossing and the Cascadia Art Museum, c. 2023

HIGH SCHOOL FIELD

The *Then* photograph (EHM 236.1) shows the Edmonds High School field, and the Field House can be seen at the far end of the field. The field began as a WPA project in the early 1940s and is now the Edmonds Civic Field. Looking further, you can see the High School from around June 1963. The activity on the field is probably a little league jamboree. Today the Field House is used by the Boys and Girls Club, and the field has just completed a major renovation.

I searched in vain for pictures of some of the vintage football, baseball, and other games on the field. It appears that past teams were mostly honored in more formal portraits rather than the action shots we tend to prefer today. My spouse did note, correctly, something that might have occurred to you. The cameras back in the early 1900s did not handle motion well.

Readers will all know what women's basketball and men's football teams look like today, so you can compare them with the uniforms they wore back in the day. Two team shots in their uniforms that at least capture a little of the spirit of the time are shown in EHM 103.25 and EHM 103.16. The Edmonds Athletic Club Girls Basketball Team photo (on the page following the fields) includes Francis Anderson (holding the ball), after whom the Francis Anderson recreation center was named, and Eathel Engel (in the upper right), who ran what is now Engel's Pub for many years.

EDMONDS HIGH SCHOOL FOOTBALL TEAM, EHM 103.25, C. 1932

THEN, C. 1963

EHM 236.1

NOW

Edmonds Civic Field

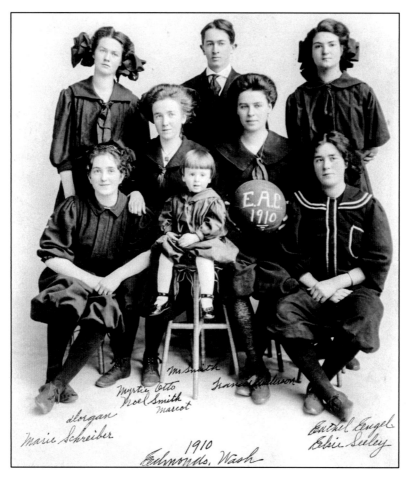

ATHLETIC CLUB BASKETBALL TEAM, EHM 103.16, C. 1910

PHILLIPS MOTOR COURT

In the early 1900s, part of what helped Edmonds and its surrounding areas thrive was the popularity of automobiles and the growing network of roads, highways, and auto ferries that supported them. The Aurora Bridge was the final link on the Pacific Highway (later known as US 99) running up to Canada. It was completed in 1932, on February 22nd (George Washington's 200th birthday). But drivers weren't cruising along at 70 miles per hour. They needed rest stops, and the Phillips Motor Court was constructed to meet that need by Donald Phillips in 1941. It gave motorists a place to sleep and for their cars to dry out when necessary. Donald's father had operated the Edmonds Dye Works, and Donald became manager after his father passed away. He was involved in several other Edmonds businesses and local activities, such as the Boy Scouts, but what we would think of today as an early motel was a legacy left by Phillips that we can still salute.

THEN, C. THE 1940S

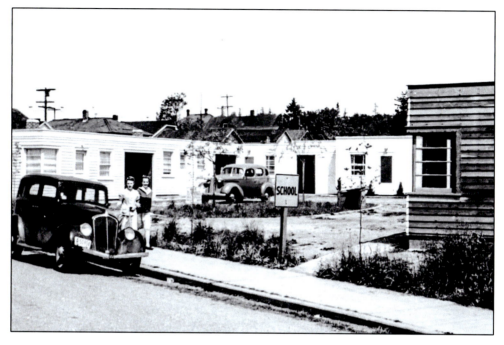

EHM 160.254

NOW

EDMONDS APARTMENTS, 304 4TH AVENUE N, C. 2023

Edmonds Classic Car Show, c. 2016

Welcome to Edmonds Sign, EHM 150.142, c. 1975

Early Women's Clubs

One early Edmonds Club was the Coterie Club, which emerged from the Book and Thimble Club. It was one of the earliest influential groups planting the seeds of the Edmonds we know today. It was organized on September 24, 1909, by a group of leading women in the community to bring "attainment of higher literary culture" to Edmonds. (Cloud, *Edmonds: the Gem of Puget Sound*, p. 130), with a clear emphasis on nourishing the growth of culture here and joining efforts for civic social betterment. They met at the home of Mrs. Kate Beeson, who became its first president. Early programs included discussions of various countries and biographical sketches, and they took part in selling WWII Liberty Bonds, as well as many other community activities (including sponsoring the Campfire Girls and Bluebirds).

They were formally incorporated on February 3, 1927, and they purchased lots for a building. The First Church of Christ, Scientist, gave them a building they were no longer using in August 1928, and the building was moved to the new property. Various church groups and other organizations also met in the building over the subsequent years.

One area where they were particularly active was encouraging the arts in Edmonds. Early on, they supported exhibits of artists' works on loan from the Seattle Art Museum. They also promoted local artists. In 1958, JoAnne Warner, then president of the Coterie, learned of space available on the second floor of the Surf and Sand Marina. During the week of May 19 to 24, 1958, an exhibit was held. Warner referred to it as a "haphazard but well-meaning art exhibit." That hastily organized event became what we now know as the Edmonds Arts Festival, one of the Seattle region's premier art festivals.

Alice Kerr (nee Lewis), in the early 1920s, was elected president of the Coterie Club and actively represented Edmonds at the state level. In 1924, she was persuaded to run for mayor as a write-in candidate, and she beat the incumbent Mayor Matt C. Engels by two votes. She became Edmonds' first woman mayor.

Another was Floretum. The Edmonds Floretum Garden Club is the oldest garden club in Washington state. It was founded in 1922 by Anna V. Bassett and other residents. Anna had been interested in creating a group as a rose appreciation club. An early special focus was on beautifying Main Street. In 1925, a poll was conducted in Edmonds to pick a city flower, and even then, there were many choices. Two flowers that are still ubiquitous in Edmonds, the rose and the dahlia, tied. Anna, of course, preferred the rose, but the majority vote of the club ended up being for the dahlia.

> "If I could only put on paper just what Edmonds looked like…Main street was what they called a corduroy road which was logs from one foot to a foot-and-a-half in diameter split in half laying the rounded side down in the mud. There were only a few houses on either side of the street up to Seventh. The Improvement Company built some between Seventh and Eighth. Along the waterfront between Main and Bell, Mr. Hyner had a little general store, and a Mr. Holmquist had a sort of hotel on the corner of Bell and Second and in between 'twas solid with saloons." – Maude DePue Arp's impressions from around 1890, cited in in John Swift's *Brackett's Landing: A History of Early Edmonds*

NORTHSIDE CHURCHES

For most new pioneer communities, there tended to be two anchors for social life. One was the saloons,[42] of course, but as men brought their families to town, churches and lodges became a critical part of the social life and a kind of "civilizing" influence on a maturing town. Three early churches on the north side of town were the First Baptist Church, Holy Rosary Catholic Church, and the Free Methodist Church (which was acquired by the First Church of Christ, Scientist).

FIRST BAPTIST CHURCH

The First Baptist Church building was built in 1909 and is the oldest church in the central part of Edmonds. It was constructed on a small lot at 6th Avenue N and Edmonds Street (then known as Hebe Way) but moved to its present site at 4th Avenue N and Bell in 1929. At that time, a basement was added to provide more space for the congregation. Later a house was moved to the property as a parsonage, and eventually, it was attached to the church itself. It is typical of many churches in New England and is now owned by **North Sound Church**.

The Baptist Church began in 1909 when a tent meeting came to town. Traveling evangelists typically ran tent meetings. Methodists, Pentecostals, and Baptists often led the earliest ones, and by the 1900s, they were happening all around the West. Out of those Edmonds meetings, ten people banded together to create a church. The first pastor of what became the Baptist Church was Reverend J.J. Payseur.

One of the notable members of the church was Alice Kerr. She moved to

[42] Peter Blecha and Brad Holden document some of this time in *Lost Roadhouses of Seattle*, including the influence on the Edmonds area during Prohibition. According to Holden, "Pretty much every corner on every block [of Seattle] was a saloon or a brothel or a gambling parlor or a boxhouse…It was quite the place back then." A *boxhouse*, by the way, was a kind of combination theater for light entertainment and a brothel, and was an antecedent of later vaudeville. Seattle was a center for all kinds of vice. As new roads such as Highway 99 and the Bothell-Everett Highway expanded saloons and speakeasies followed, and of course urban influences still travel those highways today.

Edmonds in 1919 and was active in the church (including at the state level). She was a champion of reform during the Prohibition era and eventually became the first woman mayor of Edmonds. Her grandson James (serving in the Philippines) was Edmonds' first casualty in WWII.

There was a bit of a controversy in the late 1980s around the Church. A Lebanon Cedar tree had been planted at the turn of the century and had grown and aged. It can be seen in EHM 123.1. It had become, some felt, a danger to the neighborhood if there was a big windstorm. Edmonds removed the tree in 1986.

THEN, C. THE 1950S

FIRST BAPTIST CHURCH, EHM 123.1

NOW

NORTH SOUND CHURCH, 4TH AVENUE N AND BELL S, C. 2023

HOLY ROSARY CATHOLIC CHURCH

Holy Rosary Catholic Church began holding services in its original church between 6th and 7th Avenues on the north side of Daley Street in 1906. Holy Rosary's bell ringing is remembered by many people who have lived here since their youth. **Holy Trinity Edmonds** (an Anglican congregation) now occupies the building and began its services there in 2014. Holy Rosary Catholic Church moved to a larger campus north of Main on 7th Avenue.

THEN, C. 1906

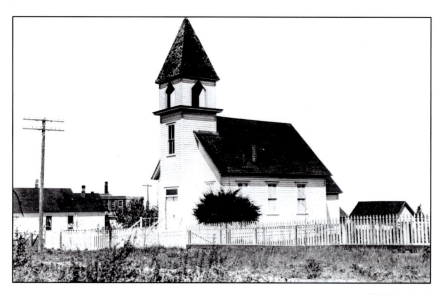

EHM 121.1

NOW

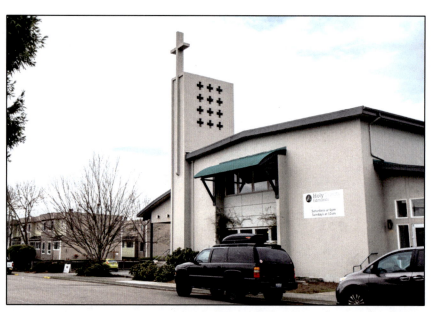

HOLY TRINITY EDMONDS, 657 DALEY STREET, C. 2022

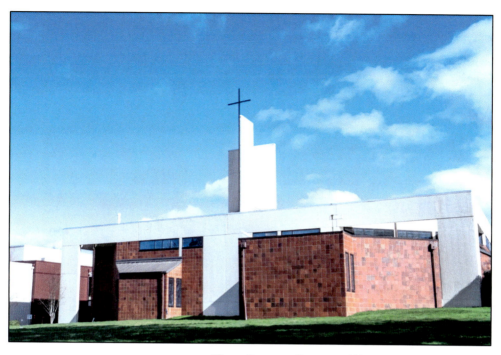

Holy Rosary Church, 630 7th Avenue N, c. 2023

Sunset from the Edmonds Shore, c. 2022

FIRST CHURCH OF CHRIST, SCIENTIST

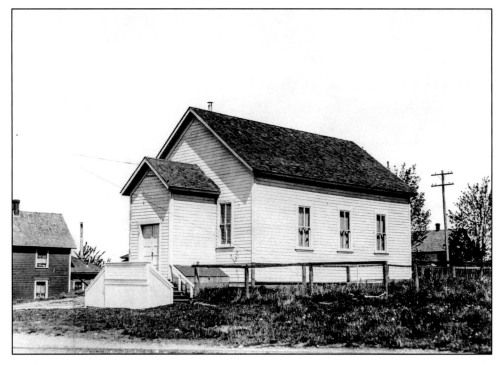

FREE METHODIST CHURCH AND THEN FIRST CHURCH OF CHRIST, SCIENTIST, EHM 125.1, C. 1922

EHM 125.1 shows the original **Free Methodist Church** building at the 5th and Bell location. The **First Church of Christ, Scientist** acquired the building in 1922. The First Church then moved the building two lots east and built their new building, shown in EHM 152.2. The new building had a very simple but distinct character. On April 7, 1929, they held their first service in the new building. The City of Edmonds eventually acquired their building for offices in the 1960s, and the First Church moved to a larger church on the south side of Edmonds on Maple. The new First Church of Christ, Scientist building is shown in the *Now* pictures.

The space originally occupied by the First Church of Christ, Scientist building in the *Now* picture is between City Hall and various City buildings (e.g., Police Department, Court, and Fire Department), close to the Centennial and Veteran's Plazas. Three flags are currently flying there. The US flag, the City of Edmonds flag, and the POW/MIA flag. The *Now* photo was taken on March 29, 2023, one of the tragic moments in recent history. The flags are flying at half-mast by order of the President and the Governor in honor of and to remember the three children and three adults killed at the Covenant Christian grade school in Nashville, TN on Monday the 27th. Days like this for people of faith are definitely when healing and prayer are needed.

THEN, C. 1928

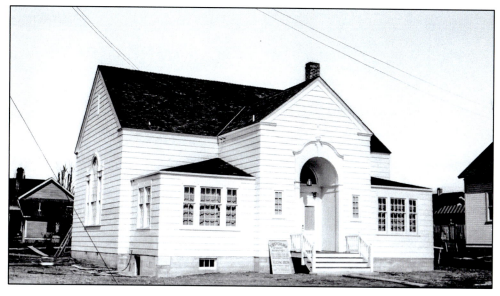

FIRST CHURCH OF CHRIST SCIENTIST, EHM 152.2, C. 1928

NOW

ON 5TH AVENUE N AND BELL STREET, BETWEEN THE CENTENNIAL PLAZA AND THE VETERANS' PLAZA, C. 2023

First Church of Christ, Scientist, 551 Maple Avenue S, c. 2023

OTHER NORTHSIDE HOUSES

Besides those we have shown so far, other houses are worth tracking down if you have time or need to get more steps in during a walk. Edmonds has a "Stages of History: A Walk Through Time" tour that can be taken.[43] The Edmonds Historic Preservation Commission also lists historically interesting houses; the current register is available on their website.[44] Examples of other interesting houses include the following:

- The Allen House[45] (1906) at 310 Sunset Avenue N- An example of the Queen Anne Free Classic style
- The Roscoe House (1889) at 133 4th Avenue N – Built by Edmonds pioneer C. T. Roscoe, Sr.
- Briggs House (1920) at 131 3rd Avenue N – A Craftsman Style bungalow
- Becklund/McGibbon House (1901) at 115 3rd Avenue N – Known as the "Chestnut House" because of its tree
- The August Johnson House (1905) at 216 4th Avenue N – A Queen Anne-style house
- Bettinger House (1907) at 555 Main Street – Exhibits Queen Anne details
- Hill House (1901) 757 Main Street – An example of Colonial Revival style

[43] https://www.edmondswa.gov/cms/one.aspx?portalId=16495016&pageId=18083454
[44] https://www.edmondswa.gov/cms/One.aspx?portalId=16495016&pageId=17272238
[45] https://patch.com/washington/edmonds/allen-house

There is a plaque outside of 216 4th Avenue N that talks about the houses along that road, and others in the surrounding neighborhoods. It is one of the plaques that mark the Edmonds Stages of History tour. The house itself was owned by August Johnson, and was built in 1905. Originally it had been located on the opposite side of the street. While there are a variety of styles on the street that typify the homes built early in the 1900s, the Johnson house has some delightful Queen Anne style elements. The decorative shingles, the wide hip-roof porch, and the elaborate carved brackets. When these houses were built in the early 1900s, the mills were going full blast. Lumber was easily available, the many of these wood frame houses built on post and pier foundations were constructed with designs that reflected the aspirations and personal brands of the owners.

This building style also lent itself to moving houses around as needed, and that frequently happened over the last century. One important reminder in the Stages of History tour is this is the kind of neighborhood that reflected the life of the community. On a warm summer evening, 4th Avenue would have been filled with children playing games, riding their bicycles, skating, and dreaming of their futures. Today, 4th Avenue is also part of the Fourth Avenue Cultural Corridor that is included in the Edmonds Creative District development. It also houses the Luminous Forest art installation, a collection of lights embedded in the street that transform the street as the weather and daylight changes.

Another Edmonds Home Builder,
Edmonds Historical Museum Exhibit,
c. 2023

Pictures of stump houses and constructions in the northwest were popular in the early 1900s, and they also reinforced the brand of the abundance of natural resources here. This one was from Snohomish County, up near Arlington, and was a viral image of the day.

JUST FOR THE FUN OF IT "PIONEER DAYS IN WASHINGTON,"
EHM 180.245, C. 1900S

The Edmonds Monorail

"When passenger service commenced on the Seattle-Everett Interurban in 1910, an attempt by Edmonds leaders to add a connection to the lines proved unsuccessful. But, in 1911, a glimmer of hope arrived.

"W.H. Boyes contacted civic leaders with the idea of establishing an inexpensive, fast and efficient mode of transportation, which would be 'expected to travel 60 miles per hour.' The Boyes Monorail Company was formed and the group obtained a 25-year franchise from the City Council; and, a line between Edmonds and Seattle was planned. Third Street, between Main and City Park, was settled as the location and on May 2, 1911 a civic celebration was held as the first post was placed in the ground. The excited crowd tossed copper and silver coins into the hold for luck, while speeches were given by Mayor Thomas Hall, and other influential residents. Mr. Boyes was also on hand predicting the line would provide 'ten-minute transportation to Seattle at a 10-cent fare.' Following, one mile of road was completed, and the monorail car, built and stored in Seattle, was awaiting its trial run.

"Unfortunately, some things are too good to be true. It seems Boyes had come to the area to promote his monorail invention, gaining capital, but lacking any particular technical knowledge. By late 1911, Boyes was making court appearances and ordered to pay back stockholders at his Pacific Railway Company. According to oral history records, in late 1912 the posts were removed at Edmonds, the company declared bankrupt, and the Boyes Monorail was history." – Katie Kelly Director, Edmonds Historical Museum

BOYES MONORAIL EDMONDS COMPANY CONCEPT, EHM 240.8, C. 1911

EDMONDS SPRING FEST AT FRANCES ANDERSON CENTER, C. 2023

EAST ON MAIN STREET

By the 1940s, development looking east on Main Street was settling into the look we see today. Some of the buildings, of course, date back much earlier. But as you head up to the edge of *the Bowl*, you are clearly heading out of the traditional downtown. Some of the buildings that can be seen looking east from 5th Avenue and Main Street in the *Then* shot (EHM 150.110) include Edmonds Diesel, Mode O'Day, Sears, a Flower Shop, and the IOOF Building on the right. On the left, you can glimpse the corner of the Safeway in the Schneider Building and Wellers Men's and Boy's Shop, among others. Many small businesses have come and gone in this area over the years, depending on the community's needs.

THEN, C. 1962

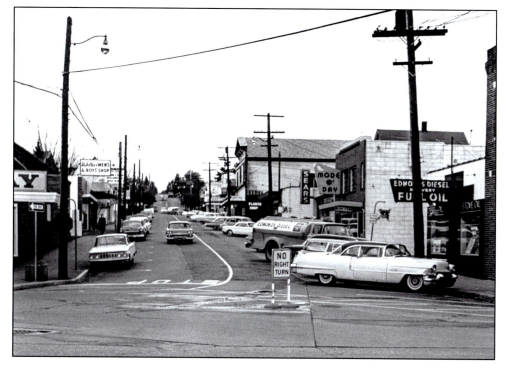

EHM 150.110

NOW

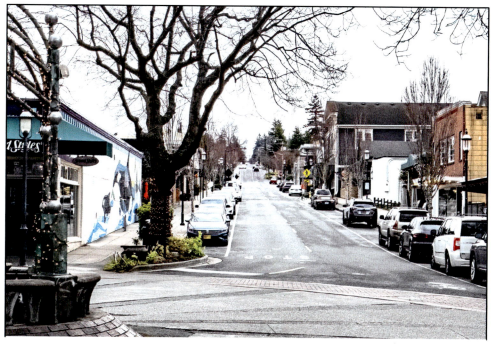

Looking East on Main Street, c. 2023

IOOF HALL

The Independent Order of Odd Fellows (IOOF) was the first fraternal order organized in Edmonds (in April 1891), and the Crystal Rebekah Lodge was created in April 1894. Its mission is to promote personal and social development, with "dedication to improving and elevating character; making the world a better place; and promoting goodwill and harmony." One of my grandfathers had been placed as a young boy in the care of the Odd Fellows in Eastern Washington, since his father, a farmer, had lost his wife and couldn't care for all ten kids. One of their pledges was to "educate the orphan." That spirit would certainly be important in rural and pioneer America, where life could be rough and short. By 1889, the Odd Fellows was the largest of all the fraternal organizations in the United States.

> "The Star Theater, operated in the Odd Fellows' hall by Orton & Weber of Seattle, offered Edmonds people their first movies, beginning in February, 1909. Each show lasted all of an hour, and featured illustrated songs by Orma Orton, with music throughout the show by an electric piano. Admission prices were 10 and 5 cents." – Cloud, *Edmonds: The Gem of Puget Sound*, p. 30

Shortly after the local chapter in Edmonds was founded, they constructed a large two-story wood frame building. The lower floor was used as the community hall. At times church members would meet there while their churches were under construction. Daniel "Dan" Martin Yost stands on the left in the *Then* picture (EHM 160.65). Looking carefully, you can see the same trim in the upper left of the earlier picture when you look for it in the building shown in the *Now* picture. The bones of the old building are still there, and the building is occupied today by Reliable Floor Coverings.

In the early days of Edmonds, the IOOF Hall was a key organizational center. It was used for dinners, lectures, musical and dramatic theater productions, and other events within the community. As you might guess, political rallies and road shows were held in the Hall. The first motion picture in Edmonds was shown in the Hall in 1909. Another IOOF service, however, that might be unexpected was burials.

According to Gaeng and Janacek's pamphlet on the Edmonds Memorial Cemetery and Columbarium history,[46] Thomas White arrived in Edmonds as a young man in 1887, moving here from Pennsylvania with his wife, Mary, their children, Mary's parents, and a large extended family. He homesteaded 160 acres of forest in what we think of as the Westgate area today. He was one of the founding members of the Edmonds Lodge No. 96, IOOF, organized in 1891. Life was tough in those early days and many of the lodges that people were affiliating with had programs to create cemeteries for their members. The first recorded burial on White's land was a 13-year-old schoolgirl named Josephine Legary. She died from complications of tuberculosis. From 1892 to 1894, additional Edmonds citizens were buried on his property, and

[46] Gaeng and Janacek, *A Place of Tradition: Edmonds memorial Cemetery and Columbarium*, pp. 4-26.

THEN, C. 1914

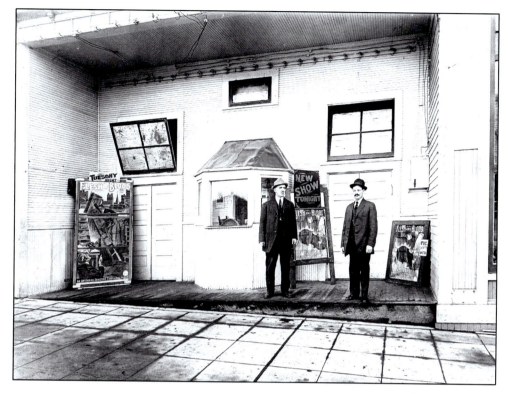

EHM 160.65

NOW

Reliable Floor Covering, 542 Main Street, c. 2022

their gravestones can be found there. In 1894, the IOOF purchased 4.25 acres from White, and the property was recognized as the IOOF Cemetery. Early on, however, it was often known as the Edmonds Cemetery. John Archibald Bish, a logging contractor living in Richmond Beach (where I grew up), was hired to clear the trees from the property in 1900.

With all the early pioneers and other notable Edmonds citizens buried there over the years, in 1972, the cemetery was placed on the Washington State Register of Historic Places. Another key addition happened in 2018 when the Snohomish County Veterans Memorial Monument was moved from a temporary location near the Edmonds Historical Museum to the cemetery. The more than 7,000 burials in the Cemetery include 14 of Edmonds' mayors, many pioneers, and 500 veterans from wars going back to the Civil War. The Cemetery is also the resting place for George Brackett, John Lund, the Deiner Family, Fred Fourtner, Christopher Roscoe, Carrie Yost Astell, Matthew Hyner, Lawrence Hubbard, Flora Smith (who taught the class that became the first church in Edmonds), and other early Edmonds pioneers whose buildings and businesses have been mentioned.

In 1982, Lawrence "Larry" Hubbard, a member of the Hubbard family that has been so influential in Edmonds' history, purchased the cemetery and deeded it to Edmonds along with a trust fund to support it. The Hubbard Foundation continues to provide grants to support it, and the Edmonds Memorial Cemetery and Columbarium is a uniquely beautiful place for loved ones and those we honor to rest in peace. The Cemetery located at 820 15th Street SW is definitely worth visiting. On Halloween, sometimes "ghosts" come to share stories of the pioneers.

One other Edmonds pioneer is worth noting here. Col. Samuel F. Street was active and visible throughout Edmonds in the early years. He had served in the Civil War and eventually moved to Seattle from Detroit after the war. In Seattle, he started a bookstore and leveraged it to buy some property in Edmonds. In Edmonds, he ran real estate and insurance businesses, was Mayor for a while, and was in demand as a speaker. He was also a member of the IOOF. Interestingly, one of the roles Street played is perhaps as Edmonds' first undertaker. He certainly advertised those services, although there is no evidence that he was either trained or had previous experience in the role. Perhaps the combination of dealing in real estate and insurance suggested managing the final resting place was a natural extension of what he was already doing.

COLONEL S.F. STREET, EHM 232.6, C. 1909

In 1899, Street passed on the undertaking role to John Thomas McElroy and his wife, Emma. They had moved here from Snohomish in 1899 and started their Undertaking Company in 1903. Like Col Street, McElroy was also a member of the IOOF. He served as the undertaker, and Emma was his assistant. They also employed a licensed embalmer, which itself was a step up for a young city. One of their ads read, "Just received a full line of undertaking goods and samples. We are prepared to give the citizens of Edmonds, Richmond Beach and vicinity, goods at cheaper rates than can be found in Seattle and Everett. We also furnish carriages and a hearse at the lowest rates. Night calls promptly attended to. Goods at E. H. Heberlein's store."

GEORGE BRACKETT'S GRAVE, C. 2023

The 1918 flu pandemic devastated the nation. Many military deaths were not due as much to battle injuries as to the influenza virus. Since there wasn't a vaccine to protect people, the steps used during the early days of the COVID pandemic were the best people could do. Many, but not all, cities put into place isolation, quarantine, face coverings, limits on public gatherings, and guidance on hygiene and use of disinfectants. Seattle and Everett implemented regulations to protect people, but Edmonds did little other than to shut down schools for three-weeks. At the time there were only about 1000 residents in the Edmonds area, and so there was a kind of natural social distancing that undoubtedly helped. There were about twenty-two recorded deaths from the influenza virus, and fourteen are buried in the Edmonds Memorial Cemetery.
– See Gaeng and Janacek, *A Place of Tradition: Edmonds Memorial Cemetery and Columbarium*, p. 11

VETERAN'S MEMORIAL MONUMENT, C. 2023

EDMONDS INDEPENDENT TELEPHONE COMPANY

In 1899 the Sunset Telephone Company began stringing lines through the trees into Edmonds, and they launched service in 1900. The switchboard was set up in the Hyner home, and at 16, Ruth Hyner was the first operator. Ruth had worked as one of the three operators for the telephone company in Everett. She is the one in the amazing hat and coat in the EHM 237.2 picture.

SUNSET TELEPHONE COMPANY AND EDMONDS POST OFFICE, EHM 237.2, C. 1900

Ruth's father, Matthew E. Hyner, was the postmaster who replaced George Brackett in the role. When L. L. Austin became the postmaster in 1901, he moved the switchboard to his office on Bell Street near 2nd Avenue. But its users weren't happy. The wires came out from Bothell and ran through woods and thickets, and the wires could go down when the weather was bad. The result was that an alternative company replaced the Sunset Telephone Company. By 1908 Allen Yost was elected president of a new telephone company, and Daniel Yost was elected manager.

The new company was called the Edmonds Independent Telephone Company and had a new switchboard and lines running both to Seattle and to Port Townsend. Ruth Nelson became the operator, and the switchboard was open from 8 AM to 10 PM. She slept in the back room of the building. Daniel would ride off himself on horseback or take a boat to track down and repair lines when they went down. For

years he spent each night on a cot next to his switchboard.

At one point, President Theodore Roosevelt was traveling through and spent several days at the White Horse Tavern in Edmonds.[47] As the President, he needed telephone service around the clock and made a deal with Yost to keep the switchboard open twenty-four hours a day. After he left, Yost continued to follow the precedent.

The original Independent Telephone Company Office was in the building on the right in the *Then* picture (EHM 160.187), and the building on the left was the company's new building. Now, Aria Studio Gallery occupies the new building, and Christopher Framing & Gallery is in the location of the old building.

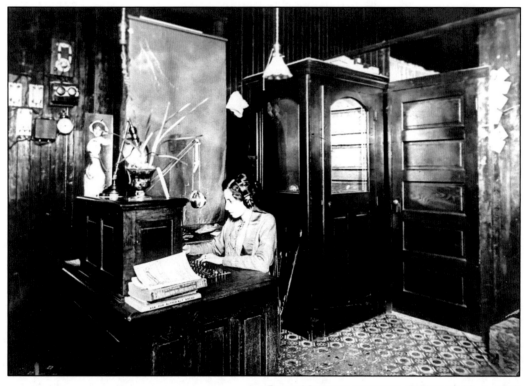

RUTH NELSON AT WORK, EHM 160.29, C. 1912

EHM 160.29 provides a glimpse into that early telephone company showing where Ruth Nelson is at work. You cannot help but wonder what all the pieces of paper are that are stuck in the wall, and the book on butternut bread under the directory makes me hungry. In EHM 160.148, the people standing in front of the old location are Kate Boshart, the day operator, Clara Sawyer, the night operator, and Daniel "Dan" Martin Yost.

[47] The White Horse Tavern located on 220th Street Southwest in Edmonds is now called the Rosewood Manor. According to Brad Holden, author of *Seattle Prohibition: Bootleggers, Rumrunners & Graft in the Queen City*, "It has a rich history…It once was a hunting club and some say that Theodore Roosevelt may have stayed there. It became a brothel at one point and it was the White Horse Tavern serving moonshine. It's now home to a Christian fellowship."

THEN, C. 1924

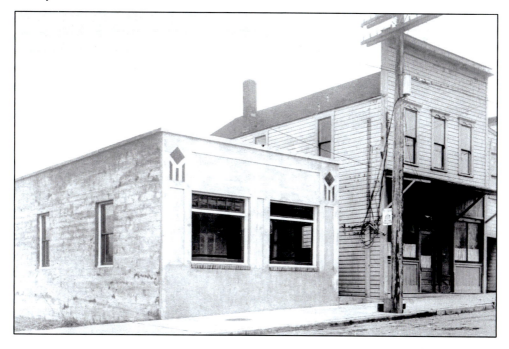

EHM 160.187

NOW

535 Main Street, c. 2022

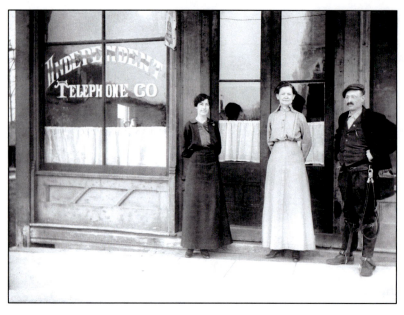

EHM 160.148, c. 1915

Edmonds Historical Museum Exhibit, c. 2023

MURALS EAST OF 5TH AND MAIN

There are a variety of murals scattered around the area just east of 5th Avenue that are worth noticing as you walk east up Main Street.[48] A link to a complete map of the murals is included in the Resources list in the Appendix.

- Next to the Museum area is "Winter Walk" by Susan Babcock and "Coastal Companion" by Ellen Clark.
- You can see "A Mother's Love" by Jake Wagoner up Main on the north side.
- On the south side are "The Salish Sea" by Nick Goettling and "An Edmonds Kind of Eve" by Cheryl Waale.

"A Mother's Love" on the Schneider Building, c. 2023

[48] All the murals are provided by the Mural Project Edmonds, which is a committee of Art Walk Edmonds.

BASSETT HOUSE

The following research is shared by Mardee Coyle Austin, who now lives in the delightful and noteworthy Bassett House:

PHOTO COURTESY OF THE EDMONDS HISTORICAL MUSEUM

"Anna Vetter Bassett was no ordinary Victorian-era woman. Born in Ohio in 1860 and homeschooled by her father (a preacher), she graduated with honors from Oberlin College in 1887 and went on to see the world! She taught music in China and Japan for several years before returning to the states with her new husband (Reverend Franklin Bassett), living in Kansas, Illinois, Missouri, Michigan, Minnesota, and North Dakota before settling in Edmonds in 1904. She was a strong, civic-minded woman and very involved in our town's early development. She shared her great love of flowers and music with others through her founding of both the Edmonds Floretum Flower Club and the Edmonds Music and Art Study Club. Anna was an active suffragist and was the first woman in Edmonds to register to vote. Her most lasting legacy lives on through the thousands of pianists that can trace their piano instruction (often through their piano instructor's instruction) back to Anna Bassett.

Bassett House on Main Street is the oldest residential home remaining in Edmonds, built by a logging company in 1888 for $90. Musicians and artists gathered here in early days. The room with the turret was the music studio where Anna V. Bassett gave piano lessons. The Bassetts bought the home in 1900, and it remained in the family for three generations until Anna's granddaughter Eloise Skavdahl sold it to a developer in 1982. The home had seen better days by that point and needed quite a lot of work. Local realtors and developers Don and Chris Van Driel turned it into a showplace home project, adding a garage and foundation, as well as an addition that doubled its size. After the extensive restoration project, it was open to the public for tours for a short time before being sold. They were careful to preserve as much of the original features and character as possible, as well as the front exterior of the home, so it looks very similar today as it does to how it looked in the 1890s."

The *Then* image shows the Leyda family outside the house in 1905. The picture is of Emma and George Leyda, and their children Marguerite, Anita, Alta, Dewey, and Emery. The Leydas owned the Fourtner building for a while and so that building was sometimes called the Leyda building.

THEN, C. 1905

EHM 180.81

NOW

Private Residence, 729 Main Street, c. 2023

THE SOUTHEAST BOWL

Edmonds grew up from the water, especially around Main Street. Many of the earliest residents lived within a few blocks of Main, especially between Main and what became Caspers Street. As the town matured over the years and the trees were cut down, further east and south areas filled in. The *Then* photo (EHM 150.56) on the next page provides a nice overview of Edmonds as it was in 1906 and before there was anything like a condo. In this view, you can see the first church in Edmonds, the Congregational Church, and its parsonage. Up on the hill, the very distinctive Grade School stands out. The big house in front (which has since been replaced by the Church of Christ, Scientist) was the Dewey House. A little house towards the right is McElroy's Undertaking Parlor. I find the stump in the middle of the road particularly endearing and a sign of the times.

The angle used by the original photographer to take the shot is particularly interesting today. It was probably from the top of the hill between Maple and Alder, and to the west of 6th Avenue. Today, of course, that entire hill is covered with condos. I was stymied for a while as I explored different ways of getting the angle and the height, and I couldn't find any willing condo owners who would let me onto their balconies for a picture or two. Fortunately, Jesse Bermensolo from here in Edmonds was kind enough to do the drone photo for the *Now* image. We got approximately the right height and in a line that captures the business that is where the Church was, the former parsonage (now a private residence), and the Francis Anderson Center that occupies the Elementary School that, in turn, had replaced the Grade School.

This picture looks down 5th Avenue as you head toward *the Circle*, providing a little context. You can get a sense of the density of condos that fill the area that had once been the magnificent forests that had called to Brackett.

HEADING INTO EDMONDS ON 5TH AVENUE, C. 2023

THEN, C.1906

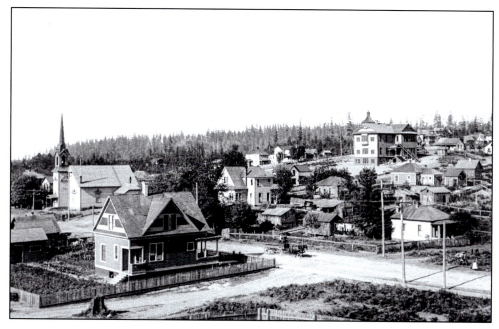

Edmonds Congregational Church, Parsonage, and Grade School, EHM 150.56

NOW

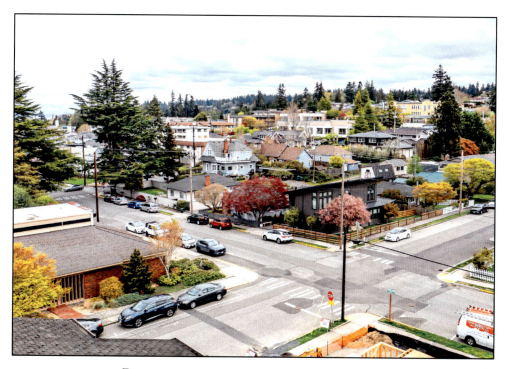

Drone photo provided courtesy of Jesse Bermensolo, c. 2023

EDMONDS GRADE SCHOOL

"During those first school years in Edmonds the Deiner children boarded at the home of Mr. and Mrs. Wellington Smith who arrived in Edmonds in 1885 with their two children, Ethel and Allen. Mrs. Smith organized the first Sunday school in the community.

"Sunday afternoons the Deiner children's stepfather, John C. Lund would row them to Edmonds in his sturdy rowboat from their Meadowdale home and would come for them again Friday afternoon…

"By 1891 when the attendance had outgrown the first schoolhouse, although an addition had been built, classes were held in Mr. Brackett's hall temporarily and for the second time he donated a site for the school, this time a half a block, situated above Seventh avenue, the site of the present Edmonds grade school. The school district floated a $10,000 bond issue and erected what was then a truly magnificent frame schoolhouse which served for 37 years." – Cloud, *Edmonds: The Gem of Puget Sound*, p. 10-11

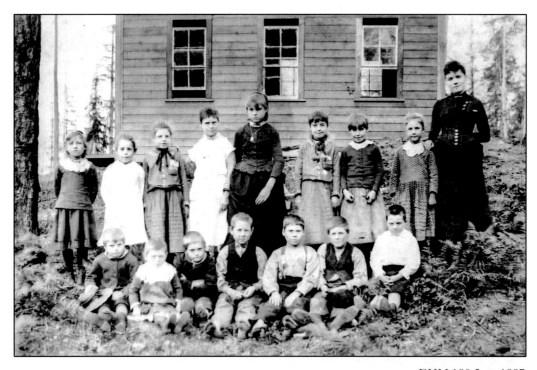

EHM 100.2, C. 1887

The first classroom in Edmonds met just eight years after Brackett landed and just four years after the first settlers began to arrive. A classroom was set up in George Brackett's feed barn for six students. By 1887, fifteen children attended class in a one-room schoolhouse about a half-block north of Main Street on a hill between 3rd and 4th Avenues. Among the students were the three Deiner children who were brought each

THEN, C. 1930

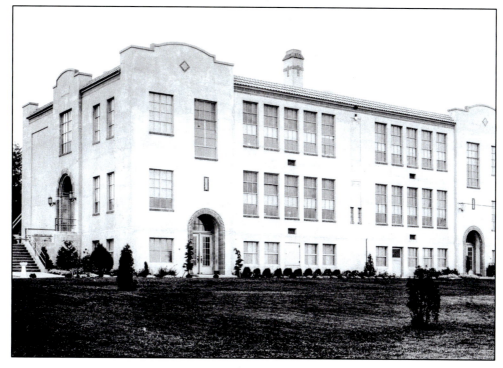

THE NEW ELEMENTARY SCHOOL, EHM 101.18

NOW

700 MAIN STREET, C. 2022

week by their stepfather John Lund (who lived north of Edmonds in Meadowdale). The students outside the first dedicated schoolhouse include Ruth Hyner (who became the first Edmonds telephone operator) and the Deiner, Brackett, and Fourtner kids (including Fred Fourtner, a future mayor). It had been built on a little hill between 3rd and 4th Avenue N, just north of Main Street. There is an Edmonds "Stages of History" plaque at approximately the location of the one-room schoolhouse.

By 1890, to handle the growing demand, a lot on Seventh and Main was donated by Brackett. George Brackett did seem to have a unique commitment to educating the children of Edmonds. As the students outgrew the small space they were in, he negotiated with the investment company that owned much of the land at that point to get back some of the lands he had sold to them to use for a school. He then gave this land to the city. A three-story frame school was constructed at the cost of about $5750 and opened in 1891 (EHM 101.22). The school comprised eight grades and was known as the Edmonds Graded School. This was the site of several early photographs that documented the growth of the downtown Edmonds area. Since there wasn't yet a high school, the lower classes ended with the sixth grade, but it was possible to get an accredited high school degree in two years, and some students did go on to college. A 370-pound iron bell was cast and placed in the school's cupola. It rang twice a day to call children to class. The bell is now sitting in front of the Edmonds Historical Museum.

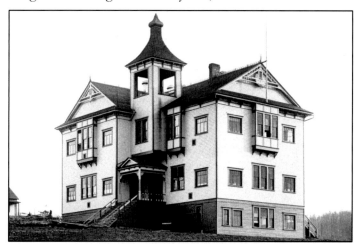

THE OLD GRADE SCHOOL, EHM 101.22, C. 1912

James Brady arrived as a teacher and principal for the new school and served in those roles for seven years. Like others in the community, he eventually operated a mill on the waterfront. He also served as a popular mayor for eight years. Alas, Brady did have a tragic death.[49]

By 1907 there were 288 students in the Edmonds Grade School. By 1909 there were 12 teachers and 336 students (grades 1 to 11). A new Edmonds Elementary building opened in 1927 and was expanded with additions in 1948, 1952, and 1961. The new Elementary School is shown in the *Then* image EHM 101.18. As we Baby Boomers aged out and enrollments began to decline, the School District eventually closed the School in 1972, and it was sold to the city of Edmonds in 1978. It is currently the site of the Edmonds branch of the Sno-Isle Library and the Francis-

[49] James Brady and his wife, Margaret, had been married for twenty-four years at his death. James was admired by many, as was his wife. Margaret was praised in the local press as "a lady of refinement and charming social qualities." Unfortunately, O.C. Garrett who arrived on April 18, 1912 to wallpaper their home discovered the bodies of James and Margaret. Apparently, Margaret had shot her husband in his bed and then committed suicide. It was said that she had been having some emotional problems more recently that had been increasing. A bucket of coal oil was found under the bed, and people speculated she had originally intended to burn down the house as well.

Anderson Leisure and Recreation Center (shown in the *Now* picture). It is also a center of various community activities throughout the year, for example, the Edmonds Arts Festival and the Taste of Edmonds.

FORMER MAYOR JAMES BRADY'S GRAVE, C. 2023

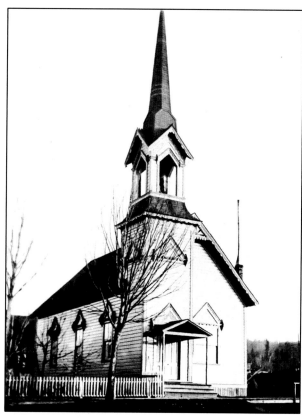

EDMONDS' FIRST CHURCH,
THE CONGREGATIONAL CHURCH, EHM 120.2, C. 1901

SOUTHSIDE CHURCHES

The Congregational Church on 6th and Dayton, from its beginning in 1888 as the first church in Edmonds, served as a place of worship and a center for community social activities. Congregational churches trace their roots to the first Pilgrims in America, so it somehow seems appropriate for one to be the first church in Edmonds. Its bell was heard across the town and gave rhythm to community life. Other churches that were springing up included the Episcopal Church, the Swedish Methodist Church, the Holy Rosary Church, the Methodist Episcopal Church, the Free Methodist Church, and the Baptist Church. A bell that hung in Holy Rosary Church, recently refurbished, is now in the tower of Edmonds' Holy Trinity Church (which occupies the former Holy Rosary building).

> "For me, as a child in Edmonds, the sound of the church bells ringing out on Sundays was a reminder that there was still hope for a better world for everyone---just around the corner. We knew that in many places people faced evil each day. There were wars, poverty, hunger and crime. But Sunday was a day for giving thanks to our Creator that we were blessed to be able to live in such a special place. Sunday was also a day set aside for family. Later, when the sound of the bells was stilled, Sundays were never quite the same." – Betty Lou Gaeng, in a *My Edmonds News* posting of April 15, 2022.

EDMONDS CONGREGATIONAL CHURCH

As mentioned, the **Edmonds Congregational Church** was the first church in Edmonds, and the first with a dedicated church building. The church began in part as a Sunday School for the children of Edmonds. They first met at the northwest corner of 3rd Avenue and George Street in the home of Flora and Wellington Smith, who had moved here in 1885. Although Flora taught Sunday School and never formally taught in public school, she impacted many. The parents eventually joined the children, and the congregation needed a bigger meeting place.

The Congregational Church held its first services in 1888. Reverend Samuel Green had led the effort to obtain land, financing, and willing hands to build the church. He preached the first sermon when it opened its doors, and you can imagine the excitement of the service of thanks and praise. The building was constructed in its classic small-town church gothic revival style on the northeast corner of 6th and Dayton. The bell tower steeple made a statement in the town's skyline that complemented the grade school higher on the hill. In 1902 the parsonage was built across the street on Dayton and joined the Edmonds Register of Historic Places in 2009. Reverend Olin L. Fowler became the church's first full-time pastor. As with the other churches that subsequently grew up, it served as a center of religious activities and home to various non-religious community social events as well.

Members worshiped there until after WWI, and then the building was sold to Frank Freese Post #66 of the American Legion. The Legion removed the steeple,

THEN, C. 1902

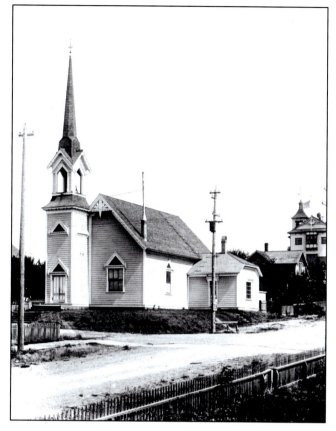

EHM 120.4

NOW

SLATE SALON AND SPA, 601 DAYTON STREET, C. 2023

THEN, PARSONAGE, C. 1960

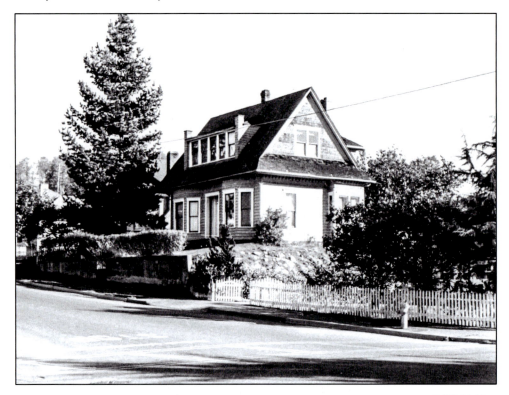

EHM 120.7

NOW

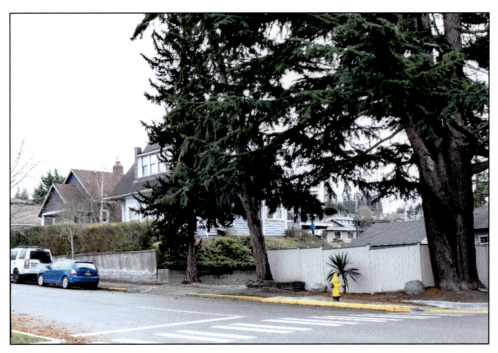

Private Home, 610 Dayton Street, c. 2023

may have rotated the building ninety degrees and added a basement. Post #66 occupied the building for eighty years but eventually had to sell it. The cost of maintaining the building exceeded their budget. They are currently housed in a building next door to the old location of the church.

In the *Then* image EHM 120.4 of the church, the old grade school can be seen in the background. Even in the *Now* image, you can see just a little of the new elementary school (now the Francis Anderson Center) if you look carefully up the hill and behind some trees. The current Slate Salon & Spa building may have been built on the footprint of the old church, although it isn't clear how much of the church was used. The ribbon cutting for the Salon & Spa was in 2014.

It is fun to look at these vintage pictures carefully. In this one of the Congregational Church's singing classes (EHM 120.5), a person is peeking out of the church door on the left, and someone (possibly the pastor or director) on the right is holding his hand up behind the choir. What could possibly be happening?

First Congregational Church's Singing Class, EHM 120.5, c. 1898

METHODIST EPISCOPAL CHURCH

Windows from the Hughes Memorial Church, c. 2023

In 1903 the **Swedish Methodist Episcopal Church** began meeting. By 1904, a small building was erected at the northwest corner of 5th Avenue and Dayton Street on land purchased for $250 from Mr. and Mrs. John Lyke. Sunday services were conducted in both Swedish and English. The Pacific Northwest is similar to much of Scandinavia and attracted immigrants from Sweden and Norway early on. Swedes often worked as lumberjacks and carpenters, and Norwegians frequently worked as fishermen. Edmonds, as a result, developed an early Swedish community. It is not an accident that two mills were known as the Little Swede and the Big Swede.

By 1908, Mr. B.F. Luc, a retired Methodist minister, started running a Sunday School in the building owned by the Swedish Methodist Episcopal congregation, which led to the formation of the Edmonds Episcopal Methodist Church. By 1915 the property was sold to the **Methodist Episcopal Church**. By 1924, they had grown so much that their Bishop Sheppard advocated for a new church building in Edmonds to memorialize Bishop Mathew S. Hughes.[50] Reverend C.E. Preston, the minister, began raising funds for the new facility, and the mission revival-style wood-frame structure was completed for $14,737. The old building was shifted to the back of the property. The new building's interior had rounded arches and stained-glass windows. The windows, in particular, were a point of pride for the congregation. It was said that because of the mission style, visitors to town sometimes came to the church and wanted to meet the padre.

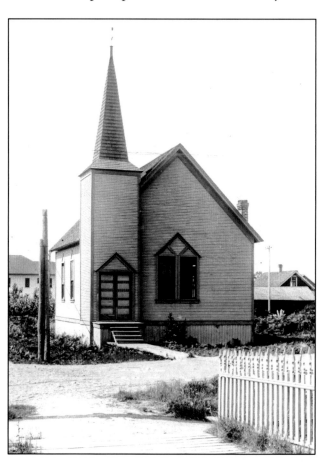

SWEDISH METHODIST EPISCOPAL CHURCH, EHM 122.8, C. 1910

By the 1950s, the church had grown so much that the decision was made to build a new church. The congregation acquired property on a portion of the Caspers farm on Ninth and Caspers Street. The new church, the **Edmonds United Methodist Church**, was completed in 1959 and even contains the stained-glass windows rescued from the old church.

[50] Bishop M.S. Hughes, D.D., LL.D., was born in Virginia, and was educated at West Virginia University. He studied law, and worked for a newspaper for a while. He was ordained to the ministry in 1887, and served as a pastor for churches in Portland, ME, Minneapolis, MN, Kansas City, KA, and Pasadena, CA. He became a professor of practical theology at the University of :Southern California.

THEN, C. 1924

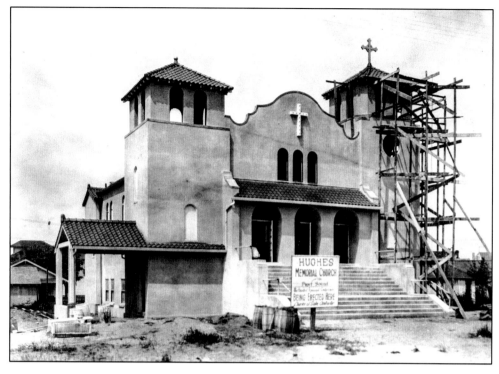

EHM 122.3

THEN, C. 1950

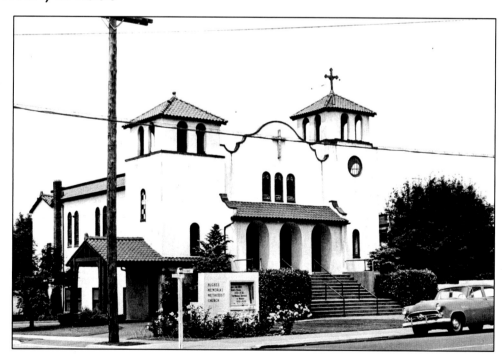

EHM 122.5

NOW

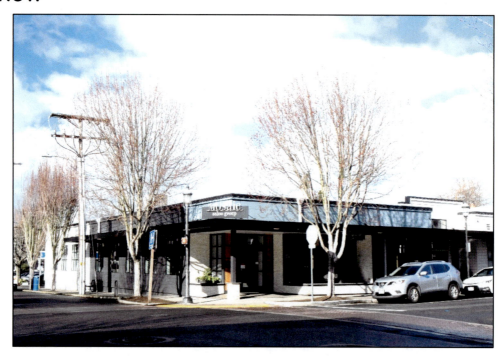

Mosaic Salon Group, 130 5th Avenue, c. 2023

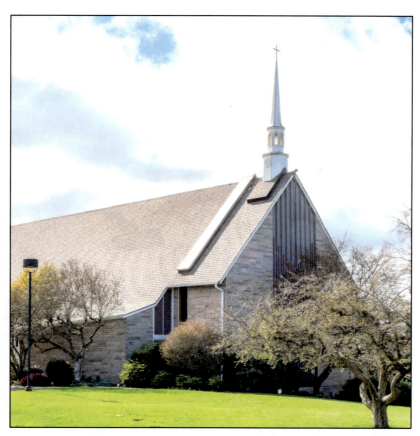

Edmonds United Methodist Church, 828 Caspers Street, c. 2023

CITY PARK ON LAND PURCHASED FROM EMMA ERBEN, C. 2023

ENGEL HOUSE

Back in 1904, L.C. Engel built two important structures on his land. One was his business on Main Street, and one was a two-story house between Main and Dayton that served as a home for his wife and three children. His children were Eathel, Ernest, and Jessye, born in 1895, 1898, and 1903 respectively. The house was situated at the southeast corner of the property, and its parlor window overlooked Dayton Street. Its entrance was on 5th Street, and a long walkway led to the house from the street. There were fishponds on both sides of the walkway, and a large garden consisting of fruits, vegetables, raspberries, and gooseberries was located to the north. A small barn was also constructed south of a small east-west path through the property.

As time passed, the original pathway and fishponds were removed to make way for a gas station, Brusseau's Cafe, and, most recently, the Red Twig restaurant. However, the original foundation and structure of the house remain on the east side of the Red Twig. Nowadays, the house's entrance faces Dayton Street at 509 Dayton, and it has been modified and updated several times over the years, now functioning as a duplex. Nonetheless, after almost 120 years, it still testifies to the quality and legacy of Engel's construction and design.

While the original L.C. Engel home was built in 1904, its grounds gradually disappeared. In the *Then* shot on the next page (drawn from EHM 160.143), the one image we have of the original house was part of a picture focusing on the Engel building. Today, you can't see anything from that angle, but you can see it from Dayton. The Shell station, shown in EHS 160.224, was built where the front yard had been in the 1940s. The gas station ended up closing in 1960, and at various points was a Tux Shop and then a gun shop. Finally, it became a restaurant. But in the *Today* shot, you can see the front of the house that still stands today.

THEN

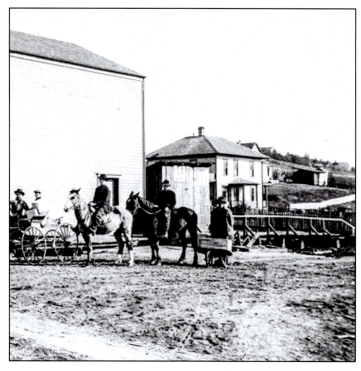

See EHM 160.143, 1910

NOW

509 Dayton Street, c. 2023

THEN, C. LATE 1940S

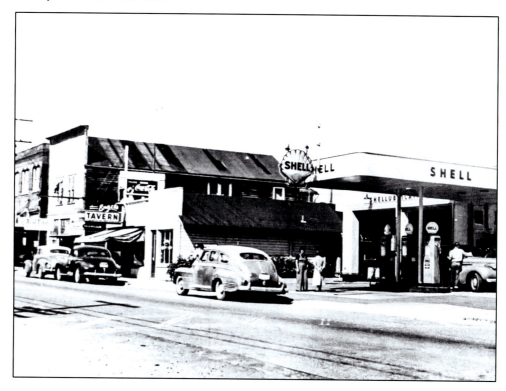

EHS 160.224

NOW

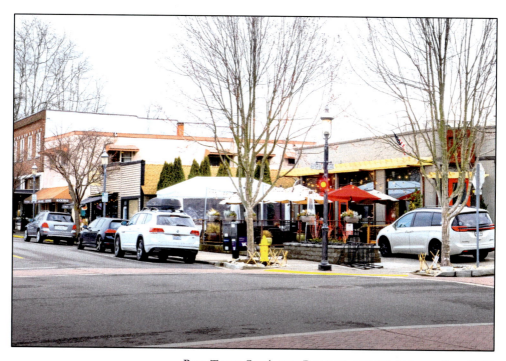

Red Twig Café and Bakery, 117 5th Avenue S, c. 2023

EDMONDS OPERA HOUSE AND ATHLETIC HALL

The Opera House played a significant role in the history of Edmonds. In the early days, life was often tough, and people sought entertainment and diversion, especially at local saloons. The IOOF Odd Fellows Hall on Main Street organized musicals, dances, and other forms of entertainment. The first traveling troupe of performers visited the Odd Fellows Hall on September 30, 1907. Churches and men's and women's clubs also sprang up, but people wanted more. Musical events, dramas, lectures, and other occasions also occurred at the Edmonds High School. But the appetite for entertainment grew as Edmonds did.

EHM 150.205, C. 1909

In 1908, the Edmonds Athletic Club was formed and grew rapidly in popularity. Allen M. Yost, a local entrepreneur and "influencer," decided to build a new athletic facility for the club, just up from his auto dealership, on the site of the old Socialist Hall.[51] He named it the Edmonds Opera House (perhaps aspiringly) and installed gymnasium equipment, a basketball court, and billiard and card tables. Two bowling alleys were even added. It could also serve as an auditorium, and it was used as a movie house, roller-skating rink, dance floor, and banquet hall. In the early days, operas were even staged there occasionally, and a stage was set up at one end where sets could be brought in as needed during theater performances. The building was dedicated on Christmas night in 1909.

A few months after its dedication, a traveling road company called the Artesian Stock Company presented "Down the Black Canyon" and "For Her Brother's Sake"

[51] The fact that there was a Socialist Hall and a Socialist Mayor during these early years suggests that are many interesting stories of early Edmonds that have yet to be told.

THEN, C. 1909 OR LATER

EHM 150.204

NOW

515 Dayton Street, c. 2022

> "In addition to the frequent Lyceum programs provided by the Edmonds High School and the occasional lectures, musical and dramatic programs staged at either the Odd Fellows Hall or the Opera House, Edmonds businessmen and civic leaders provided a Chautauqua for several years. The first Chautauqua was a gala affair, presented under a huge tent on the high school grounds, in July 1916. To enhance the festive spirit, the Edmonds Cornet Band was revived, and played concerts on Main street each evening in advance of the Chautauqua program…The all-important bass drum had no regular player listed, but it is supposed this position was filled by volunteers from among those who happened to be present on each occasion."- Cloud, *Edmonds: The Gem of Puget Sound*, p. 53

on the Opera House stage. Local performances and variety shows were sponsored by various groups (e.g., Legion Post #66) and featured members of the Chamber of Commerce and others. Chautauqua programs were held from 1919 to 1920 in the building[52], and the Edmonds Community Chorus performed there. The athletic club remained successful, and for several years, the local basketball teams brought fame to Edmonds. The hall was even used as a roller-skating rink as skating became more popular.

In essence, the Opera House was an early Edmonds version of Seattle's Climate Change Arena. The building was sold to Masonic Lodge #165 in 1944, and Yost was an early member of the Lodge. It still serves the community by supporting a wide range of events, and the recent 50th Anniversary Celebration for the Edmonds-South Snohomish County Historical Society was held there.

Now Relaxation, Edmonds Harbor, c. 2019

[52] The Chautauqua movement in the late 19th and early 20th century was an adult education and social movement that brought speakers, teachers, musicians, showmen, preachers, and other "influencers" and celebrities of the day to rural America. A Chautauqua refresh could be a popular addition to today's Edmonds.

YOST AUTO COMPANY

"Perhaps one of the most fortunate events of 1890, so far as the future history and development of Edmonds were concerned, was the arrival of the Allen M. Yost Family…Mr. and Mrs. Yost brought up a sturdy family of two daughters and seven sons: Daniel, Joseph, John, Carrie, Elsie, Jacob, Edward, George and Samuel---the last one born at Edmonds---most of whom were destined to contribute a substantial share to the growth and well-being of Edmonds." – Cloud, *Edmonds: The Gem of Puget Sound*, p. 14

In *Edmonds: The Gem of Puget Sound*, Cloud suggests the 1890s were about the steamboat, and the priority was the docks for Edmonds. The focus in the first part of the twentieth century was the railroad, and the future of Edmonds pivoted around when the trains came through and where they stopped. You could say that the 1920s were about public transportation (e.g., buses), but the 1930s were about the automobile. The Yosts were at the heart of both of these trends. EHM 202.3 shows a family that shaped Edmonds then and is still influencing it today. In the picture, they range from Allen M. (54) and Amanda C. (58) Yost, to the youngest, Martin (3 weeks).

THE YOST FAMILY, EHM 202.3, C. 1910

The Yosts were a key family in Edmonds' history. In 1890, Allen and Amanda Yost arrived in Edmonds with their six sons and two daughters. Allen had been an unsuccessful farmer in Kanas, and when he stepped off the dock here, he had $9 in his pocket. He did have his skills as a carpenter, and they were needed here. By 1894 he had bought into the Currie Mill, and by 1895 the Yost & Sons mill was producing lumber and shingles on the Edmonds waterfront. Yost bought the 500 acres south of Edmonds that eventually became what is Woodway today to get access to more trees.

He served on the city council at various points, was a member of the first park board, and was mayor in 1903 for a short time. Yost and his sons started the Edmonds Spring Water Company, the Edmonds Independent Telephone Company, and the Yost Auto Company. All three helped grow the new town. The franchise that allowed Yost to buy out and integrate the three competing water companies meant that soon there was a dependable source of water, and dependable water meant it made sense to have an organized volunteer fire department. He even created the new Opera House at the request of the newly formed Edmonds Athletic Club members. The Yost Park tennis courts are built atop the holding tank for the Edmonds Spring Water Company dam built along Shell Creek.

> "In the spring of 1907 the [*Edmonds Tribune*] noted that 'Edmonds streets are lined each Sunday with automobile parties from Seattle'…Two years later a seven-passenger Austin from Seattle valued at $4800 was destroyed by fire near the Odd Fellows' Cemetery, and later T.A.A. Siegfriedt's horse shied while passing the wreck and overturned his sulky. Joyriding around Seattle was becoming such a hazard that the editor [Siegfriedt] was moved to suggest a law which would prohibit unchaperoned girls from riding in automobiles after dark." – Cloud, *Edmonds: The Gem of Puget Sound*, p. 31

SAM YOST, A.M. YOST, AND GEORGE YOST (AND JUDGE), IN A STOCK CAR DURABILITY TEST, EHM 202.18, C. 1913

THEN, C. 1920

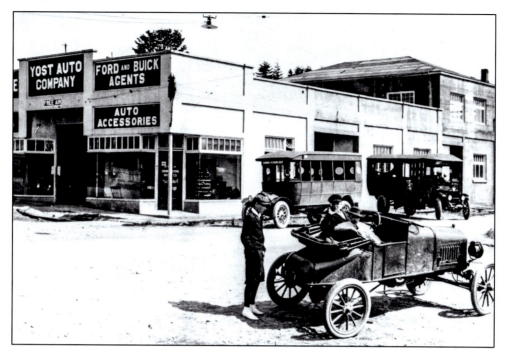

EHM 241.24

NOW

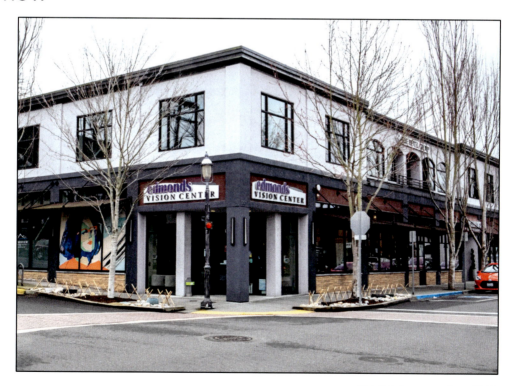

201 5TH AVENUE S, C. 2023

Alan Yost became the first Edmonds resident to own an automobile in 1911, an Everett 30, and EHM 202.18 shows the Yosts in one of their many cars. George Yost often served as chauffeur and chief mechanic. According to Joan Swift in *Brackett's Landing: A History of Early Edmonds* (p. 44), one story about him says that "he refused to walk from the athletic club to the candy store across the street but, instead, drove with a flourish around the block." Cloud shares another story from these early days of autos in Edmonds:

> In 1913, Mr. and Mrs. Yost, with George, "had gone east to pick up another Cadillac. George was so happy with the performance of this eight-cylinder car that he wrote home from Minnesota a glowing account of the trip and offered a prize of $1,000 to anyone who could guess the exact speedometer reading when the Cadillac reached Edmonds. In August the Yosts arrived, having covered 8716 miles in their car, all, George said, without the slightest trouble."[53]

1912 was when the North Trunk Road from Seattle to Snohomish County was completed. The cut-off to Edmonds was completed three years later, and several bus companies (including the Yosts') started operating between Seattle and Edmonds. In those early days, if you wanted service, you might have dealt with Ernest Heberlein, who ran an auto agency selling Flanders autos from his hardware store, and S.T. Sherrod, who sold gas in front of his hardware and furniture store.

By the end of 1913, A.M. Yost & Sons built the concrete building on the southeast corner of 5th and Dayton, shown in EHM 241.24. George, Jacob, and Samuel Yost formed the Yost Auto Company to operate a garage and a Ford dealership. They eventually became a Buick agency and started operating a bus line between Edmonds and Seattle. They mounted custom bodies on Buick chassis. By 1915 the Yost Auto Company provided the Edmonds schools with bus service, which continued until 1933.[54] In the picture, you can see the Yost showroom from around 1918 to 1920. Two of their buses are coming out of the garage. In front, George Yost can be seen with the "Bug" and two other Yost Boys. School buses provided by Yost are seen in the background. In the front

> George Yost came up with the idea for a two-unit bus and patented it. There was a driver's cab, and the bus body was a kind of trailer swinging on a pivot drum. It was powered with a Ford V8 engine. With its unique and strange design, it was typically known as the "Alligator Bus." In 1934, two of these buses were acquired by the Suburban Transportation System. It was so popular they started replacing their other standard buses with these new coaches. Unfortunately, the big bus companies successfully got the Washington State Legislature to make it illegal to carry paying passengers in a "trailer." The existing ones were grandfathered in and did continue to provide service until the 1940s.

[53] Cloud, *Edmonds: The Gem of Puget Sound*, pt. 39.
[54] *Edmonds: 100 Years for the Gem of Puget Sound* shares a story from *More Than Four Walls*, a collection of memories by former Edmonds High School students. They note that every once in a while the students would all run to the rear of the coach, and they could make the front wheels of the school bus rise off the ground.

Edmonds and Richmond Beach Bus, EHM 240.24, c. 1920

Alligator Bus, EHM 240.9, c. 1934

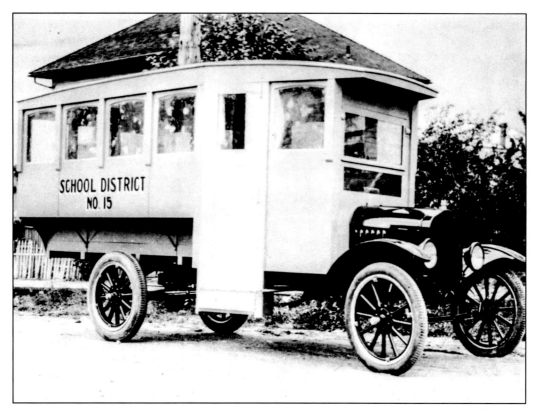

School Bus, EHM 240.22, c. 1915

is George Yost's car with the Yost boys. In 1918 an addition was made to the rear of the garage that can be seen here, and in 1920 another 2nd story addition was authorized that doubled their space.

Around this time, A.C. and R.A. Ellington established the first "auto stage" line from Richmond Beach and Edmonds to Seattle. The idea was to connect with the Phinney Avenue Streetcars at Eighty-fifth and Greenwood. Shortly after, their garage had a major fire (including losing one of their new "auto stages," and Yost and Sons bought them out. It is fun to look at pictures of some of the Yost buses. EHM 240.24 shows Nina Yost boarding a bus from Edmonds to Seattle, EHM 240.9 shows one of the Alligator Buses, and EHM 240.22 shows an early school bus.

In 1946, as WWII ended, the Yosts sold their business to the Edmonds Motor Company. They bought property between the original garage and Maple Street and built a Chevron station which was then leased back to the Edmonds Motor Company (and that can be seen in EHM 160.244).

J. Ward Phillips purchased the property that housed the Chevron station in 1973 and converted it into a set of shops and restaurants known as Old Milltown, in honor of early Edmonds. The look and feel of the buildings were designed to convey those pioneer days. A developer bought the property in 2006 to refresh it, but Cascade Bank (now Opus Bank) eventually took over the property. A Bellevue-based real estate developer acquired the property in 2011 and has invested heavily in sprucing up the buildings and attracting tenants. It is still possible to see some of the bones of the earlier structures in the area's layout.

THEN, C. 1950S

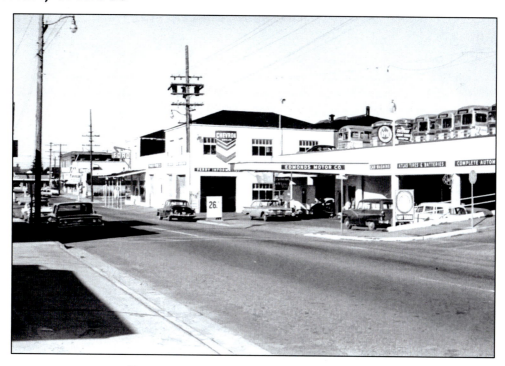

Edmonds Auto Company (Replaced Yost Auto), EHM 160.244

NOW

Hazel Miller Plaza and Shops, 203 5th Avenue S, c. 2023

Interestingly, when the refurbishing process was going on around 2007, a group of local artists acquired some of the doors from the shops. Eventually, the doors were "adopted" by various artists who used them to inspire works of art. A show was held in 2011 to exhibit the doors. Doors not only carry a rich source of messages that artists can riff off, but these doors also carry a lot of history.

As part of a program to create a central downtown open space for community use, the area in front of the shops was purchased and developed by the City of Edmonds to include a fountain, gardens, seating, and a small stage. It is now called Hazel Miller Plaza, and in addition to being a gathering place for people to grab something to eat or drink and sit and enjoy the atmosphere, it is also the site of concerts throughout the summer.

Hazel Miller and her husband were beloved members of the Edmonds community, where they had retired from their very successful Seattle business, the Seattle Quilt Manufacturing Company. They made the famous "comfy" sleeping bag. The Hazel Miller Foundation has continued to be active in the spirit of the Millers, and they are a vital part of making our community a vibrant place to live, work, and learn.

EDMONDS CLASSIC CAR SHOW, C. 2016

Edmonds Crows, c. 2023

Edmonds Baby Seals, c. 2023

A.M. YOST HOUSE

It is fascinating to visit A.M. Yost's house today. For someone so influential in early Edmonds life, the Yost family lived in a relatively modest house. Other pioneers ended up with what would have been mansions. Not so with A.M. Yost. It says something about the man.

THEN, C. 1913

EHM 182.3

NOW

PRIVATE RESIDENCE, 6 ½ AVENUE S AND PINE STREET, C. 2023

There were many Yosts, of course, and they had houses scattered around Edmonds. Like many children, I suspect, it appears they wanted to "improve" upon their childhood home. This house (EHM 182.6) belonged to Joseph Stephen Yost and is on 7th Avenue S and Fir Street. Today the house looks quite different, and there has been a lot of remodeling over the years. However, the front porch door and windows have remained pretty much the same.

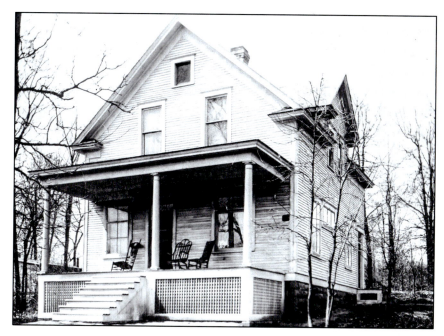

EHM 182.6, c. early 1900s

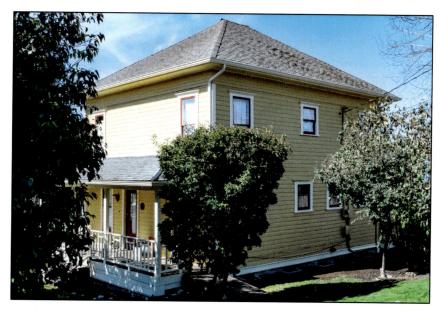

Private Residence, 7th Avenue S and Fir, c. 2023

The house belonging to John Elmer Yost on 658 Maple Street is still there. EHM 182.22 shows John holding his son Charles, with his wife Georgie and daughter Gladys. I like how Gladys is looking up at her mother. But again, while you can see the lines of parts of the original structure, it also has undergone extensive remodeling. It appears that some of the changes have been to add more space and provide more views of Puget Sound from the 2nd floor, and that would make a lot of sense. The current home's landscaping does hide what was a porch facing the street.

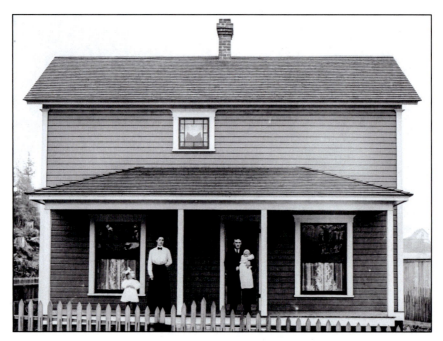

EHM 182.22, c. 1909

PRIVATE RESIDENCE, 658 MAPLE STREET, C. 2023

It is worth reminding ourselves of where the Yosts began when they first arrived. As with many of the pioneering families, the foundation was about converting trees to lumber and shingles.

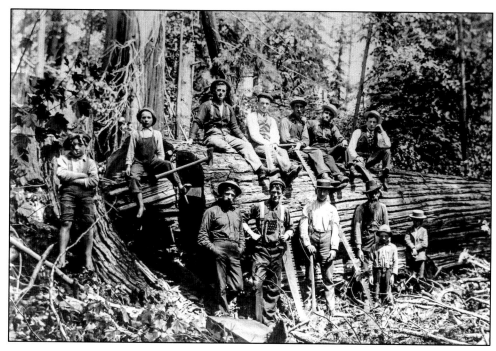

YOST CREW ON THE EDGE OF EDMONDS, EHM 144.15, C. 1900

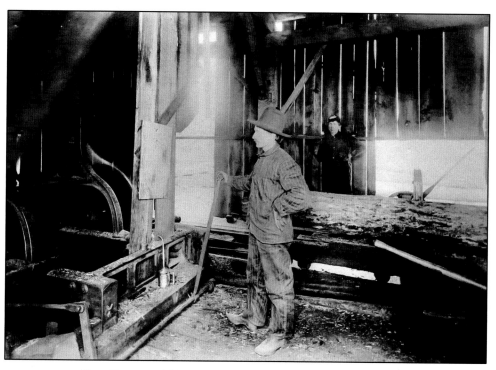

DAN YOST AT A.M. YOST & SONS LUMBER COMPANY, EHM 141.16, C. 1904

SOUTHSIDE MURALS

The collection of murals in Edmonds continues to grow. A pointer to a recent list is included in the Appendix with the list of Resources, but it is definitely worth keeping your eyes open as you explore this area of Edmonds. You never know what you will find, and new ones keep appearing. The following are some examples to look for:

- On the wall facing the mall with the Ace Hardware, you can see one of the early murals called "Seabaste Mallinger" by Mona Smiley-Fairbanks.
- In the picture below, on Girardi's Osteria Italiana's wall facing Walnut Coffee, you can find "Untitled" by John Osgood. It captures the spirit of an Edmonds sunset. Grab a latte from Walnut or a wine from Girardi's and enjoy the mural.
- "Darkness Reflected" by Sami Sully-Pronovost is on a wall on the corner of 4th Avenue S and Dayton.
- There are two murals on Salish Crossing down Dayton by the railroad tracks (where the Cascadia Art Museum is located). Both are by Andy Eccleshall. One facing the tracks is called "Giant Edmonds Octopus," and the other is called "Pearl of the Puget Sound."

"Untitled" by John Osgood, c. 2023

OTHER SOUTHSIDE HOUSES

Several other houses on the Edmonds Register of Historic Places are worth visiting in this area. They include:

- The Erben Houe (1910) at 803 6th Avenue S – The Erbens were active in the early days of Edmonds in the new century.
- The Dr. Palmer House (1895) at 820 Maple Street – Dr. William Palmer was Edmonds' first dentist.
- The Rynearson House (1890) at 524 Main Street – One of the local blacksmiths, Winfield Rynearson, and his family lived here. His daughter, Myrtie Otto, continued to live there until 1970.
- The Scalf House (1910) at 645 Fir Street – It has been described as a "well-preserved simple Victorian two-story residence."

GOAT PLAYGROUND IN A HOME IN WOODWAY, ORIGINALLY YOST LAND, C. 2023

LOOKING UP 5TH AVENUE TO MAIN STREET

In the image EHM 150.179 *Then* photo from the early 1950s, we see the look of Edmonds just before its transformation into the Edmonds we think of today. Left to right in this image, you can see Crow Hardware, Geisler's Variety Store, Osborn's Jewelry, Hubbard Reality & Insurance, McGinnis Pharmacy, Edmonds Toy & Hobby Shop, Ferne's Beauty Salon, and the Edmonds Bookshop. In the *Now* photo, you can see the Edmonds Bookshop, Cole Gallery and Art Studio, Clines Jewelers (which is moving to a larger space on *the Circle*), and the Starbucks.

Going further south and looking back to the center of downtown Edmonds, various places seem to come and go, and some are more like "every day" shops for residents. Longtime favorites include the Pancake Haus for inexpensive, hearty breakfasts (and as a meeting place for various organizations in town), and Hamburger Harry's for a burger and beer. You can get Italian at Girardi's Osteria and Chinese at Furi. There are grooming and exercise places, and Walnut Coffee is a place that probably knows your name by the time you return after your first visit.

Ace Hardware, which had moved from Dayton, seems appropriate for Edmonds. Sure, you can get hardware, but there is also a deli. There is a small grocery store, and you can pick up your wine there. It is a collection point for Amazon deliveries. You can get hunting and fishing licenses, and you can even renew the license for your car. Most importantly, you can find nice people who want to help you find solutions.

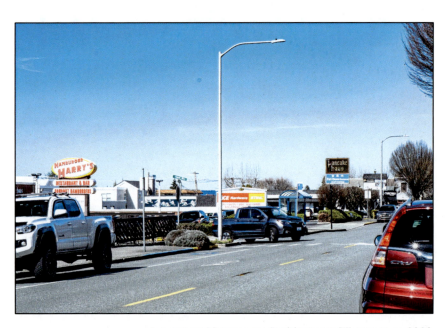

LOOKING NORTH ON 5TH TOWARD WALNUT, C. 2023

THEN, C. 1954

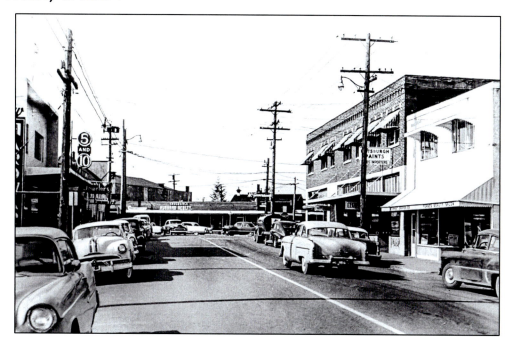

EHM 150.179

NOW

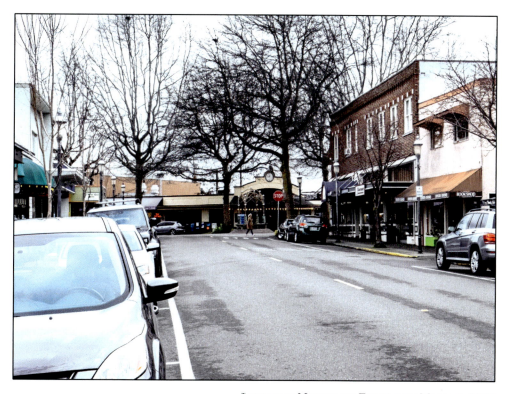

Looking North to Fifth and Main, c. 2022

5TH AVENUE AND MAIN INTERSECTION

To finish this tour, we are back where we started at the intersection of 5th Avenue and Main Street near the Edmonds Historical Museum. This intersection is the heart of the downtown area of Edmonds and, as the city that surrounds it, has gone through many iterations. From its very nature, though, through the history of Edmonds, it has always been the place to see and be seen and where the action is. As mentioned earlier, the Summer Market, the Art Walk, and local festivals and parades often center in and around this space. The best summary of the history of this intersection I've found is Larry Vogel's post on *Patch.com*.[55]

In the 1920s, the Park Band of Edmonds would perform there. The Kiwanis Club started a tradition by erecting a Christmas tree at the intersection in 1927. EHM 150.115 shows the placement of a scrap metal collection site during WWII. These drives were common across the country at the time and built community on the home front. In 1960, the Edmonds Arts Festival was a street fair held in this area.

As part of the "Main Street Project" and the general revival of the downtown area in the 1970s that transformed the aging city into the Edmonds of today, a symbol of that center was proposed. Businessman Al Kincaid had been instrumental in creating a traffic circle around a fountain in the early 1970s. The City of Edmonds Arts Commission and Public Art program made it part of the city's public art collection in the mid-70s. The original fountain and sculpture was a

EHM 150.112, 1950

[55] https://patch.com/washington/edmonds/the-cedar-dreams-fountain

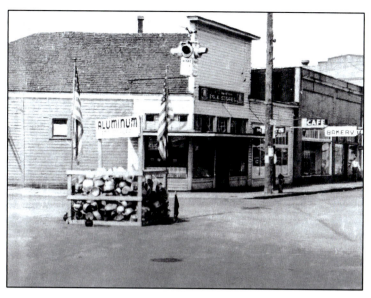

WARTIME ALUMINUM COLLECTION, EHM 150.115

EHM 150.111, C. 1990

free-form copper fountain and was not universally loved.

An out-of-control auto destroyed the abstract-looking sculpture in 1998, so a formal search and selection process to replace it began. That year, during the interim, a Lifetime TV crew filmed a made-for-TV movie in Edmonds, and the gazebo they created was used as a placeholder for the final design. It sits on the base of the former sculpture. At the end of the shoot, the gazebo was given to Edmonds, who kept it in place while the process was moving forward to create a permanent structure.

EHM 150.103, c. 1998

The final design we see today in *the Circle* at 5th Avenue and Main Street intersection was selected in 1999. It was designed by Benson Shaw, a Seattle artist, and was funded by the Edmonds Arts Festival Foundation. The general idea was a public space built around a central fountain and pergola and integrated with the surrounding traffic circle and sidewalk traffic. It is known as the "Edmonds Cedar Dreams Fountain," and its design perfectly summarizes how the Edmonds of today continues to reflect the echoes of its past. Larry Vogel's post describes the concept:

> "The central pergola incorporates structural references to the historic architecture of the city. The steeple on Edmonds' first church, the cupola on the historic Hyner house and the arched doorway of the Carnegie Library [building] are all reflected in the design. The upright pillars topped by lacelike metalwork evoke the

forests of Edmonds' past. The concrete railing encircling the base is reminiscent of a steamship wheel, and the columns supporting the railing were shaped so that the spaces between them look like cedar trees…The roadway, made up of contrasting concrete in a spiral design reminiscent of a circular sawmill blade, pays homage to Edmonds' industrial roots. The surrounding sidewalks feature benches repeating the design of the pergola balustrade, interpretive plaques set in the concrete and metal and glass inlays representing droplets of coastal fog on Western Red Cedar foliage."

LOOKING NORTH AT THE FOUNTAIN AND THE EDMONDS HISTORICAL MUSEUM, C. 2023

LIFE AROUND THE CIRCLE NOW

However, *the Circle* isn't really *Now* until it is filled with people and atmosphere. Here are a few photos taken in the area.

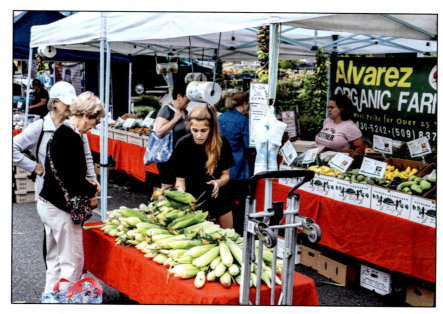

Edmonds Historical Museum Summer Market, c. 2022

Elvis at the Classic Car Show, c. 2022

Fourth of July Parade, c. 2023

First Pride of Edmonds, c. 2023

CONCLUSION

In some ways, the Edmonds of *Now* is a natural evolution from the foundation of *Then*. Certainly, the challenges that come from change and the social problems of the day still abound, as does a kind of "can do" spirit as the city wrestles with those challenges. But of course, the Edmonds of *Now* is also different in many ways from the early Edmonds. In the beginning, everyone could know nearly everyone else. The people we've been discussing owned multiple businesses, bought and sold those businesses, and held various government and other offices. In the early days, they fought fires together and levered carts out of mud and snow. They danced, played sports, and attended church with the people they saw daily. They did what had to be done to keep Edmonds moving forward, and business, political, and social worlds were entwined.

In the R.L. Polk & Company's Edmonds Directory of 1894-95, Edmonds was described as:

> "...situated 17 miles north of Seattle, on the Great Northern Railway. Steamers from all points north and south stop here and give Edmonds easy communication with all ports on the Sound and the North Pacific Coast. The principal industries are the manufacture and shipping in large quantities of lumber and cedar shingles. There are four shingle mills and one lumber mill. Edmonds is also represented in the fraternal orders by the Sons of Temperance, Odd Fellows, Good Fellows and the Ladies Guild of the Episcopal Church. The churches comprise the Episcopal and Congregational. There is also a live weekly newspaper, *The Edmonds Lyre*, ably edited by J. Hartson Dowd, and published every Saturday. The present population is about 750. *Great Northern Express and Telegraph*. M.E. Hyner, postmaster." [53]

Today, Edmonds has more than 42,000 people. It covers nearly ten square miles and includes a rich international district along Highway 99 and suburban areas up north to the Lund Gulch in Meadowdale. It is 75% Caucasian, 9% of the population is Asian (predominately Korean), 7% is Hispanic, and 9% are from other racial groups. The median age is 45, and there is a wide distribution of ages around town. Poverty is around 5.7% at this point. While lower than the state and other major cities in Washington, it still is significant as we work together as neighbors to build the community we envision. Edmonds contains a variety of neighborhoods, including Firdale, Five Corners, Perrinville, Seaview, Sherwood, and Westgate, each with its own rich history and stories to tell. You could refresh the elements of that Polk description and get pretty close to a *Now* description. Still, the Economic Alliance of Snohomish County has also provided a good summary of Edmonds *Now*:

> "The third largest city in Snohomish County, Edmonds has many characteristics: a growing economic base, diverse

[53] Cloud, *Edmonds: The Gem of Puget Sound*, p. 17-18

marketplace, excellent school system, and outstanding quality of life that make it an excellent location to locate, start or grow a business.

"A charming waterfront town, celebrated as an arts community, Edmonds offers a vibrant downtown, sandy beaches, stunning views, and a full calendar of exciting events. Fanning out from the central fountain, the walkable downtown boasts art galleries and day spas, as well as shops and boutiques offering clothing, garden supplies, housewares, jewelry, books and travel accessories, specialty wine and foodstuffs. Restaurants, cafes and bistros, offer a delicious dining experience and beachfront eateries with outdoor tables provide scenic views of Puget Sound, the Olympic Mountains, and magnificent sunsets."

APPENDIX: PANDEMIC IN EDMONDS 2019 TO 2022

APPENDIX: EDMONDS NOW SCRAPBOOK

Edmonds Underwater Park, Ferry, and Olympics, c. 2023

Afternoon in the Edmonds Harbor, c. 2023

Morning at the Pancake Haus, c. 2023

John McCutcheon Concert at the
Edmonds Center for the Arts, c. 2023

Edmonds Arts Festival, c. 2023

REDress Project Art Installation Honoring Indigenous People, United Methodist Church, c. 2023

Winter Sky While Drinking Lattes in *The Circle*, c. 2021

Rainy Fall Morning in The Circle, c. 2022

EDMONDS HISTORICAL MUSEUM SUMMER MARKET BOOTH, C. 2023

EDMONDS HISTORICAL MUSEUM SUMMER MARKET, C. 2023

GRAND OPENING OF THE CIVIC CENTER PLAYFIELD, C. 2023

EDMONDS CHERRY BLOSSOMS, C. 2019

Main Street Commons Construction, c. 2023

Camp Vintage (newly Opened) Climbing Rose, c. 2023

The Beat Brackett 5K, c. 2023

The Baby Brackett 1K, c. 2023

Sign for the Mar-Vel Marble Building that was demolished to make way for the Graphite Arts Center, Edmonds Historical Museum Exhibit, c. 2023

Lot Awaiting Construction Equipment for the Graphite Arts Center, c. 2019

First of the 2023 Summer Concerts in the Edmonds City Park, c. 2023

Edmonds Sunset on the Summer Solstice, c. 2023

APPENDIX: HISTORICAE PERSONAE DRAMATIS

There are a lot of characters in the stories of the history of Edmonds, so it is worth an attempt to lay out where some of the most notable people fit within the timeline.[54]

Date of Appearance	Name	Event
1876	George and Etta Brackett	Brackett moves his family to what would become Edmonds.
1885	Flora Smith	Flora and her husband Wellington arrive, and Flora starts the first "school," a Sunday School. It leads to Edmonds' first church.
1887	Matthew H. Hyner	Hyner, his wife (Clara), and their three children arrive in Edmonds on the steamer Monroe.
1889	Ole and Anna Sorensen	The Sorensens arrive from North Dakota.
1890	Allen M. Yost	Yost, his wife, and eight children arrive. He has $8 in his pocket.
1890	William H. Schumacher	Schumacher builds the Schumacher Building.
1891	Arthur Mowat	Mowat's house, the only remaining one from the original Brackett plat, was completed.
1897	Ernest "Ernie" Hubbard	Hubbard arrives in Edmonds.
1903	Colonel S.F. Street	Street steps in after A.M. Yost resigns as mayor and begins serving.
1904	Zophar Howell III	Howell organizes the Edmonds

[54] The translation of the Latin title is "historical persons of the drama."

		Chamber of Commerce.
1904	Louis Christian Engel	Engel, a German immigrant, arrives in Edmonds.
1905	Missouri T. B. Hanna	Hanna and Professor Frank H. Darling by the *Edmonds Review*, and she becomes one of the first woman newspaper managers in America.
1907	James "Jim" Everton Wilson	Wilson opens the Crescent Grocery Company.
1909	Anna V. Bassett	Bassett becomes the first woman to register to vote in Edmonds.
1909	Rev. John W. H. Lockwood	Lockwood is appointed Edmonds' first librarian.
1909	Florance Roscoe Beeson	Beeson purchases the property after the 1909 fire and begins building what we know as the Beeson Building.
1910	Frank W. Peabody	Peabody is serving as the resident manager for the Coon, Kingston, Peabody Company and operates a real estate office.
1912	Fred Fourtner	Fourtner, one of the first students in Edmonds, returns and sets up business.
1912	James Brady	Brady, a beloved mayor and educator, is found in bed tragically murdered by his wife.
1916	Fred Sticker	Sticker opens the Danish American Bakery.
1921	Thomas and Helen Berry	The Berrys purchase what would become the Princess Theater.
1924	Alice U. Kerr	Kerr becomes the first woman mayor of Edmonds.
1937	Betty Lou Gaeng (nee Deebach)	The Deebach family moves to Edmonds. Betty Lou became the doyenne of Edmonds' history.
1973	Doug Egan	Egan is the first president of the Edmonds-South Snohomish County Historical Society.

APPENDIX: RESOURCES

BOOKS

Cloud, Ray V. (1983). *Edmonds: The Gem of Puget Sound*. Edmonds, WA: Edmonds South Snohomish County Historical Society.

DuBois, Sara McGibbon and DuBois, Ray E. (2014). *Images of America: Edmonds 1850s-1950s*. Charleston, South Carolina: Arcadia Publishing.

Edmonds Fire Safety Foundation (2004). *Edmonds Fire Department: Celebrating 100 Years*. Edmonds, WA: Edmonds Fire Safety Foundation.

Gaeng, Betty Lou, and Janacek, Jerry (2021). *A Place of Tradition: Edmonds Memorial Cemetery and Columbarium*. Edmonds, WA: Edmonds Memorial Cemetery and Columbarium.

Humphrey, Robert (1984). *Everett and Snohomish County: A Pictorial History*. Brookfield, MO: The Donning Company Publishers.

Reinert, Harry (Ed.) (1990). *Edmonds: 100 Years for the Gem of Puget Sound*, The Edmonds Paper: Edmonds, WA.

Satterfield, Archie (1990). *Edmonds: The First Century*, Edmonds, WA: The City of Edmonds.

Swift, Joan (1975). *Brackett's Landing: A History of Early Edmonds*, Edmonds, WA: Joan Swift.

Whitfield, William (Ed.) (1926). *History of Snohomish County. Washington Volumes I and II*. Pioneer Historical Publishing Company: Unknown.

SEARCHABLE HISTORICAL COLUMNS

Edmonds Beacon. https://www.edmondsbeacon.com/
My Edmonds News. https://myedmondsnews.com/
Patch. https://patch.com/wasington/edmonds/

OTHER WEBSITES

Edmonds Historic Preservation Commission. https://www.edmondswa.gov/government/boards_and_commissions/historic_preservation_commission#:~:text=The%20mission%20of%20the%20Edmonds,and%20appreciation%20of%20local%20history

Edmonds Register of Historic Places. https://cdn5-hosted.civiclive.com/UserFiles/Servers/Server_16494932/File/Government/Boards%20and%20Commissions/Historic%20Preservation%20Commission/Register%20of%20Historic%20Places/Edmonds_Historic_Register_Map.pdf

Edmonds Stages of History Walk. https://www.edmondswa.gov/government/departments/cultural_services/edmonds_stages_of_history__a_walk_through_

time

Edmonds Art in Public Places. https://edmondswa.maps.arcgis.com/apps/Shortlist/index.html?appid=73be47330c884b26823854b86b027e37

LeWarne, Charles (2008). "George Brackett (1842-1927)." https://www.historylink.org/File/8475

Historic Sites of Edmonds. https://cdn5-hosted.civiclive.com/UserFiles/Servers/Server_16494932/File/Government/Boards%20and%20Commissions/Historic%20Preservation%20Commission/Surveys%20and%20Tours/HPC_walking_tour_11x17.pdf

Edmonds Mural Map. https://static1.squarespace.com/static/534bf97fe4b0bb0f73fd3cba/t/635ade03506660168df2e265/1666899463985/AWE_MPEmuralmap.pdf

Edmonds Museum and South Snohomish County Historical Society https://historicedmonds.org/, https://www.facebook.com/edmondsmuseum, https://www.youtube.com/@edmondshistoricalmuseum2817

My Edmonds Neighbors. https://www.facebook.com/groups/1552898245012481

Vintage Edmonds. https://www.facebook.com/VintageEdmonds

AUTHOR

Arnold (Arnie) Lund, PhD is currently the Vice President of the Board of Directors for the Edmonds Museum and South Snohomish County Historical Society. He grew up just south of Edmonds in Richmond Beach. Edmonds was "the big city." He and his dad worked there at various points. He graduated from the University of Chicago in chemistry with minors in philosophy and psychology and a commitment to learning from the past to inform the future. His professional field is human-computer interaction, focusing on design to ensure technology works for people. He has worked at leading innovative companies such as Bell Labs, Ameritech, Microsoft, GE Global Research, and Amazon. He is passionate about storytelling that changes lives and the power of technology to create compelling stories. When he retired the first time, it was to pass what he had learned on to the next generation. He became a Professor of Practice at the University of Washington, where he taught multi-media design. Retiring the second time allowed him to concentrate on his lifelong interests in the art of photography and history as he started his photography business and joined the Historical Society Board. *Edmonds Then and Now* is the convergence of his life interests, although probably not the culmination.

Dr. Lund is also the author of three other books, two of which are on the history of religion. He has written chapters in and edited various books. Arnie has received roughly thirty patents; and has published over eighty articles on popular culture, emerging technologies, and management topics. He is a member of the Association of Computing Machinery SIGCHI's Academy and is a Fellow of the Human Factors and Ergonomics Society. He has served on several Boards and Executive Committees of organizations devoted to making the benefits of technology accessible to everyone. His photographs have appeared in newspapers, books, and exhibitions, and can be found on his website and Instagram.

amlundjr@gmail.com
arnielund.com
www.instagram.com/arnielund/
linkedin.com/in/arnielund/

"We are making photographs to understand what our lives mean to us."

- Ralph Hattersley, Photographer

"Photographs open doors into the past, but they also allow a look into the future."

- Salley Mann, Photographer

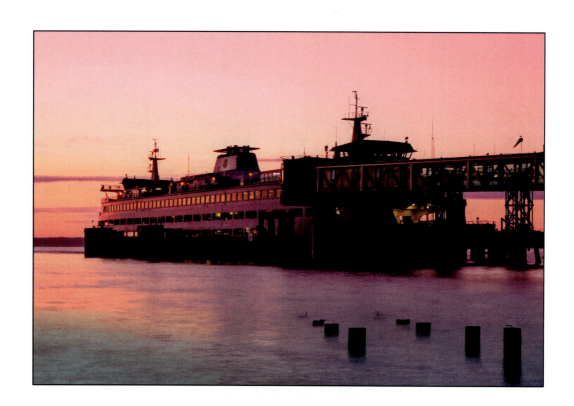